I0668896

Displaced Allegories

Duke University Press Durham and London 2008

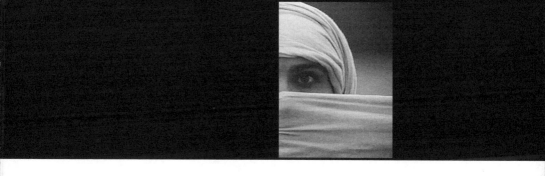

Post-Revolutionary Iranian Cinema

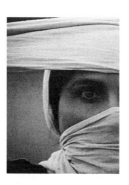

NEGAR MOTTAHEDEH

© 2008 Duke University Press

All rights reserved.

Printed in the United States of America

on acid-free paper ∞

Designed by C. H. Westmoreland

Typeset in Quadraat by Westchester Book Services, Inc.

Library of Congress Cataloging-in-Publication

Data appear on the last printed page of this book.

Duke University Press would like to acknowledge the support of the Persian Heritage
Foundation, which provided funds towards the production of this book.

For John and for Michelle

Contents

Acknowledgments

Displaced Allegories began because of an intervention in national cinema studies initiated at the University of Minnesota in the mid-1990s. I was a graduate student in the Department of Cultural Studies and Comparative Literature and was invited by John Mowitt to work as a research assistant on his book project on postcoloniality and film. His research reactivated cine-semiotics to address the conundrum of difference in the film language of postcolonial cinemas and then later (in *Re-takes*) articulated a definition of enunciation that would bridge film text and film industry. His project captivated me and I still get a bit breathless, all these years later, when I look back at that moment of recognition.

Keya Ganguly was at the University of Minnesota by that time and was working on the films of Satyajit Ray from a similar angle. Her ornate, brilliant article on Ray in *Camera Obscura* was one that I would return to over and over. Intrigued as I was by the films that were being produced by the Iranian industry and that were circulating in film festivals all over the United States, I decided to start my own investigations into the language of Iranian cinema under the Islamic regime. Afterward, I came across Hamid Naficy's early research and writing on contemporary Iranian cinema and the function of the veil in post-Revolutionary films. These three scholars—John, Keya, and Hamid—have guided and inspired me over the years it has taken to complete my own research on Iranian cinema under Islamic rule.

Following my defense at Minnesota, I moved to Ohio and spent weekends going to film events with Gerry Mischke and Michelle Lach at the Wexner Center for the Arts in Columbus. Michelle's passion for Kiarostami

sparked mine. The section on women in Kiarostami's work evolved from our impassioned conversations as we left the screenings and from various conferences on women and veiling in Iranian culture and cinema. Those conversations were memorable, and I am grateful for them. Nasrin Rahimieh, Farzaneh Milani, Mohamad Tavakoli-Targhi, Richard Tapper, and Laura Mulvey, who either invited me to conferences on Iranian cinema or encouraged my research on women and film, were also instrumental in the formation of my approach to Kiarostami's *oeuvre* in this book.

The book's argument that Iranian cinema is the apotheosis of 1970s feminist gaze theory really came together once I made my move to Duke University. It was largely in response to questions asked by Susan Willis, Jane Gaines, Ranji Khanna, Renata Salecl, Ariel Dorfman, Ken Surin, Wahneema Lubiana, and Fred Jameson during my job interview—questions on colonialism, the veil, film and nation, modernism, and color—that I wrote the book in its current form. I wanted to articulate the nature of a cinematic language where the look is proscribed. I thought that such an articulation would contribute to our understanding of how film studies can read national cinemas in the cross-cultural encounter.

The discussions I had with the graduate students in my "Contemporary Iranian Cinema" class in the Literature Program at Duke in the spring of 2003—Arnal Dilantha Dayaratna, Abigail Lauren Salerno, and Shilyh Warren—were formative, and their insights helped shape my reading of Iranian cinema as a displaced allegory of a curtailed film industry. Jane Gaines, Fred Jameson, Susan Willis, Ranji Khanna, Jan Radway, Alice Kaplan, Toril Moi, Lisa Klarr, Michelle Koerner, and Selin Ever read the complete manuscript and gave me many valuable comments. Mazyar Lotfalian, Ramyar Rossoukh, Elena Glasberg, Walter Mignolo, miriam cooke, Bruce Lawrence, Dudley Andrew, Joan Copjec, Michael Fischer, Clare Hemmings, Amit Rai, Naghmeh Sohrabi, Jasbir Puar, Ana Mariella Bacigalupo, Kiran Asher, Ben Sifuentes-Jáuregui, Susan Martin-Marquez, Diane Nelson, and members of the interdisciplinary seminars at Rutger's Institute for Research on Women and Duke's Franklin Humanities Institute read or heard and discussed parts of the book with me. These discussions were pivotal in formulating my arguments regarding the language with which Iranian cinema speaks to the world.

At Duke University Press, my editor Ken Wissoker has been consistent in his stand for the value of pursuing a "new-old" form of reading film (cine-semiotics as applied to national cinemas) and Courtney Berger has

been a constant supporter and advocate in my writing and yoga practice. We've spent many memorable times together in Paul Sobin's Anusara classes. In yoga and in tireless support, no one can top Griffin, but there are friends of a human variety that I couldn't do without in the last two years of writing and completion: Nancy Kimberly, Nicole Rowan, Michael Murphy, Ranji Khanna, Srinivas Aravamudan, Rebecca Stein, and Antonio Arce.

My reading of *Maybe . . . Some Other Time* was published in *Camera Obscura* 15:1 (2000). "Where Are Kiarostami's Women?" was published in *Subtitles: On Foreignness in Film*, edited by Atom Egoyan and Ian Balfour (MIT Press, 2004). My discussion of Mohsen Makhmalbaf's *Gabbeh* was originally published in a special issue on film feminism in *Signs: Journal of Women in Culture and Society* 30:1 (2004). I am grateful for the generous comments that the anonymous readers and editors of these essays provided. I would like to acknowledge the Harold Leonard Fellowship in Film Research at the University of Minnesota, the Rockefeller Foundation Residency Program at Rutgers University, the John Hope Franklin Humanities Institute, and the Iran Heritage Foundation for providing me with valuable resources to write and complete this book.

Producing a National Cinema,

a Woman's Cinema

In his *Last Will and Testament* published after his death in 1989, Ayatollah Ruhollah Khomeini, the spiritual and revolutionary leader of the new Islamic Republic of Iran, reflects on what he calls the nation's "state of self-estrangement." Crucially, he attributes this state of estrangement to the national body's alienation from its own sense perceptions, these being configured by the senses' fundamental attachment to film technologies.[1] Under the former Pahlavi rule, media technologies were used to transport the bitter seeds of westernization to Iran. Khomeini thus saw the nation's estrangement from its sensorium as a direct result of the preceding monarchic regime's ceding ownership of Iranian media to Western powers and the subsequent contamination of the national body by foreign pollutants. By Khomeini's logic, then, the impurities introduced into the media by the intervention of foreign forces stained national vision and hearing under the Pahlavi regime and linked the body of the nation to the world outside, configuring the Iranian subject as a *supranational* subject. The contamination that penetrated the national body not only attuned the body's sensorial capabilities to the needs of foreign powers; it also severed the spiritual link binding the nation to the *imaginal world* of the Shiite imams. The pollution of the national sensorium by globalizing forces working through media technologies implied the weakening of the national body and the distraction of the body's forces from production and national knowledge, even from "life."[2]

It is evident in his writings that for Khomeini, women's bodies marked the site of contamination.[3] They were the very fissures through which foreign impurities were introduced into the nation. Produced and characterized

as spectacles, women's bodies were used by media technologies to derail and weaken Iranian society, leaving Iran susceptible to other contaminants ushered in by colonial invasion, imperialism, and capitalism. This take on technology was not new to Iranian Shiite thought. Shiite modernists such as Jalal Al-i-Ahmad and Ali Shari'ati had attributed the "Westoxification" of the nation to contaminants introduced by Western technologies in the 1960s and '70s. Nevertheless, and perhaps surprisingly, Khomeini did not reject media technologies altogether; instead, he believed such "features of modernity" were in need of a thorough cleansing.[4]

In the attempt to cleanse its technologies, the post-Revolutionary Iranian film industry came to produce a cinema that I will argue is the apotheosis of 1970s feminist gaze theory. This introduction provides some historical and religious background for my thesis, focusing on Iranian cinema's stance against voyeurism and the effects of this stance on the cinema's enunciative constitution of the real in the temporal and spatial coordinates informing its fiction films.

Voyeurism and the Modesty System

To protect the nation from further contamination, the post-Revolutionary Islamic government established a system of modesty that aimed to make the modesty of Iranian women the hallmark of the new Shiite nation. Confined by the modesty system, women's bodies became the veiled and thus the purified sites of renewed national honor and heterosexual potency. In post-Revolutionary cinema, veiled female bodies were generated to stand against the contaminating influences previously introduced into mediating technologies, and to guard against forces that film studies refers to as the meta-desire of cinema itself, articulated in terms of Western melodrama's dominant codes of voyeurism and fetishism.[5]

In an effort to produce a national cinema against the voyeuristic gaze of dominant cinema, the post-Revolutionary film industry was charged with reeducating the national sensorium and inscribing a new national subject-spectator severed from dominant cinema's formal systems of looking. The industry was asked not only to represent another world, a purified Shiite world, but also to produce a new national body unhampered by the conventions and codes that habitually render time and space continuous and hence realistic in dominant cinema's scopophilic and voyeuristic procedures.

To respond to these demands, new formal procedures had to be developed. Moreover, if aesthetic procedures and perceptions in the new cinema were to reorient national sense perception, then new habits of contact and identification between media technologies and the senses had to be cultivated. Iranian film audiences would have to become so habituated to the new "grammar" of cinema technologies—its alternative renderings of temporal, spatial, and subject relations—that they as viewers could essentially innervate the new culture produced and represented on screen and do so as "distracted" viewers through their unhindered sensorial identification with a purified cinematic apparatus. For a new Iranian cinema and a new Islamic culture to take shape through the reinvigoration of the senses, the national body would have to incorporate the newly purified media technologies into its habits of reading the world, as part and parcel of its own sense perception. But first, Iranian cinema had to develop a new literacy to which the senses and the technologies that extended the sensorium in the realm of film production were attached. A new syntax of shot relations signaling "nationalized" spatial (and hence temporal) relations in film would have to be constructed on the basis of the Islamic Republic's prohibitions on the desiring look and its understanding of the purified sensorial link that could bind the national body to the imaginal world of the Shiite imams.[6]

In *Displaced Allegories* I argue that in response to these demands by the Islamic government, Iranian film narratives became secondary to the religious and political task of nation building approached through the senses. Building on Shiite prohibitions on the desiring look, a new narrative cinema emerged as a displaced allegory of the determining conditions of the post-Revolutionary film industry. This allegory was distinct from the direct content of the narrative in the films, a second-level message that could certainly accompany the narrative but that would necessarily arise on the level of form rather than from the ideological ground of the film narrative's content. I argue in *Displaced Allegories* that the structure of the narrative in post-Revolutionary Iranian fictional cinema mediates the national situation and the constraints on the industry. It does so in a displaced and allegorical fashion.

Proscribed Vision and the National Cinema

Moving forward with the understanding that prohibition and production are deeply correlated, I aim in this book to explore what happens in a cinema

where voyeurism is proscribed. Given government specifications against long-dominant codes that render the commodified image "real" in film, how is a cohesive sense of the real maintained and meaning produced in the cinematic grammar of Iranian films of the 1980s and '90s?

Linguists characterize the development of language under stable conditions as evolutionary, but argue that these evolutionary changes create special characteristics (such as the development of dialects and the appearance of creoles and bilingualism) under colonial rule and in the context of censorship and severe regulations. Armed with this linguistic understanding, I suggest that under conditions of visual censorship, innovative codes and conventions were created in the Iranian cinema of the 1980s and '90s that resonate with a feminist negative aesthetics articulated on the basis of 1970s "gaze theory" in film studies.

John Mowitt shows how codical innovations are articulated in the bilingual syntax of postcolonial cinemas, arguing in this way for a "semiotically inflected cinema studies within multicultural curricula."[7] Yet despite the "clues" of a growing focus on language and national dialects within the narratives of such films as Abbas Kiarostami's *Taste of Cherry* and Bahram Bayza'i's *Bashu: The Little Stranger*, little critical attention has been paid to the puzzling grammar that emerged in the cinematic language (i.e. the conventions, codes, and techniques) of Iranian films made after the 1979 revolution. Focusing on the work of both domestically popular (Bahram Bayza'i) and internationally renowned Iranian auteurs (Abbas Kiarostami and Mohsen Makhmalbaf), I investigate these formal, "linguistic" or "grammatical" (as I alternately call them) techniques of narrative construction alongside a reading of narrative trends in the representation of Iran's ethnic and linguistic diversity in their films.

Although the effort to purify Iranian cinema from foreign influences has undoubtedly failed, and failed considerably, on the grounds of cinema's international history (and the Iranian film industry's imbrication in that history), innovations in film language have emerged around the post-Revolutionary film industry's figure of the veiled woman fixing her modest body as the index of Iranian cinema's address. Kiarostami's work especially emphasizes that innovation in Iranian post-Revolutionary cinema's enunciation emerged not as a negation of the governmentally prescribed sexual taboos; rather that such innovation built formal structures that would not be possible without the restrictions placed on the industry. Post-Revolutionary Iranian cinema, I argue, found new ground not in the negation of government regulations, but in the camera's adoption of the

governmentally imposed veiled, modest, and averted gaze, producing the national cinema as a woman's cinema. The remainder of this introduction paves the way for this reading of "the national" in the works of Bahram Bayza'i, Abbas Kiarostami, and Mohsen Makhmalbaf in the chapters that follow.

Transmitting a Revolutionary Cry

In the autumn of 1978, during the course of the Iranian Revolution, and before Khomeini's much-anticipated arrival in Tehran, a recording of a Muharram recital (rawzeh) by the Ayatollah Kafi of Mashhad was widely distributed on cassette tape.[8] In this recording, Kafi places a telephone call to the third Shiite Imam, Imam Husayn, and cries out to him to quit the plains of Karbala because the greater enemy is in Iran in the person of the Pahlavi Shah, the nation's ruling monarch.

The considerable circulation of this "telephone conversation with the beyond" is a powerful example of how the theocratically informed vision of the new nation came to take shape, oddly enough, by mechanical means and from a distance in both space and time. The revolutionary cry that embraced the possibility of change in Iran was reproduced and transmitted by mediating technologies to Iranians everywhere, including those living outside the nation's borders. Rather than rejecting modern technologies, the nation's religious leaders actively employed them. Their voices could be heard coming from cassette decks that young children carried around on crowded sidewalks in every major city above the sound of bustling traffic. In response to the mechanical echoes of a revolutionary cry, a populist revolution rose up to topple the Shah, and in 1979 a theocracy was established to govern the new nation, with Ayatollah Khomeini as its leader. Here, where technology and the senses conjoin, the new national body was conceived. The Islamic Republic of Iran was born as a Shiite nation as a consequence of "the cassette revolution."[9]

Looking back on the history of the Iranian Revolution and the role of mediating technologies in it, it is important to note the significant distinction between the Sunni and Shiite branches of Islam. It is clear, for example, from Ayatollah Kafi's popular rawzeh that Iranian Shiism is animated by an expectant messianism that is deeply rooted in its imamology and that puts it at odds with Sunni orthodoxy. According to Iranian Shiism, the Prophet Muhammad, his daughter Fatima, and twelve Imams compose the luminous body of Muhammad's revelation, whose role is to

cast a guiding light on, and hence unveil, the depths of the divine teachings to the followers of Muhammad over time. The martyred third Imam, Imam Husayn, stands as the heroic figure of Iranian Islam, called upon to participate in historical happenings as a figure of personal transformation and political revolution.

A mystical veil surrounds the whereabouts of the twelfth Imam, however. This mystery advances the significance that he gains in Shiite religious history. As a young child (in AD 873), the twelfth Imam went into occultation from the world of sensory experience. For hundreds of years now, he has been thought to reside on the Green Island, a timeless place, a land of no-where (Na-koja-Abad), a land without coordinates. His imminent return imbues every moment of time with significance. "Present simultaneously in the past and the future," writes Henri Corbin of the twelfth Imam, the Hidden Imam "has been for ten centuries the history itself of Shi'ite consciousness, a history over which, of course, historical criticism loses its rights, for its events, although real, nevertheless do not have the reality of events in our climates."[10] Though hidden from sense perception, the twelfth Imam exists in the hearts of his followers and is the "mystical pole" (qotb) on which the existence of the world depends. The no-where, the Na-koja-Abad, in which the twelfth Imam resides, perhaps along with the other Imams, is self-sufficient, immune and closed to the outside world, at least according to the accounts of those who have seen it. Only those who are summoned are able to find their way to this unknown region—to an imaginal world that is described as both an oasis in the desert and an island in green waters.

Summoning the Imaginal World

The Iranian Revolution summoned this imaginal world, and it was this world that the Islamic theocracy attempted to establish in the empirical world as the body of the isolationist nation it named the Islamic Republic of Iran. If purified from outside contaminants, the national sensorium could manifest the imaginal world as the body of the nation itself. For as Kafi's telephone call suggests, this imaginal world is present both in the past and in the future.

Historically, in the Iranian context, the imaginal world appears in the empirical world and is perceived by the senses of the believers during the month of Muharram, the first month of the Muslim year.[11] The life-giving energies of the imaginal world animate the rawzeh and other similar rit-

ual performances, such as the ta'ziyeh passion play. In the course of the ta'ziyeh performance, which recalls the early history of Shiism, actors (or role-carriers) and spectators together become imaginal bodies, resurrection bodies, that enact simultaneously the history of Islam and its redeemed messianic future on an open stage, which in the course of the play comes to belong to no time and no place (Na-koja-Abad). Constituted by the empirical body of the believers, this historical stage is the national body alive in the present, as it becomes, in the course of the Muharram rituals, the future purified imaginal body of the nation itself. This articulation of the national as an imaginal world conditioned by an ambivalence in time and space figures importantly in my close readings of the work of Bahram Bayza'i in chapter 1.

The Commodified Image and the Imaginal World

It would be wrong to conflate the experience of the believers who participate in the Muharram rituals with fantasy, or to describe the world of the imaginal as an imaginary world. The realm of fantasy and imagination belongs to the image world, a world that is different in spiritual degrees from the imaginal world described here. The word *imaginal* derives from the combination of the words *image* and *original* in Corbin's lexicography. As such it stands for the site of the original image.

The logic of commodification under capitalism has introduced an image form that is the reduction of the imaginal world to the world of the senses. As a result, human sense perception has been corrupted by its attachment to the processes of characterization and production, those voyeuristic and fetishistic enunciative processes that constitute the commodified image that passes in dominant cinema for the real itself. By this logic, the perceptual faculties of the believers, once purified, can access the imaginal world and call upon the figures residing in the no-place of Na-koja-Abad to right the wrongs let loose on the body of believers by its aggressors. Numerous speeches and writings by Ayatollah Khomeini suggest that technologies of sight and hearing, as prosthetic extensions of the collective national body's senses, will, once purified, enable believers to access the world of the imaginal—a world outside all coordinates.

The evocation of telephonic technology in Kafi's recording points toward the temporal confluence informing the imaginal world to which the Iranian national body is intimately bound. Imam Husayn is known to the Muslim world as the grandson of the Prophet Muhammad, whose right to

the leadership of the Muslim community was usurped by the caliphate. In the famous battle of Karbala in AD 680, Imam Husayn was the principal victim of a ten-day carnage unleashed on the Prophet's family by the Umayyad caliphate. Although he was ultimately defeated in the course of this battle, Imam Husayn is revered by Iranian Shiites as the one who stalwartly rose up against the enemy of Islam. Kafi's telephone call to Imam Husayn recognizes that past moment's confluence with the revolutionary moment of collective resistance against the oppressive rule of the Shah during the Iranian Revolution. The use of the telephone implies that, as Avital Ronell has argued, "contact with the Other has been disrupted; but it also means that the break is never absolute. Being on the telephone will come to mean, therefore, that contact is never constant nor is the break clean."[12] Kafi's text is telephonically charged in this way. His "telephone to the beyond" recognizes that the archaic past is always present, as is the imaginal world beyond, even if it is temporarily absent to the senses. The bodies that are present in that topography of Na-koja-Abad are linked to the empirical world of the senses and can be called upon, however intermittently, by technologies that extend the range of sight and hearing, to take part in the affairs of this world and set them right.

The task assigned to the post-Revolutionary film industry in the Islamic Republic was to purify these technologies and thereby articulate the Iranian nation as a this-worldly displacement of an imaginal world—in other words, to create a world beyond the commodified image world of Hollywood. In its attachment to the purified prosthetics of cinema, the Iranian national body would become a resurrected imaginal body capable of accessing the imaginal world, indeed manifesting it with technologically reconditioned senses. This subject, born out of a technologically assembled sensorium, was the subject to whom the guardianship of the nation would be entrusted. The new subject of post-Revolutionary Iranian cinema would be the bearer of a sensorium cut to the measure of the nation's will to independence. It would manifest the culture and the nation as the imaginal world in displaced allegorical fashion.

Introducing Veiling and the Modesty System

In 1982–83, the Ministry of Culture and Islamic Guidance was charged with overseeing the activities of the Iranian film industry. The aim was to attend more carefully to production practices, ensuring that they conform to the requirements of a new, purified culture. The Ministry applied the

"rule of modesty" to the cinema, prescribing the "commandments for looking" (*ahkam-i nigah kardan*). The restrictions on the look took the form of laws that enforced the veiling of Iranian women from their male counterparts both on and in front of the screen.[13]

This logic expressly acknowledged visuality as a site of a tactility that submits the viewer to the immediacy of heterosexual desire borne in the female body. The act of veiling operates as a shield against heterosexual desire. Without the veil, a woman is considered naked in public male space.[14] A cinema that shows a female without the veil thus provokes "carnal thoughts." The recognition of this carnality came to ground post-Revolutionary Iranian cinema's oppositional address and its objective to constitute a purified national sensorium through film. Iranian cinema's address as a tribute to the carnality of the filmic gaze, and its principled rejection of cinematic voyeurism, produced the national cinema as a woman's cinema.

In contrast to the gaze of the psychoanalytic subject, who is posited as the ideal viewer of classical cinema in Laura Mulvey's analysis, the male spectator's look on a nonfamilial female body in post-Revolutionary Iranian cinema's conception of visuality and spectatorship is not, indeed cannot be, a gesture of voyeurism, nor is it a fetishism based on distance. Rather, the act of looking transforms the viewer's identity. Ideally, the act of looking collapses the distance between the subject who sees and the subject looked at. In the context of film viewing, the look onto the screen collapses distance and touches the very site of heterosexuality and desire in the female body on screen. The look is tactile. As Fatima Mernissi, in her discussion of sexuality in the Muslim context, has argued, "The eye is . . . just as able to give pleasure as the penis."[15]

To look at an unveiled woman in cinematic space, even if it is a screen image, is considered a disruption of spatial configurations. Her presence without a visual shield—a veil, a curtain, or a wall—interferes with the order of homosociality, the order, namely, that defines public space and with it the cinema. A woman's unveiled presence in public space exposes the object of private vision to a public look. Because it is tactile, the gesture of looking incites men to *zina* (illicit intercourse) in that men are thought to be defenseless "against the disruptive power of female sexuality."[16]

Based on this conception of visuality and territoriality, modesty laws in post-Revolutionary Iranian cinema as embedded in the "commandments for looking" inscribe the projected subject within the film text as male

and assume that a nonfamilial heterosexual male is always present in the audience. The male viewer's look on a mediated image of an unveiled woman on screen engenders direct contact. The situation is immediately sexualized. Thus, though mediated, the interaction between an unveiled, on-screen female and a male in the audience is considered immodest and reprehensible as a relation between the sexes.

The ubiquity of female veiling in film narratives, and more crucially in diegetic private spaces within the narrative, signals in this way the encoding and inscription of the spectator in the profilmic situation.[17] The veiled presence of a woman within her own fictional quarters is not unlike a gesture of looking directly at the camera. The ever-presence of the veil *reflexively* points to, addresses in fact, the presence everywhere of an unrelated male viewer in the film theater. The veil meets his look, and foregrounds in this way the looked-at-ness of the film itself.

Women's veiling in private and especially in diegetic women-only spaces thus renders direct address by the film narrative equivocal, countering the spectator's absorption into scenes that coyly "let themselves be seen." Such cinematic voyeurism, an "unauthorized scopophilia" responsive to the self-absorption of the diegesis in dominant cinema, is the condition of film viewing globally, a habit inscribed by film technologies in human sense perception. As a gesture of self-awareness, the veil confronts the voyeurism inscribed in cinematic spectatorship, the female body is effectively protected from the spectators' voyeuristic gaze, and public space is maintained as a male space.

Confronting Voyeurism

Aware of the presence of the film viewer, post-Revolutionary Iranian cinema signals a stance against the "hermetic" and "closed" system of representation that cuts itself off from the space of the spectator and that configures the diegetic filmic space as one of "self-sufficiency," detached from the realm of the sacred. According to Joan Copjec, the moment of self-sufficiency in visual representation "marks the point when the 'post-sacred world' is installed, that is the point at which moral and religious certainties are at once erased and melodrama springs into existence."[18] Post-Revolutionary Iranian cinema's resolve in foregrounding the film's looked-at-ness against the absorption of the spectator's gaze in dominant cinema's own constitution reflects Iranian cinema's continued insistence on the imaginal world of the sacred and emphasizes its antagonism to-

ward the voyeuristic codes embedded in the image in Hollywood cinema.[19] By foregrounding the nation's own continuity with the imaginal world, Iranian cinema posits, and opposes, melodrama's role in establishing the scopophilic coordinates of cinematic realism in the filmic image globally.

The ubiquity of the veil in all cinematic representations in Iran significantly transforms scopophilic conventions, classical film practices, and dominant habits of film viewing. Whereas everyday life in Islamic cultures takes place in spaces that separate the public from the private, the encounter between the film diegesis and its audience in Iranian post-Revolutionary cinema articulates all spaces on screen as effectively public and in continuity with the space of the film's screening. The cinematic screen places private space squarely within the public domain and forces the public, by virtue of dominant narratological strategies, to inhabit the spaces of the private in fiction. As a result, veiling and modesty come to define (oddly, one should add) both private and public spaces in post-Revolutionary Iranian fiction films, producing continuity between the spaces on screen and the space of the film's reception. It is in this way that the post-Revolutionary film industry genders both cinematic technique and technology as it situates the veiled female body at the defining threshold of a filmic enunciation and address that places national space in continuity with a sacred imaginal world.

A Feminist Approach to International Films

In my reading, this attempt on the part of the industry to "lean on the body" emphasizes the need to attend to the question of syntax and to film's processes of enunciation. The fundamental importance of syntax for feminist film practice and film theory has underscored that what is at issue is more than the image of women on screen and the representation of their practices. It has established that "the 'convincing' character, the 'revealing' episode, or 'realistic' image of the world is not a simple reflection of 'real life,' but a highly mediated production of fictional practice."[20] Thus what is at stake in my reading of Iranian films is the syntax that works to characterize the female body as a term in post-Revolutionary Iranian films and the address that the veiled female figure comes to configure for the cinema itself.[21]

Through a historically and culturally engaged analysis of some films of Bayza'i (chapter 1) and Kiarostami (chapter 2) and of Mohsen

Makhmalbaf's *Gabbeh* (chapter 3), I aim to describe the characteristics of a national inflection in film grammar and syntax and to show how the language of post-Revolutionary Iranian cinema is shaped by its grounding in the time and space of the new Shiite nation. In drawing on this paradigm case of a national cinema, I hope to demonstrate the paramount significance of enunciation and code-related analyses to the study of international film in the discipline of film studies—a field of study that has traditionally seen film as a medium that communicates globally because of its dependence on a visuality and a visual language (Hollywood's) assumed to be universal and hence legible across national boundaries. What my readings illustrate is that cinematic visuality is culturally and politically informed, and that the narrative image arises out of these determining structures, as a displaced allegory of the limits placed on, and the conditions informing, the industry itself.

By slowing films down into "a series of celluloid fragments"—a practice that Judith Mayne identifies as essential to feminist analysis—my concern is to grasp Iranian cinema's fraught relation to the question of gender and to anticipate in this way a feminist approach to international film studies grounded in cinema itself. By studying the fragments of a nationally constituted woman's cinema and by taking on a tradition of feminist film analytics from the 1970s and '80s that would irrevocably change the direction of Anglo-American film studies, I explore the critical possibilities opened by post-Revolutionary Iranian cinema in an attempt to articulate new theoretical parameters for engagement with film practice on a global scale.

National Address and Enunciation

Although I interrogate the category of "the national" by way of asking about the location of Iranian cinema in a geographical sense, namely its source in national soil, culture, and politics, my focus in this text remains on the statements the films make regarding the nation in their enunciation, that is, in the site of their production, and in the sites designated for the reception of their address. In focusing on the question of address, in the dual sense of location and enunciation, my readings of the films of Bayza'i and Kiarostami ask what factors determine a cinema's belonging or not belonging to a national context? What is a film's address? Is the sphere of a national cinema the site of its production, from which it is sometimes exiled, or the place of its reception, for which its address is at times overdetermined?

In reading post-Revolutionary Iranian films closely, I show how the question of address or location bears on other questions of address and enunciation. Regarding the question of a film's belonging to a bordered context, in other words, I argue that the answer emerges only by charting the film's constitutive landscape, by mapping its enunciative cine-scape—where it plots its source(s) and the site(s) of its reception. Asking questions such as "Who speaks?" "To whom does the cinema make its address?" and "How is this inscribed in the film text?" makes it necessary to pay specific attention to enunciation and to how films reflect on the place and function of the spectator in relation to the narrative as they orchestrate character and spectator looks, recognizing that such orchestrations are functions specific to film as a medium.[22]

Realism and National Narratives

In *Displaced Allegories* I argue that Iranian cinema's cine-scape—the landscape of its enunciation—is emphatically anchored in the veiled figure and bound by the acknowledged presence of the projected male viewer in front of the screen. In this cinema, sexual difference is fundamental not only to cinematic visuality but also, and more importantly, to the landscape that plots filmic enunciation. Forced by the films themselves to attend to enunciation and to how a film both articulates and presents its address, I identify the quandaries that arise from a purely representational or narratival approach in the study of international films. For it is within the hidden landscape of a film's enunciation—the site that produces the narrative fiction and the filmic representations—that the dichotomies between the real and the fictional, realism and fiction, authenticity and the authority of film to speak to the authentic are inscribed. The site of enunciation is where identity and audience implication are produced and plotted, and where the distance between industry and film text is bridged.[23]

Post-Revolutionary Iranian cinema's commitment to stand against the voyeurism of the gaze in its production process raises crucial questions that often remain unaddressed in readings of a "national cinema" precisely because the "nation" is assumed to be available in the reading of the narrative as such. Iranian cinema's rejection of cinema's meta-desire (voyeurism) highlights for film studies the fact that national difference in international film is not or not necessarily inscribed in narrative or allegory alone. Indeed, the shift that this rejection provokes on the level of

enunciation affects filmic codes of realism, making "the real nation," conventionally thought to take shape on screen, unavailable to hasty readings of the image track. As my readings of Kiarostami's and Makhmalbaf's work emphasize, the problems posed by the censorship of vision in post-Revolutionary Iranian cinema accentuate the fact that the narrative is a displaced allegory of the determining conditions of the industry itself. This recognition brings to the fore a critique of the fetishization of the narrative as crucial for any theoretical engagement with international film.

As Laura Mulvey has argued, although "a different understanding of the gaze underlies the Islamic discourse of veiling and Western feminist concepts of voyeurism," a feminist analysis of Iranian cinema as a counter-cinema is well positioned to put "the 'problem' of cinema as a mode or representation" in conversation with "the 'problem' of woman's representation on the screen."[24] If this "conversation" is to contribute to the study of films on a global scale, the agenda requires a careful consideration of the protocols associated with theories of visuality in feminist film studies alongside issues that emerge by attending to syntax and cinematic enunciation in close readings.

With a goal of envisioning a feminist film analytics on the global track, I proceed with the understanding that cinema's mode of address is doubled and always forked. Forked most obviously in the disjunction between sound and image, but as fundamentally in the disjunction between the screened narrative and the process involved in the production of a film's address and enunciation, that is between the conscious product (generally, the narrative) and the mostly unconscious historical, political, and cultural influences that give shape to film's foundational formal landscape, namely its enunciation. I turn to these forkings in order to understand and uphold the contradictions that arise in attempts to locate that which is constitutive of what film studies has called "a national cinema" and to understand the address of this woman's cinema in the global context.

Awestruck by the stretches of colorful landscape that fill the screen at retrospectives and international film festivals, Western journalists persistently review Iranian cinema with a sense of wonderment. What casts the industry as unique in the film festival market, however, is the uncanny way in which post-Revolutionary Iranian cinema's fictional narratives glide between the realms of the real and of the fictional. The disintegration of boundaries between the fictional and the everyday, between temporal and spatial limits, has become a trademark of the Iranian screen since the Revolution.

This blurring of boundaries has much to do with the cinema's efforts to counter and effectively disarticulate the cinematic voyeurism that has shaped sense perception in response to the global dominance of Hollywood cinema. The veiled figure at the threshold of Iranian cinema's enunciative landscape guides the camera's look at its objects. Emphatically gendered and sexualized, the nationalized technology transforms and renarrates the time and space coordinates embedded in the codes and conventions of classical Hollywood cinema. Iranian post-Revolutionary cinema's newly purified and gendered technologies transform the cinematic image, informed as they are by a tactile, immediate, and embodied gaze. The veiled figure at the threshold of this cinema's enunciation effectively disassembles, reassembles, and codes Iranian cinema so as to resist the conventions assigned to it by standardized and standardizing norms. The veiled figure of the Iranian woman sets the terms for the nation's cinematic address and its narrative articulation. As Raymond Bellour incisively argues, "The American cinema is entirely dependent . . . on a

system of representations in which the woman occupies a central place only to the extent that it's a place assigned to her by the logic of masculine desire."[1] The limits set on a masculinist visuality by modesty laws in post-Revolutionary Iranian cinema, by contrast, dictate a different system of representation that ironically coincides with the antivoyeurism and negative aesthetics of the feminist avant-garde.

Given the Shiite conception of the space of *the imaginal*, post-Revolutionary Iranian cinema's foundational difference from other cinemas rests on a confusion of boundaries that renders all spaces diegetic (private and public) as one and hence coextensive with the space of the cinema. Grounding the cinema's address, the veiled female body at the cinema's threshold engenders an uncanny traffic between this space of lived reality and that of ritual fantasy. Dictating the terms of the visual relations in the cinema, this veiled body shifts the deictic conventions that inform the construction of diegetic spaces, those that measure the distance between the far away and the close by and that animate the distinctions film is able to make between what is here, in this space, and what is elsewhere. Film generally constitutes its deixis by linking character looks. A shift in the constitution of looks in the diegesis, and between the diegesis and the spectator, transforms visual perceptions of spatiality and markedly affects film's temporal registers; for any change in the way that space is constituted affects the cinematic codes that link shots and scenes and that produce the difference between then and now, between the past and the present in films.

This shift in visual relations away from standardized codes and conventions disintegrates narrative continuity according to classical film theory. Narrative continuity relies largely on a standard of spatial and temporal representation in order to cohere. Even a minor manipulation of visual relays has consequences for the standard construction of scenes and shot conventions. Used to reinforce the sound track, a shot–reverse shot construction typically connoting "a conversation," for example, fails to signal the presence of two speakers in conversation if the reverse shot is absent. A minor change such as the elimination of the reverse shot that is used to link the look of the first speaker with that of the second breaks with cinematic code and fails to communicate meaning, dislodging the continuity of diegetic space and time. Like many voyeuristic codes undone by modesty laws, this shot pattern is a basic term in an established "grammar" that has become cinema's vernacular over time—part and parcel of global sense perception.[2]

In view of the global dominance of Hollywood codes and conventions as formal laws governing the grammar and meaning of shot constructions, film narratives lacking dominant codes of spatial and temporal continuity should in effect make little or no sense. Such would be the conventional wisdom of both apparatus and gaze theory in film studies. The crucial question, considering the success of post-Revolutionary Iranian cinema in the world market (an issue I return to in chapter 3), is how these films handle the shift in spatial and temporal relations to ensure meaning (i.e. comprehensibility) despite the cinema's deictic difference.

For the director Bahram Bayza'i, the ability to maintain narrative continuity and coherence notwithstanding the shifts in the film's deixis and the resulting movement between the real and the fictional hinges on a turn to the indigenous cultural practice of the ta'ziyeh: "At the age of twenty, I saw a ta'ziyeh."[3] The ta'ziyeh is the annual Shiite mourning play representing the historical, political, and religious struggle that marked the defeat of the family of the Prophet Muhammad against the caliphate in Karbala in 680. The mourning play commemorates the break between the Shiite and the Sunni branches of Islam in the course of the power struggle in Karbala. It provides the enunciative landscape and the temporal and spatial tropes shaping Bayza'i's work—an *oeuvre* that is popularly considered by Iranians to be genuinely and traditionally Persian in its scope. The ta'ziyeh's dramatic tradition also affects the work of more internationally accessible Iranian auteurs such as Abbas Kiarostami and Mohsen Makhmalbaf, as discussed in subsequent sections.

Judgment Day

Of the three filmmakers, however, Bahram Bayza'i is the only one whose work for the cinema has referred to the rich ta'ziyeh tradition directly. Born in 1938 in Tehran, Bayza'i is among the most popular filmmakers in Iran, even though his work often met with severe government resistance, censorship, and delay before the Iranian Revolution and has continued to do so since. A former university professor who was denied his academic position after the Revolution, Bayza'i is considered a leading authority on the history of drama in Iran and is known for his commitment to Persian folklore, his command of the Persian language, and his knowledge of Persian narrative styles in his compositions of film scripts and performance works for the theater. Biographers suggest that Bayza'i's love for

cinema was kindled at a very young age. He watched Egyptian films with his father, who enjoyed them because of his knowledge of the Arabic tongue. His mother, born to a literary family and an ardent fan of art films, enjoyed Persian movies and took her young son to the cinema at least three times a week.[4]

Almost all of Bayza'i's twelve major directorial efforts in fiction film to date either make a reference to a ta'ziyeh performance or use its conventions. In *Death of Yazdgerd* (*Marg-i Yazdgerd*, 1981), one of Bayza'i's early post-Revolutionary films, a circular cinematic mise-en-scène signals the film's affinity with the ta'ziyeh, which traditionally stages the Karbala carnage on an open circular stage. In the staging of the ta'ziyeh performance, the audience sits on the ground around a central circular platform in a large courtyard sometimes covered by an enormous white tent. Historically, women would sit in the front rows during the performance, men behind them.

In its traditional form, in a circular setting, the drama takes place both on and off stage. The ta'ziyeh role-carriers, who enact the historical events surrounding the carnage and martyrdom of the grandson of the Prophet Muhammad, Imam Husayn, and his family in Karbala, mingle with audience members, staging battles in narrow corridors stretched between the spectator-participants. The staging of the ta'ziyeh emphasizes, in this way, the temporal conjunction between the present and the past by situating the audience in the present as mourners lamenting the historical battle and the death of the Shiite heroes while role-carriers for the heroic figures resurrect history in their performance. Interwoven into the action by the movement and address of the role-carriers, ta'ziyeh audience members are also placed in the past, as participant-witnesses to the tragedy suffered by the family of the Prophet in the seventh-century battle of Karbala. The mourning play reenacts and then recollects this moment of loss as the moment that established the Shiite branch of Islam.

The ta'ziyeh's circular stage is never "reset" or transformed in any major way. In fact, any change of scene is effected by the movement of the role-carrier himself. To go from one place to another, the actor merely announces his intention to travel and often walks or rides on horseback once around the circular stage to arrive at "the new location." This integration of time and space, of past and present, of here and there, sets the tone of a performance in which the blurring of eras and spheres ensures the blurring of the differences that separate sensuous reality from the

imaginal world, and of those that establish an actual historical happening as separate from the time of its performative transformation.

The blurring of the distinctions between past and present in the performance assumes foreknowledge of the historical happening on the part of the audience. This consciousness of history instills a sense of magical knowingness in the characters themselves in the course of the performance. As the imaginal world reveals itself on stage, the audience becomes a resurrected body—a witnessing imaginal body—conscious of the fullness of a past that is resurrected in a future that is also a now. On stage, the characters speak of the past, present, and future in one breath, as if the events to come in the historical drama have already taken place and will take place again. Thus every role-carrier openly anticipates his character's ultimate destiny in the battle and also recognizes in death a future victory in which the family of the Prophet will emerge as hero-martyrs for a Shiite nation that is yet to materialize as the future body of Shiite Iran. In its redemption of all-time, the ta'ziyeh's imaginal time represents the Day of Judgment.

The Travelers: Screening the Ta'ziyeh's Temporal Tropes

The ta'ziyeh's characteristic sense that knowledge embraces all time and that characters in effect know their end also configures Bayza'i's narrative articulation in the film The Travelers (Mosaferan, 1992). As the character Mahtab Ma'arefi boards a vehicle that is to take her family to her sister's wedding in Tehran in the opening sequence of The Travelers, she turns unexpectedly to the camera. In her direct address to the audience before beginning her journey from her home by the Caspian Sea, she asserts that the car she is about to board will be in an accident that will prevent her family from arriving at their destination. As if stating a known fact while, in fact, anticipating a future that is yet to be screened, she declares, "We will all die." The family members and the driver of the car then in turn address the camera directly to identify themselves, as if registering the necessary details for the imminent police report on the accident. These gestures of direct address reiterate the film's intimate connection with the ta'ziyeh tradition in which role-carriers at once identify with the heroes of the drama in a performative reenactment and simultaneously disassociate themselves from the heroes in reverence for the historical specificity of their lives and identities. Fantasy, fiction, and historical facts merge;

time—past, present, and future—collapses; spaces run into each other. The ta'ziyeh provides in this way the spatial and temporal tropes for Iranian cinema's post-Revolutionary address.

Bashu: Screening the Ta'ziyeh's Spatial Tropes

Bayza'i's first cinematic release after the Revolution, Bashu: The Little Stranger (Bashu: Gharibe-ye Koochak, 1987), relates the story of a mother (Na'i) in rural northern Iran and that of Bashu, a young boy from Khuzestan in the south. Bashu appears on Na'i's farm having escaped the terrors of the Iran-Iraq war and having witnessed the death of his family in the course of it. Na'i works in the fields and takes care of her children, and by accepting Bashu into her family, she defies the ways of the village. When Na'i's husband eventually returns from his long absence at the conclusion of the film, Bashu, whom the narrative has constructed as Na'i's counterpart in a story of labor and love, accepts Na'i's husband as the proper head of the household and as his own adopted father.

The circular ta'ziyeh stage, as well as its temporal and spatial coordinates, gives shape to a late scene in the film in which Na'i writes a letter to her absent husband. While dictating to Bashu, who transcribes her words into standard written Persian, Na'i walks about her yard, performing random chores and hanging her wet laundry out to dry. As she paces, the camera follows her in circular motion; encircling the area alongside her body, the camera restages the background. Gendered in association with Na'i's veiled body, it transforms the scorched gravel of her private yard into the public space of war where her absent husband will receive her letter at some later time.

In the political setting of post-Revolutionary Iran, in which filmmakers are unable to show heterosexual intimacy on screen, Bashu: The Little Stranger solves the problem of visual and physical contact between an unrelated man and woman by creating a fictionally necessary spatial distance between the female lead, Na'i, and her husband. The narrative takes for granted that the husband has to be away from the farm to make a living (at war). Yet the film insists on establishing the connection between the couple, regardless of the distance separating them. In the context of censorship where heterosexual intimacy is denied on screen, Bashu utilizes the temporal and spatial tropes of the ta'ziyeh tradition to encode cotemporal perceptions of time and space as they have been cul-

tivated on national soil and within the national dramatic tradition. Engaging the ta'ziyeh tropes of temporal and spatial continuity, the film signals "conversation" between the husband and wife without using the standard exchange of glances in the shot–reverse shot.

The circular movement of the camera to the rhythm of Na'i's body ensures the perception of temporal continuity between the here of the farm and the elsewhere of the war as she dictates a letter to her husband. As the camera turns, as if around a circular ta'ziyeh stage, it transforms Na'i's time and space at the farm into the time and space of her husband at war, then turns back again to the backyard and to Bashu, to signal the intimacy and the immediacy of the conversation that has taken place between the husband and wife and their intermediary, the husband's representative, at home. While Na'i's husband is visibly absent from most of the track, Na'i shares in his time and space while relating to the visible presence of Bashu. Troubled by the inability to maintain continuity in the face of an intimate heterosexual exchange, the scene engages the ta'ziyeh's malleable deictic tropes. In the now-time of the present, where the elsewhere of war and the here of the everyday conjoin, Bashu emerges as the allegorical figure of the absent-yet-present beloved. The trope of the letter here stands as a displaced allegory for the impossibility of a coincident exchange of sentiment in post-Revolutionary Iranian cinema.

Screening the Direct Gaze

Although the release of the film was delayed until 1988 because censors had problems with certain of its scenes, we should note that Bashu was one of the first films to break with the prohibition against the direct relay of the female gaze following the Islamic government's introduction of modesty laws to cinema. As such Bashu marks the beginning of the third and last phase in Hamid Naficy's classification of the industry's early years after the Revolution. The first phase, in the early 1980s, was marked, Naficy observes, by the total absence of women from the screen. Filmmakers were too afraid of repercussions to take risks with female characters, so they eliminated women from the script entirely. The second phase, around the mid-1980s, involved female figures in long and medium shots; close-ups were rare, and women appeared as "pale presences" (Naficy's term). By the late 1980s, women started appearing in leading roles. Medium shots and occasional close-ups projected a "powerful female presence" that created, according to Naficy, a "more fluid cinematic atmosphere."[5]

Of *Bashu*, Naficy writes:

[In one of the opening scenes] . . . Na'i is off camera and the film cuts to a shot showing empty space. Suddenly, Na'i rises into the frame in a surprising close-up, her hair and chin covered with a white scarf, emphasizing her dramatic and intense eyes. With this one shot, which draws attention to the alluring possibilities of unveiled vision . . . [Bayza'i] breaks years of entrapment of films by rules of modesty. Defying those rules, Na'i [played by Bayza'i's long-time lead, Susan Taslimi] gazes directly into the camera in close up—something that she does several times henceforward.[6]

Rising up from amid the grassy green, her eyes framed by a white veil (see figure 1), Na'i finally finds Bashu's hiding place and lures him into her household with food and water. Here he grows accustomed to being Na'i's partner as he participates in the care of the children and of the farm. He partakes in Na'i's ritual drummings and crow calls, and affectionately monitors her market commerce and hospitality.

This simple story of human kindness and acceptance in a time of war is the setting for other preoccupations centered on questions of aesthetics, film language, and film reception in the context of an emerging film industry after the Revolution. My close reading of key scenes from *Bashu: The Little Stranger* will suggest the ways in which these themes are self-reflexively taken up and addressed by the film.

Scene One: Take One

Bashu: The Little Stranger opens to the arid landscape of southern Iran, situating the Iran-Iraq war as the force behind the forward movement of the narrative and one of the film's own central concerns. Twelve opening shots (see figure 2) stage bombings and explosions to signal the ravages of the Iran-Iraq war in the south. They do so significantly on two tracks, the visual and the aural, combining synchronously to emphasize the horrors of technological warfare and its effects on the senses of hearing and vision. In this sequence of twelve shots, each shot transition is motivated by a new explosion on the visual track and each cut is signaled by the shattering synchronous sound of a bomb.

There are two exceptions to this pattern, in shot 8 and shot 10. Shot 8, a medium-long shot, represents a woman turning in panic, her black veil in flames. Shot 10 is a long shot of a young girl wearing a red dress and a black headscarf attempting to run to safety.

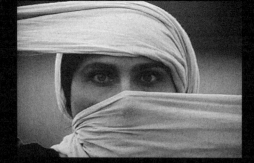

1 Na'i gazes into the camera in Bahram Bayza'i's *Bashu: The Little Stranger.*

While the effects of war (the sounds and sights of explosions) are signaled by the film to be the motivating force for the plotting of the narrative—indeed, what gets the film going, moving the protagonist, Bashu, from one setting in the south to another in the north—a secondary motivation in shots 8 and 10 suggests female bodies as central to the processes involved in the production and transition of shots. The violence done to the movement of two veiled female bodies by the sight and sound of war is set up as the motivation for the cuts in this segment of the film. The cuts on the moving bodies both disrupt movement within the shots and summon the edit that brings about continuity between one shot and the next, i.e. between shots 8 and 9 and shots 10 and 11. The film, in effect, draws on both the shocks of warfare and the presence, movement, and ultimately annihilation of veiled female bodies to produce its own narrative building blocks. Informing the rhythm, the length of shots, and the movement between shots, the dual forces of war and moving veiled bodies generate the film's narrative structure from the outset. The sound and sight of war are set up to motivate the cuts that violently produce the film reel and to anticipate subsequent shots in the sequence. Juxtaposed in the process of editing, representations of war and of veiled female bodies serve to project the forward movement of the film itself and thus structure continuity and meaning in the narrative. The film's own technologies of sight and sound are synchronized to the technologically mediated images and sounds of war.

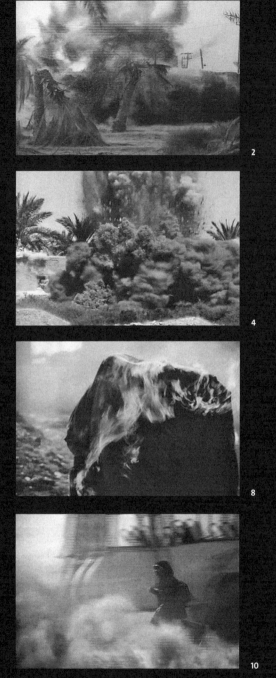

2 Four frames from twelve opening shots in *Bashu: The Little Stranger.*

Moreover, the narrative's movement and the film's progression are shown to hinge on these impulses and to be structured in the intercutting of shots by the violent presence and then unsettling absence of the veiled female bodies.

Scene One: Take Two

The immediacy of the reflection on war and its effects on sense perception in the opening scene sets up the narrative preoccupations of the film and its attendant concern with sensorial responses. The link between the technologies of war, film technologies, and sense perception is arranged by means of the editing and foregrounded to self-reflexively "think" technology (of war and of cinema) alongside sense perception, emphasizing the role of technologies in the manipulation of the senses, in particular here the senses of sight and hearing.

We come to realize in the course of subsequent scenes that the woman in the burning veil (figure 2, shot 8), the man who falls through the ground, and the girl whom the camera captures running across the frame (shot 10) in the opening sequence are Bashu's mother, father, and sister. All three perish in the bombings of the southern village. Bashu reenacts this scene of devastation, speaking to a bewildered Na'i in his dialect, a dialect of Arabic from southern Iran. Though perceptibly alert to the anxiety nested within Bashu's gestural language, Na'i fails to comprehend his speech in this early scene. Bashu mimes the death of his family as he speaks to Na'i and as he mourns their loss. Following Bashu's gestural lead, the film reel mimetically produces the correspondences between Bashu's sensorial gestures and the film's own production process. It retrieves earlier footage that it then replays and juxtaposes with shots of Bashu's reenactment. In this process, Bashu's own gestures are produced by the film as that which motivates the film's recovery (copying) of the opening shots. One could say that Bashu's sense perceptions, gestures, and movements are set up by the film as the motivation behind the film's own technosensorial re-reel. The film's production processes mimic Bashu's body and in the process of mimicking, the film retrieves and replays itself. In effect, the film entitled *Bashu: The Little Stranger* becomes Bashu's own body. Mimesis makes film and body one, foregrounding the links envisioned by the film between film technology and technological embodiment, links lucidly envisioned by the Islamic government's call to create new citizen-subjects through film technologies in the early years of the Revolution.

This first scene of re-reel is set on the morning after Bashu's arrival in Na'i's northern village. Curious, Na'i attempts to engage Bashu in conversation. In this heavily choreographed scene the camera follows Na'i as she scatters seeds in the air, as the chicks flock to the yard, and as she barks back at her dog and crows to the crow that circles above. Na'i communicates with the animals by imitating their sounds.

Corresponding to the eye-line match that situates Bashu's gaze in relation to Na'i's figure, the camera captures the ghost of Bashu's mother in a long shot. A swift pan of the camera creates the correspondence between Bashu's look and the camera's own, a correspondence between human visuality and visual technology that is reinvoked moments later in terms of a technological embodiment as Bashu narrates his escape from the war and the devastation of his family home. He remembers these events by gesturally recalling the death of his family. As he begins to speak to Na'i in Arabic about his parents and their death, the gestures that recall the devastation in the south are juxtaposed with shots from the film's opening war sequence. As Bashu raises his arms in the air to gesture toward the corporal sensation of falling, the film immediately recovers and replays the sequence of film in which Bashu's father falls into a hole. The image track of this shot of the father is edited, that is, juxtaposed and linked to the shot of Bashu's gestural recollection, without the accompanying sound of the bombings. As Bashu turns on himself, patting down his body as if in flames, the cut-on-action to the next shot recovers the corresponding image of Bashu's twirling mother in a burning veil. The film re-reels to mimic Bashu's body and to establish correspondences between the film's technological body and Bashu's own. This scene is not only the first scene to introduce mimesis as associated with the human instinctual responses to attacks, it is also one of the first instances of doubling or copying that suggests the film's more broad-scale preoccupation with mimesis in the technological age.[7]

Mimesis

The film returns repeatedly to instances in which mimesis (imitation, copying, and miming) and the production of correspondences are emphasized as its grounding concerns. We witness, for example, Na'i copying the sounds of animals throughout the film, a habit that Bashu picks up and mimics repeatedly. We watch Na'i's children acting like birds and dogs

with floppy ears. And we are moved when we see Bashu interpret and reenact Na'i's gestures from earlier moments of the film, in doing his own rounds on the farm. The village children too relate to Bashu mimetically as they reproduce and, in playing with one another, transform Bashu's gestures. They copy the anxiousness that makes Bashu fold his arms across his chest, his gaze to the horizon to fix the tall masts that waved in the seaport in his hometown, and his play at being a boar or a dog.

The film's emphasis on the children's penchant for creative mimicry, for pretending to be other people and other things, produces a deep sense of self-reflexivity in the film. The film reflects back on film technology's own mimetic capacity to create correspondences between the world and the space of an image alongside the corporal mimesis that takes place on the image track. Film technology and human body connect and transmit in these acts of mimicry, making body-and-image-space one through the film's process of reproducibility. For just as the film *Bashu* re-reels to mime Bashu's gestures, so too does Bashu's own body. His fictional body re-reels and replays like the film reel by miming the film's opening scene.

Re-reel Take Two: Copy and Play

Having situated the correspondence between human mimicry and technological mimicking in the scene of "the first conversation" (between Bashu and Na'i on the morning after his arrival), the repetitive return to such acts of mimicry as "play" nudges us as the film's audience to think about the play of film technologies as well—to think how film, in other words, does more than create indexical copies of the world on celluloid. Do film technologies' mimetic gestures of capturing and projecting merely produce reproductions of the world? Do they not also create, that is, produce new worlds, extending and transforming the boundaries of the known and the conscious through play? In their mimetic play, film technologies, like children's bodies at play, create correspondences where before there were none. In play they transform what is tactile and present to vision into something altogether different. One obvious example of such transformational correspondence is the pan that links the ghost of Bashu's mother with Na'i in the scene of "the first conversation." Other examples actualize the correspondence as a form of technological synesthesia.

In the scene of "the first conversation," Bashu recalls the wreckage of war by embodying it and signals the devastating effect of the war on his

senses. It is clear in my reading of the opening sequence that war is staged as the motivating force behind the narrative and its plot; it is involved in the ordering of Bashu's images and sounds. But the mimetic recollection of that scene of bombing demonstrates that war has created distortions in the hero's sensorium. Bashu signals the deafening sound of war by pressing his hands over his ears and the obstruction of his vision by waving his hands in front of his eyes.

<div align="center">Re-reel Take Three: Synesthesia</div>

The devastation of Bashu's senses is reconfirmed in a later scene when his recognition of the correspondences between airplanes and birds in flight proves to be a misrecognition. The film signals the deviation by reproducing synesthesia in the film body. The camera shows what Bashu sees overhead as a bird and projects instead the sound of a warplane on the sound track. As the audience we recognize Bashu's identification of correspondence between bird and warplane by experiencing technological synesthesia through our own senses as we watch (and hear) the film.

The film's technology shows its capacity to create correspondences through juxtaposition—the image of a bird juxtaposed with the sound of a warplane—but in doing so also demonstrates its ability to separate and mediate sight and sound in different ways. The film shows its productive technologies as able to transform empirical objects through creative play, distortion, and projected synesthesia. The ability to nonsynchronously produce sights and sounds, in other words, shows that film does more than produce copies of originals, or true images of the world. In reorganizing the correspondence between sight and sound on the reel, in setting the sound of warplanes to the visual images of a flying bird, or by removing the sound of war in Bashu's recollection of the images associated with his father's death, for example, the film reorganizes the spectator's sense perceptions, creating what we see and hear in the theater as different in degrees from what we might see on a tourist trip to, say, a village in northern Iran. In going through film technologies, the human sensorium experiences the world aesthetically, through its senses, but differently so. As Walter Benjamin points out in his essay on photography regarding the possibilities opened by technology, "it is another nature which speaks to the camera rather than to the eye: 'other' above all in the sense that a space informed by human consciousness gives way to a space informed by the unconscious."[8]

Reproducing the Imaginal World in the Senses

Film technologies reconfigure objects by their juxtaposition of images and sounds. By conjoining and delinking the film's two main tracks, these technologies open up spaces in ways that habituated consciousness has closed to both human visuality and hearing. As prosthetic extensions of the human sensorium and as the inheritors of the human mimetic capacity to reproduce correspondences, the cinematic appartus operates according to the logic of semblance and play. This capacity in film technology, as Miriam Hansen argues, allowed Walter Benjamin to imagine "an alternative mode of aesthetics on par with modern, collective experience, an aesthetic that could counteract, at the level of sense perception, the political consequences of the failed—that is capitalist, imperialist, destructive and self-destructive—reception of technology."[9]

Film technologies, as prosthetic extensions of human vision and hearing, enable the possibility of reorganizing sense perceptions: they can reconfigure the senses by bringing things closer, by slowing things down, and by opening up spaces through a form of playful reproduction. This is only one way in which the notion of "the optical unconscious" in Benjamin's Artwork essay can be usefully employed in understanding the workings of film technologies.[10] In the process of film viewing, the spectator's senses are habituated to modern mechanized stimuli and recalibrated by them. For Benjamin this recalibration is political, revolutionary, and utopian. In going through technology, the senses (i.e. human aesthesis) may become politicized in collective and revolutionary ways. It is precisely for these reasons that cinema can be seen as a valuable tool in Khomeini's political and utopian project of regenerating the national body: a project that corresponds to the "politicization of aesthetics."[11] *Bashu: The Little Stranger* acknowledges this through its attention to technology and to the question of mimesis.

The film goes further to suggest how the very constitution of the spectator is necessarily changed in the process of film viewing. Indeed, in the transmutation of the sensorium, the body comes to incorporate film technology in the same way that Bashu's body incorporates the opening shots representing the Iran-Iraq war. In the process of incorporation, the spectator's body, like Bashu's, also registers war's effects on the senses. In the intimate contact between human and machine, the spectator is bound to recognize the need to assimilate the film's processes of production, its meaning-producing language, as his or her own, and to do so as a means

of comprehending that which film technologies represent on screen. The body comprehends the film narrative by mimetically ingesting its technologies. A later scene brings home this need for human mechanization, by mechanizing the bodies of Bashu's playmates in the act of playing.

Innervating: The Technological Body

In "the scene of the children's dance," a pan across a green rice field rests to frame Bashu humming and drumming on a homespun instrument. The village children approach Bashu to ask what he is doing. "Plants grow to this sound," Bashu explains, echoing Na'i's comment in an early scene about her own use of sound-makers to help her rice field grow. As the children watch and giggle, one of them starts a beat with a pair of utensils. Another picks up two big rocks and follows the beat. The rhythm is perceptibly mechanical and the children move their bodies vertically to the beat of the musical instruments as Bashu continues to dance to his own drum. In a shot that captures the lower bodies of the children, hands and knees move mechanically from side to side as if they were moving parts of a factory line. Repetitive and measured, they move to the rhythmic sound of the musical beat. The mimetic gestures of the children playing boars and pretending to be the growing harvest in the continuation of this scene only serve to reinforce this earlier moment in the scene in which the film represents the human body's mimetic resemblance to things, objects beyond nature. The children's bodies reinscribe the materiality of the celluloid's movement through the tracks of the projector in their mechanical movement and presence, creating what Sigrid Weigel refers to as "an instantaneous 'corporeal resemblance' to an image from the sphere of mechanics."[12] Body movements and sense perceptions commingle with mechanical processes. The children's bodies take on the technological body as their own.

In this scene, meaning and where it is made are signaled as things that emerge out of the encounter between the human and the technological. The film signals the incorporation of technology as fundamental to comprehension, implying that the absorption of the technological as (a meaning-producing and structuring framework such as) language, much like a standardized language in interhuman communication, is essential to the spectator's own comprehension of the film. The children must incorporate the movement of the film through the reel to understand Bashu's mimetic reproduction of Na'i's gestures in this scene. They must re-reel themselves through the film's technology to comprehend Bashu's

gestures. To understand the language that the film speaks means inner-
vating film technologies and in doing so, ingesting the processes of film
production as a corporal human function. Comprehension involves
mimesis—repetition, but with a difference.

Scene One, Take Three: The Scene of the Schoolbook

Speaking directly to questions of communication, film literacy, and na-
tional citizenship, the scene that opens to a roaring fire in Na'i's backyard
is suggestive that comprehension involves mimesis. The scene captures a
transitional moment in the film in which the Gilani children of Na'i's vil-
lage discover a way to communicate with Bashu, who up to this point in
the film has spoken only in his native Arabic tongue.

The scene is washed in arid tones reminiscent of the opening scene of
the bombings in the south. Responding to the sound of planes overhead
and the hallucinated, ghostly figure of his veiled mother nearby, Bashu
screams in Arabic, gesturing toward the village children and Na'i to duck
and take cover. The children, who are straddled on Na'i's backyard fence
oblivious to the horrors of the war that Bashu has experienced, laugh at
him and point fingers. Bashu runs toward them as if his obvious distress
can come to his own defense, and a fight ensues. Falling to the ground
among the other children, Bashu makes a hard choice between picking
up a rock or a book on the ground before him. He gets up, holding the
abandoned book in his hands. He then speaks for the first time in a lan-
guage that the presumed audience of the film and the literate children un-
derstand. This is the schoolchildren's common language—the language
of the schoolbook. The children are fascinated by Bashu's literacy, and
Na'i is dumbfounded. The children quarrel among themselves about the
accuracy of Bashu's reading and ask Bashu, in surprise, why he quit
school and of the whereabouts of his parents.

In response to their questions, Bashu sets in motion the film's opening
scene of destruction (figure 2) once more by throwing a stone at a model
building built by Na'i's children. The "building" collapses. The collapse,
represented by the model on the visual track, is synched to the sounds of
war on the film's sound track (figure 3, frames 11 and 12). The audience is
reflexively reminded that this sound, the sound of war, was absent in the
earlier scene of "the first conversation" in which Bashu re-reels the film in
his gestural reenactment of the death of his family for Na'i the morning
after his arrival. Clearly, technology reproduces. It does so through
mimetic play. Yet play produces differences in the process of reproduction.

As the "building" collapses to the sound of war on the sound track, Bashu hides his face in his palms and weeps.

A Standard Language

Although Na'i does not choose to speak in the language of the book, and is herself obviously unable to read and write Persian, she understands that significant communication has taken place between Bashu and the schoolchildren (figure 3, frame 5). Her comprehension of this is mediated to the audience through a shot–reverse shot pattern that formally inscribes the movement of the dialogue between Bashu and the children. The shot–reverse shot enables the viewer to recognize that "communication" is taking place through the use of eye-line matches between characters (frames 9–10). The point-of-view and reverse point-of-view shots (frames 7–8) place the children and Bashu in communication with each other and suture the viewers into the visual track by positioning them to adopt Na'i's gaze as their counterpart within the diegesis. Na'i's look onto the scene of the children's exchange hides the fact that a camera is "seeing" on behalf of the spectator. It hides the fact that the camera is connecting the looks of characters within the narrative to each other, and our visuality to Na'i's look. This is done in order to produce narrative continuity; in order to create sense and generate narrative meanings in the seamlessness of connecting shots.

The scene functions in the overall film narrative to articulate a series of observations regarding the diversity that makes up the nation, emphasizing the geographic differences in landscape and culture. It also brings home to the audience a representation of the unity that a standardized language organizes around the multiplicity of national languages, dialects, and peoples in Iran. It is clear in this scene that although the spectator has become aware of the forces affecting the various parts of the nation and of the nation's racial, ethnic, and geographic diversity, the northern villagers are quite unaware. No one in the village seems to know about the war or about the commercial goings on in Bashu's home in the south where the British and the Americans have for years cultivated their interest in petroleum. The villagers from the north know little about the different languages and cultures that Iran comprises. In this scene, north and south share little in terms of ethnic and linguistic heritage, or in religious practice for that matter. The children are united only through the trope of the nation and the standardized language of the schoolbook. "Persian," Nasrin Rahimieh writes,

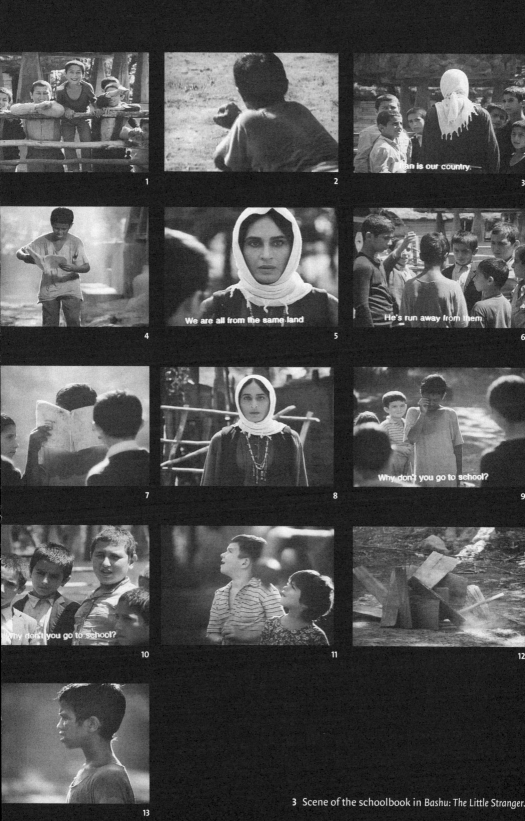

3 Scene of the schoolbook in *Bashu: The Little Stranger*.

. . . the standard language of Iran since legislation in 1935 is the only means through which educated Iranians of diverse ethnicities can communicate with each other. This legislation coincided with a rise in nationalism. In its most fervent moments, this same nationalist spirit vilified Arabic language and culture, which, beginning with the Islamic conquest of Persia in the seventh century, changed the linguistic, religious and cultural map of Iran. That the pre-Islamic Persian empire already comprised many different ethnicities and languages is a point lost to modern nationalists, whose single–minded zeal for Persian also ignores Iran's existing diversity. . . . In the remote setting of Na'i's village, the artificiality of Persian—or its function as a "paper language"—is emphatically brought out.[13]

"Paper language," a language spoken in this scene to the rhythm of dominant conventions in classical narrative cinema, foregrounds the artificiality of film language and articulates the issue of film literacy as vital to the film.

A Universal Grammar?

In the course of the children's fight, Bashu gets himself up from the ground to read a section of the schoolbook with which most of those who have been educated in the Iranian school system are familiar (figure 3, frames 3–5). As he reads, the book declares on behalf of Bashu that "we are all the children of Iran," implying that despite their differences the children all belong to one homeland and are of one nation. Notably, it is only the language of the book and the use of the standard convention connoting linguistic exchange that communicate this national unity in the film. The tensions that exist between the characters themselves in their dialogues with one another only serve to acknowledge their cultural, racial, and linguistic differences, their lack of unity. In a later scene Na'i herself attempts to convince her husband that Bashu belongs to the nation and to the family on the basis of a tactile humanism ("like all children, he is the child of the sun and the earth"), but she manages this only through the efforts of the village literate, who writes what she dictates to her husband in the language of the book and in letter form.

Consequently, the film demonstrates that only a standardized mediating language, however artificial, enables communication across set boundaries. Riddled with regulations that force the film industry's independence from dominant cinema and its standard codes, the question that the film raises, in its patterns of editing, is whether film can do with-

out a similarly standardized language, one that by virtue of the dominance of American cinema around the world is embedded in the global sensorium.

Scene of Father's Letter: Literacy at Stake

Scene twenty-seven, in which Na'i's family and Bashu are gathered around the old village literate in Na'i's backyard, points toward the film's answer to this question. In this scene, four establishing shots accompany the voice-over of the old literate neighbor, who reads from a letter written by Na'i's husband and father to her children.

Four shots introduce "the scene of Father's letter" (figure 4, frames 1–4). These shots are followed by a long shot (frame 5), which finally opens the film to the site of the small gathering of listeners in Na'i's backyard. Scattered about the old man, Na'i and the children listen to the words printed on a single page and written in a chaste, standardized Persian, i.e., in the language of the schoolbook. Here and throughout the film, this page, the trope of the letter, represents the absent father (frame 6). In this scene the letter displaces the schoolbook of the previous scene as a medium that can similarly communicate between the far away and the home. Yet, as Rahimieh notes, "Na'i and her husband, who would normally address each other in Gilaki, have to rely on Persian in order to exchange letters. The imposition of Persian modifies the meaning of the letters."[14] Comparable to Bashu's "mispronunciation" of the standardized text in the schoolbook, the act of writing both transmits through equivalence and transforms through the process of transcription. Thus writing, like film, is presented as a mimetic procedure that both fixes through communication and transforms in the process of exchange. Emphasizing the linguistic transformation that occurs in the transition from medium to medium, the film performs a self-reflexive gesture, raising the question of literacy in relation to mediation and communication in film, as well. Film, like any medium of communication, is mimetic of address. Film reads and writes the earth much like a letter or a book, but it does so in shadows, in light, and in sounds that transform the earth and shape it into a world. A world created by film technology demands not only a standard in order to communicate meanings, but also a standard of visual literacy on the part of its audience for the meanings to be understood. What takes place in "the scene of Father's letter," then, is significantly different from the processes operating in "the scene of the schoolbook," which immediately precedes it.

1

2

3

4

5

6

4 Scene of Father's letter in Bashu: The Little Stranger.

In the earlier scene, the language of the book is situated as the standard language that communicates above ethnic differences to the nation's literate, producing through this language a landscape grounded in the trope of the nation. When the book speaks on behalf of Bashu to the children and to the audience (frames 3–5 in figure 3), the camera also speaks. Like the nationally shared schoolbook, the camera speaks in a standardized language of codes that are perceived to be universal in cinema. The filming and editing process in the scene creates eye-line matches and produces shot–reverse shot patterns that tell the audience, in the grammar of classical narrative cinema, that the person in the first shot is communicating meanings to the person or persons framed in the next shot. The repetition of the standard code emphasizes the scene's message ("communication"). The camera seamlessly reiterates the action of the sound track; standardized practice produces sense alongside temporal and spatial continuity. The character in shot two is thus positioned by way of an eye-line match to be in proximity to the character in shot one, and temporally present, in communication with him or her. In keeping with the scene's standardized editing, standard sound synchronicity is motivated by Bashu's reading of the standardized text of the schoolbook. Or, put differently, Bashu's reading of the standardized text sets in motion standardized codes. The meaning of Bashu's gesture of communication is seamlessly transmitted in this way to the literate (schoolchildren) and nonliterate (Na'i) alike. As audience we grasp the meaning of the standard code and understand that communication has taken place.

It becomes clear in "the scene of Father's letter" (figure 4), however, that communication through a standardized language does not necessarily constitute meaning comprehension by all. While written and read, the language of the book in "the scene of the schoolbook" is shown to be the mediator of meaning, supported by editorial strategies on the image and sound tracks to connote meaning, sense, and comprehension by a system of looks and a standardized montage. These two tracks, sound and image, come together seamlessly, to hide the camera and sound technologies behind character looks and within the visual exchanges. The camera and the film's sound technologies are buried in the "scene of the schoolbook." In "the scene of Father's letter," however, the producer of meanings is revealed to be the camera itself. The seams of the film suddenly unravel.

In the four opening shots of "the scene of Father's letter," "the message" that is communicated on the visual track becomes nonsynchronous with the unfolding narrative. While we can assume that the children and Na'i are gathered to hear the literate neighbor read a recent letter from Father in this scene, we do not see the gathering, nor do we see the old man. We only hear the voice of the old village literate on the sound track. Habituated to certain classical norms, we feel disoriented as spectators in relation to these shots. What are we hearing? Who is seeing in these four shots? Where are we?

In classical terms, a standard establishing shot would orient us in relation to the sound and the narrative, first. The establishing shot would position the characters spatially in relation to each other in the diegesis. Thus the communal gesture of receiving and reading the letter would be set up to create seamless synchronicity between what is seen on the visual track and the letter heard on the sound track. As spectators we would know who is speaking, who is hearing, and, more importantly, where this is taking place. Indeed, the camera's own visuality would be linked to the body of a character within the scene, thereby positioning us as viewers in spatial relation to the events taking place in the scene. A spectator within the diegesis would stand in for our visuality and hearing; that character would in this way stand as an alibi for the camera's look as well.

Things proceed differently in "the scene of Father's letter." The first establishing shot in the scene does not occur until shot 5 (figure 4, frame 5). Instead, as the scene opens, still shots of objects accompany the voice that is heard on the sound track. These shots take the place of the standard establishing shot. In shot 3, for example, we hear the voice of the old man: "Take care of the oven." The standardized Persian spoken on the sound track suggests to us that the man is reading from a text; the words do not sound like those of a villager in conversation—they are written words. But we cannot be sure of this because the camera does not show him reading from a letter. Instead the image track accompanies the voice with an uncanny framing—with a still. The camera frames an oven. Where are we? What is going on?

The Camera Is

The camera shows an oven. No character within the film is set up as "seeing the oven." We must assume then that it is the camera that sees.

Uncanny and unsettling, the camera forces itself to the foreground, showing us, the film's viewers, how it has been seeing for us all along, how it has set its seeing up as a prosthesis for our look. It shows how it frames the world for us and how it has been framing Bashu's and Na'i's world throughout. Without an establishing shot to open the scene, the film declines to script a single character to inhabit the perspective of the seeing subject. Noting this absence, feeling disoriented by the oddity of the four opening shots and the alienated sound of the voice with no obvious bearer, we are forced to reflect on the status of technology as a producer of meanings. As we hear the village literate read, "Take care of the oven," the shot on the visual track communicates, "Here is an oven." There is, in other words, a marker of deixis in the "here" of the shot. The deixis suggests the direct address of the camera to the film audience. It reflects on itself as the bearer of the film's address. This kind of forced reflection is one that the film gestures towards several times henceforth.

Indeed, the camera identifies itself as an interpreter that mediates and translates the standardized written Persian we hear on the sound track. It translates the words into corresponding visual images that are represented within a frame: "Here is an oven." "I am showing you an oven." The camera is not interested in forwarding a narrative in this scene as it is elsewhere in the film. Rather, it actualizes objects as visually framed words. Its objective in this scene, unlike in the preceding scene, is not to move the narrative forward by showing us communication between characters within a film world, but to foreground its own role in the film; to reflexively observe its own linguistic function. This gesture on the part of the film underscores what most film narratives hide within the fictional figure of characters and in eye-line matches, namely that the camera-as-interpreter speaks, and not only to advance a narrative. (If it were to do so, the film would set up the scene to represent the family gathered around the village literate and show them listening to him as he reads the letter; such a scene would communicate, "The village literate and Na'i's family are gathered to read the letter you hear on the soundtrack.") The film insists, rather, that we notice the camera's function as a framing device, as a mode of address. In its act of framing, it defines and determines the spectator's relation to the images on screen. Using conventions of framing and editing, the film constructs the meanings of images for the spectator. By rupturing the continuity of the narrative, the camera foregrounds its function as the producer of the film's address.

The film's address, inscribed as it is by acts of framing and in the film editing processes, like any other act of meaning production, demands a grammar that becomes integral to the film spectator's patterns of viewing. It is the "becoming habit" of this grammar that makes viewing the world through the look of the camera as natural as the spectator's own visuality. As Allan Sekula argues, photographic literacy is learned. To say that photography is a universal, independent language assumes "a quasi formalist notion that the photograph derives its semantic properties from conditions that reside within the image itself. But if we accept the fundamental premise that information is the outcome of a culturally determined relationship, then we can no longer ascribe an intrinsic and universal meaning to the photographic image."[15] Thus, Sekula suggests, even cinematic photography "depends on larger discursive conditions" and is "an outcome of an interplay of iconic, graphic and narrative conventions."[16]

In the four opening shots of "the scene of Father's letter" (figure 4, frames 1–4), the camera functions as a translator. In identifying with the camera's gaze, the spectator, too, becomes a reader-interpreter. This gesture of total reflexive and mimetic identification with the camera indicates to us as spectators that the film is asking us to correlate what we hear as written with what we see, i.e. to enact a translation that actualizes semblance in a different medium. The word "oven" in the letter means the visual iconic sign "oven" in close-up. The viewer can make this translation only by identifying with the look of the camera; by ingesting this technological look as his or her own. The viewer has to have internalized the film's mechanical body and its conventions of framing in order to perform this function of translation in relation to the still image on the visual track. By foregrounding this identification between the mechanical body of the film and the spectatorial body, the film requires its audience to consciously reflect on the film's own process of production. To reflect, that is, on the process of shot construction and framing as a process based on an emergent cinematic literacy that depends on the viewer's total identification with the cinematic apparatus; an identification which, as I have suggested, amounts to the ingestion of the technology itself. The film ruptures narrative continuity in this sequence and becomes self-reflexive. In this moment of rupture, when the camera disengages both from the forward motion of the narrative and from the perspective of a film character within the diegesis, it addresses the question of cine-semiotics to the

post-Revolutionary Iranian context: What would it mean to purge, renew, and energize the nation's sensorium through film technologies? What would it mean to say that film communicates Islamic values to all citizens when its language is so completely dependent on the standardized codes of dominant cinema?

Creating a New Filmic Language

In the scene of the schoolbook, meaning could be communicated because the children have all been educated in the book's standard language. The camera acknowledges this by using a standardized code—a filmic grammar, if you like—to reinforce the meanings and messages that are being communicated between the children and Bashu. But by displacing the schoolbook with the letter and by rupturing the narrative flow to reveal the camera (and not a character) as the mediator of the look, in the scene of Father's letter the film takes up afresh this issue of literacy. At the moment of narrative rupture (therefore on the enunciative level of the film's own address), the film implies that if post-Revolutionary Iranian cinema is to communicate the new nation to all Iranians, literate or not, then its spectators must be able to read and comprehend the film's language, its technologies' address, in order to understand the film's messages and meanings. "But would this not involve the incorporation of the newly purified technology into the human body?" the film asks. The film shows itself unwilling to accept the charge that films communicate without dependence on a form of literacy. For as Christian Metz has suggested, cinema is a "mental machinery" which, Metz argues, viewers have "internalized historically and which has adapted them to the consumption of films."[17] If the Islamic regime sees cinema as a medium that must be purified and purged from its historical conditioning by outside forces (from such codes and conventions of voyeurism as those implied by the shot–reverse shot patterns of the schoolbook scene), then it forces cinema to dispense with a standardized language and a grammar internalized by American cinema's historical and global conditioning of the senses.

But again, if this medium should be used to communicate Islamic values and to function as a fundamental tool in the construction of a purified, Islamized national body in Iran, Bashu insists that first the national industry would need to produce, and viewers would need to internalize, the language of the purified national medium. The national body must be

habituated to film technologies' new functions, absent the codes and conventions that depend on the voyeuristic pleasures of classical cinema, codes that have historically enabled films to communicate meanings, to inscribe the spectator in the diegesis, and to achieve closure. For Iranian cinema to communicate in new ways, the national sensorium must go through the purified technology of cinema. It must internalize its new and modest configuration in order to be purged, itself, of the old senses. The process of sensorial reeducation is essential. But for a medium that has been tasked to communicate a purified Islamic culture and to constitute a new citizenship, a new standardized cinematic language must also be developed.

While in the late 1990s new methods of cinematic representation did develop as a result of modesty laws, *Bashu: The Little Stranger* was one of the earliest films to raise the issue of communication and film literacy directly. From the very first sequence representing the modest enclosure of the female figure within the black veil and the annihilation of female bodies in movement by the violence of the cut, *Bashu* asks how film can be made a universal medium of communication that is to convey a purified national culture, when it has for so long spoken in "a language" that has depended on Hollywood's voyeuristic codes and its representations of a fetishized female body to achieve communication and meaning comprehension. How can films communicate when the object of the camera's voyeuristic gaze is covered and cut?

While *Bashu* provides few answers to the issues it raises regarding a national cine-semiotics, Bahram Bayza'i's next film, *Maybe . . . Some Other Time* (*Shayad . . . Vaghti Digar*, 1987), attempts to conceive what a semiotics of Iranian film may look like. In my discussion of *Maybe . . . Some Other Time*, I argue that Bayza'i articulates the presence of a duplicity of tongues in Iranian cinematic productions in a direct affront to the isolationist and purificatory discourse of the Islamic regime.

Cine-Semiotics for Iranian Cinema

In a paper given in Paris, and published in *Iran Nameh*'s special issue on film, director Bahram Bayza'i argues that the hundred-year success of cinema in Iran is conclusive in the claim that "the image" is now "the language of the people." In our country, he writes, "little by little, the language of the image replaces the literary language. The image is the language of the people, the word is the language of the privileged (*khavas*)."[18]

To my mind, this association between the image and the everyday language of "people" posits a direct link between cinema and the constitution of a national identity through linguistics. It calls for a serious consideration of the applicability of the semiotic project to contemporary Iranian cinema and highlights the role of cinema in the constitution of the new nation and its citizen-subjects.

Bayza'i argues that in the history of Iran, where a minority was literate, "it was photography and film that slowly, over the course of several decades, introduced new thought and the birth of a new culture to the diversity of the masses. The [leaders'] enmity towards [the image] also lies here. The image is more truthful than the complicated writings that serve hypocrisy."[19] The image, for Bayza'i, obviously speaks in an unhypocritical tongue for and about the everyday life of Iranians. But in a cinema vexed with visual censorship, the question is: What can film say? Indeed, what does it say?

My reading of Bayza'i's *Maybe . . . Some Other Time* moves away from a narrative interpretation and toward a reading of the film's enunciative practices in order to understand the ways in which the film constitutes its address. In an era when government demands dictate a purified national culture to Iranian cinema and in a time when social theorists are asking if a continuous Iranian identity can be established on the basis of its national history, I suggest that film, as the space of cultural negotiations, goes beyond representing a culture, a nation, or the vision of a utopia. As I noted in the contrast between the scene of the schoolbook and the scene of Father's letter in *Bashu*, the process of film production involves a subtle negotiation between discursive or enunciative strategies and narrative statements. Observing a similar negotiation in *Maybe . . . Some Other Time*, I suggest that the film questions the applicability of the premise of a "continuous national" or even a "pure" identity for contemporary Iran.[20] My reading of the film shows that due to the problems posed by the issue of modesty in the Iranian cinema in the post-Revolutionary period, women's bodies, as the politically repressed site of the narrative in film, become the places in which the nation's address takes shape. Informed by the work of the progenitor of cine-semiotics, Christian Metz, on enunciation, my reading of *Maybe . . . Some Other Time* suggests that cinema is not only a site in which national identity is represented—that is, on the level of the narrative, the diegesis, or in visual representations—cinema is also importantly constituted by an ambivalence in that it embraces the repressed

and unconscious site in which filmic enunciation and address are articulated.

From my discussion of the scene of the schoolbook in *Bashu*, it is clear that film constructs the narrative by putting together images through oft-repeated filmic articulations. It does so by placing one shot next to another, making one image the caption for the next. As Metz argues, "Going from one image to two images, is to go from image to language."[21] Films must be considered "signifying systems," then, in that they organize and arrange strings of images and sounds. The labor involved in organizing is part of the discourse that constructs the narrative and thus produces sense. Editing or montage is part of this process, certainly, but it is not the sum total of the language of cinema. "Cinema is language *above and beyond the particular effect of montage*," Metz writes: "It is not because the cinema is language that it can tell such fine stories, but rather it has become language because it has told such fine stories."[22] The discursive labor involved in the production of narrative sense through image and sound lies at the heart of Metz's discussion of enunciation, which, though much contested, I evoke here as the language or grammar in film.

Enunciation in Film

In *The Imaginary Signifier*, Metz maintains that while film is traditionally presented as a narrative or story, it is the film's discourse and the very principle of that discourse's effectiveness that obliterates the traces of filmic enunciation and hence imbues film with coherence and continuity as "story."[23] As the comparison between the scenes of the schoolbook and of Father's letter in *Bashu* demonstrates, the sense of continuity and coherence in the narrative depends on the ability of film to hide the traces of its production. The seamlessness of the narrative and the concealment of the operation of the film's productive technologies are effected by embedding the latter's workings—its enunciative processes—in the narrative's illusion of temporal and spatial continuity and in the bodies of the characters shown on screen. Our visuality, associated with the camera's look on the scene, is embedded in Na'i's look in the scene of the schoolbook; in the scene of Father's letter, this look is exposed as the camera's own. Each scene constitutes its meaning and purpose by repressing (in the scene of the schoolbook) or alternately by exposing (in the scene of Father's letter) the process of enunciation. How such meaning is gener-

ated in films and how narrative coherence is maintained are two of the fundamental problems informing semiotic film analysis.

Deixis as Reflexivity

In linguistics, deixis is that marker of the statement evidencing the moment of enunciation inscribed in it. The "I" in a statement reflects on the person who speaks the statement. In film theory deixis has a similar function. Less a marker of the pronoun, it is more fundamentally the marker of the film's reflexivity—the film's way of identifying the location of its own address. "Not being an I, the source of enunciation does not produce a YOU answering the I . . . ," Christian Metz observes; "the film, far from being an absent instance stuck between two present ones, would resemble rather a present instance stuck between two absent ones, the author who disappears after the fabrication, and the spectator, who is present but does not manifest his presence in any respect."[24]

In semiotic film analysis and specifically in the work that is associated with Metz, the markers of filmic enunciation are instead identified as moments in the narrative where the film reflects on the process of its own coming into being as film, as the sites and locations of its address. Enunciation in film appears within the narrative as an "imprint," writes Metz, "that is yet depersonalized and transformed into a landscape."[25] This landscape plots national location and industry, as well as the textual codes and conventions that produce meanings in the film text.

In his 1987 article "The Impersonal Enunciation, or the Site of Film: In the Margin of Recent Works on Enunciation and Cinema," Metz evokes enunciation as filmic reflexivity. This reflexivity marks the moments of metafilmic splitting: "All figures of enunciation consist in metadiscursive folds of cinematic instances piled on top of each other. . . . It is as if the film could manifest the production instance that carries it only by talking to us about the camera, the spectator, or by pointing at its own filmitude, that is, in any case, by pointing at itself."[26] Transformed into a landscape made up of a geography of directions and orientations between source and destination, enunciative moments are reflective moments in which the film folds over, repeats, or reflects on the process of its own coming into being as discourse. A film narrative is understood by Metz to mark enunciation by producing splittings that fold, fork, and then reflect back on the film itself. At such moments, as we shall see momentarily especially in my reading of the scene set in Haq-Negar's apartment, the process

of production ruptures the narrative veil, just as the unconscious ruptures conscious psychic processes (at moments of parapraxis, say), to indicate the genealogy of the film's production process, its technological and industrial base, its modes of address, as well as its projected sites and moments of reception. For as Metz points out, "Cinematic enunciation is always enunciation on the film. Reflexive rather than deictic, it does not give us any information about the outside of the text, but about a text that carries in itself its source and its destination."[27]

The Marks of Enunciation

Enunciation shows its mark precisely at moments of reflexivity in the film narrative:

> For what is enunciation basically? It is not necessarily, not always, "I-HERE-NOW": it is, more generally speaking, the ability some utterances have to fold up in some places, to appear here and there as in relief, to lose this thin layer of themselves that carries a few engraved indications *of another nature* (or another level), regarding the production and not the product. . . . Enunciation is the semiological act by which some parts of a text talk to us about this text as an act. . . . [28]

Typically, moments of enunciative breach, when the film shows its seams, are inscribed in the diegesis by the presence of door frames, windows, mirrors, cameras, sound equipment, fictional audiences, and so forth. Such moments alert the spectator, reflexively, from within the narrative, that his or her vision is mediated: a window frames a landscape much the way a film frames its scenes; an audience in a fictional theater on screen reminds the audience of itself sitting in front of the screen. Such self-reflexive foldings or splittings that appear on the narrative screen are opportunities for Metz to search out the inscription of enunciation in film. Thus he defines enunciation as the site of metafilmic splitting.

National Enunciation

When we read film statements or narratives as products of a national cinema, it must be understood that such statements operate to repress the enunciative processes of national production. The production process is set at a remove from the seamless narrative (in the same way, latent thoughts articulate manifest dreams from a place elsewhere). If narrative

works to repress the process of production, a national cinema's address can only be interpreted insofar as it is read through the space of enunciation—through that geography of difference in film that configures the meaning of the film statement or narrative as both temporally and spatially distant and distinct from the process of production. What this means is that if the nation is posited as the subject of the filmic statement, it must also be said to be at a remove (in both time and space) from the filmic enunciation.

The meaning of a film's address is deferred. Enunciation bridges this gap between the industrial location of production and the film's narrative statement. As a commodity that is often seen as representative of national consciousness—an allegory of sorts—film must be said to produce and proliferate an extraordinary configuration of splittings and forkings. These configurations of contradiction and difference, of delay and distance, unsettle any notion of fixity in the production and representation of culture and nation in flim as indexical of the source or context of national production.[29] In the context of national cinemas, one could even say that the subject of the filmic enunciation—at a temporal and spatial remove from the product or statement—speaks from another place, from an elsewhere, and in a different tongue.

Extending this argument, I submit that if post-Revolutionary Iranian cinema in the hands of the Islamic government serves the nation by producing representations of the nation's purified identity, then the nation's address, its enunciation, can be and indeed must be differentiated by degrees from the nation spoken in the film statement and represented in the story on screen. A look back on *Bashu*'s scene of the schoolbook furthers the argument. For if we accept that Na'i's look onto the children's fight in *Bashu* covers for the fact that it is actually the camera that looks, then we must also affirm that any representation of the nation in film—just like any body or any identificatory character look—stands as an alibi for a repressed yet productive force (the camera's look, the editing process) that produces the nation in filmic effigy.

My question to *Maybe . . . Some Other Time*, simply put, addresses the nature of this productive force: What kind of cultural, historical, and technological configuration is productive of the national identity that is represented on screen under the Islamic regime? This nation in effigy, what is its source? Where do its codes and conventions stem from? The historical background to Bayza'i's 1987 film bears out the dynamic of relations between narrative statements and the film's sources or sites of enunciation,

and thus a brief consideration of this background will provide some insights into these questions.

Credits: Bahram Bayza'i

Bayza'i's work permit was temporarily withheld after the production of *Bashu: The Little Stranger* in 1985. In an interview with Saideh Pakravan dated February 1995 in the journal *Chanteh*, Bayza'i claims that his next film, *Maybe . . . Some Other Time* (1987), was one that he did not want to make and for which he was heavily criticized. He states that he was given the film script for *Maybe* and that he was pressured by the Islamic Republic's Ministry of Guidance (*Vezarat-e Ershad*) to make it. He admits to having been under severe financial pressure since the beginning of the Revolution, and knowing that any director with his track record would not be given an assignment, he accepted the job. In response to the interviewer's comment on the apolitical and uncontroversial nature of the film, which was consecrated by the Ministry of Guidance, Bayza'i contends that although *Maybe . . . Some Other Time* may not be pointedly political or controversial on the narrative level, it should be seen as politically significant nonetheless. He points out that the film directly addresses the question of identity (*hoviyyat*) and that this is one aspect of Iranian life that has not been adequately explored in recent years.

In addition, Bayza'i points out, the film concerns the Iranian middle class. The government, Iranian intellectuals, and foreign critics, he says, are all prone to overlook this important stratum of Iranian society. In contrast, "village films," like *Bashu*, have become a convention of Iranian cinema and a touchstone of the international film festival circuit. In a significant comment that alludes to his fascination with the performing arts and cinema of Asia, Bayza'i remarks that like the Japanese filmmaker Akira Kurosawa, he too would like to be awarded a prize for making a film about present-day conditions and about the middle class in his country. It seems, then, that *Maybe . . . Some Other Time* transforms this insight into a direct critique of the representation of contemporary Iran in international film festivals and in contemporary Western media, situating that critique in the body of a contemporary Iranian middle-class woman.

I should note in passing that the film appears apolitical because it abides by all the rules of modesty, to the extreme of having the female lead sleep veiled. Yet Bayza'i smuggles into this strategy a critique of the contemporary move within Iran to homogenize culture through film, in a

manner that relies on a recognition of the dependency of Iranian cinema on standardized conventions in dominant cinema. This is a point that I pursue further in the analysis of the film.

Maybe . . . Some Other Time

Maybe . . . Some Other Time is the story of a pregnant middle-class woman (Kian), a foster child who, in search of the reasons for her uncertainty about her identity, encounters a replica of her biological mother in a painting laid aside on the floor in the cellar of an antique shop. In a quest for answers she also finds her previously unknown twin sister (Vida), an accomplished restorer and painter, who is married to the owner of the antique shop (Haq-Negar).

Following the overture and the introduction of the main characters, the film opens onto the screen of a documentary in a film studio, where Kian's husband (Modabber) is working on dubbing the sound track for the documentary on transportation and pollution in Iran. While doing so, he recognizes his wife in a car, waiting for the traffic to move. Sitting next to her in the driver's seat is another man. Jealous, Modabber studies the shot repeatedly and persuades the film crew to find the segments of the film that have been edited out. Significantly, this reference to film editing, and in particular to what editing removes, is one of the first instances in the film that reflect on filmic enunciation (the site of narrative production) and thereby alert the viewer to the continuing process of production and hence to the character of the film as thoroughly self-referential. This sequence also indicates the project of the film as historically redemptive. The documentary on pollution recalls a segment of Bayza'i's *The Crow* (*Kalagh*, 1976), a film made before the Revolution and destroyed during the course of it. Stills from *The Crow* are mounted behind the men in the editing room on the board in *Maybe . . . Some Other Time*. These stills are, it seems, also intercut with shots that figure into the black and white sequence of *Maybe*. This sequence in the editing room not only serves to remind us, through the mise-en-scène, of the film's own making, that the film is technologically produced, it also recalls a part of Iranian cinematic history that the Islamic Revolution has erased from popular memory.

As the crew recovers the time and place of the shot, Modabber moves to interrogate his wife and to collect clues about her mysterious and secluded life as a housewife. Other clues (like the license plate number that was edited out of the documentary film) lead him to the owner of

the car, Haq-Negar (the name translates as "seer of truth"). Modabber finds out that Haq-Negar runs an antique store and sets up an appointment to visit Haq-Negar in the store. He uses the making of a documentary film about antiques as an excuse to find out more about Haq-Negar's relationship to his wife, Kian. Unsuspecting, Haq-Negar agrees to cooperate with the film project.

In the cellar of the antique store, among the hundreds of objects that recollect the greatness of Persia's past and its relation to the world at large, Modabber finds a dusty portrait of his wife, Kian, in the corner of the room. He asks to buy it, to which Haq-Negar responds that it is the property of his wife, Vida, and is not for sale.

The Antique Cellar: Take One

The scene of most interest to us in this discussion is the one in which Modabber brings his wife, Kian, to the antique store for the first time (his second visit). During this visit, Kian walks around the cellar, looking at the objects spread around the room. She passes the painting on the floor without noticing it or its angled reflection in an adjacent mirror. Walking past rows of gramophones and telephones—technologies of hearing and aural communication that anticipate the forthcoming stutter in the film— she encircles the large antique globe that holds a central position in the cellar scenes, finally encountering the image-portrait of someone whom she recognizes and denies as herself and its replica in the adjacent mirror (see figure 5, shots 32–39).

In this scene, a long shot (shot 32) situates Kian looking at "her" image. In the foreground, an ominous sculpture of a mother and child prophesies the "encounter" between Kian and her mother, in effigy, as well as Kian's own impending motherhood. As she walks close to the painting, the camera moves past the globe to capture a close-up shot of the portrait. The conventional reverse shot of Kian's close-up is interrupted by shots 35–37 of the antiquarian showing Modabber the helmet of Uzun Hasan, the stirrups of Sultan Mahmud, and the seal of Genghis Khan.[30] Introducing the objects by name, Haq-Negar holds them up to the direct gaze of the camera. Kian's moment, the moment of direct recognition of herself/mother, one that typically demands the filmically mediated relay of gazes through the shot–reverse shot, is interrupted through an encounter with the nation's past, Persia's invaders and neighbors, which come together in a dialectical constellation through filmic montage. Modabber, who could not respond to Haq-Negar's query in an earlier scene about whether he saw the antique cel-

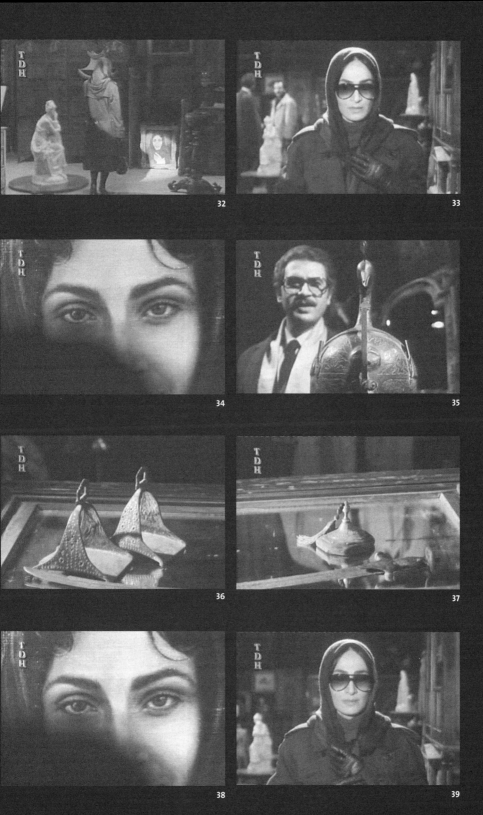

5 Kian in the antique cellar in Bahram Bayza'i's *Maybe . . . Some Other Time.*

lar as "the rubbish heap of memories" or "the treasury (or archive) of history," comments in a voice-over to shots 38 and 39 framing Kian's recognition of her own face in the painting: "The past of the world is here."[31]

The interrupted shot–reverse shot in this sequence, a visual stutter of sorts, draws attention to the mediating conventions of dominant cinema at the same time as the sound track introduces the traditional mediator of foreign films in Iran in the figure of the voice-over. The dubber, who was significant in creating the widespread popularity of foreign films in Iran, translates for the viewer the significance of the "stutter" in the grammar of a film that serves to represent a purified national film industry: "The past of the world is here," he says.

When her husband comes up to her, standing before the portrait, Kian runs out of the cellar in utter distress. Once in the car, Modabber advises her to take tranquilizers. During the conversation with Haq-Negar in the antique cellar, the time and place of the shoot that night are set. The crew is scheduled to set up at Haq-Negar's apartment for the initial filming— an agreement which Modabber had reached with the antiquarian's wife, Vida, over the phone earlier that day.

The Antiquarian's Apartment: Take One

When he arrives at Haq-Negar's apartment, Modabber learns that the paintings hung on the wall are all by Vida, who, according to her husband, is a great restorer of old pottery and other antique objects. Modabber, seeing Vida's exceptional likeness to Kian, calls his wife on the phone and asks her to come to the apartment. Meanwhile, the small film crew arrives, sets up, and tests the equipment. This is, of course, yet another self-reflexive sequence in the film, which again alerts us to the processes that construct the film we are witnessing. In particular, we are being shown the process that the editor edits out. The missing content and the missing process are thus fused as the past of production, which the present of the film narrative brings back.

When the doorbell rings, Modabber asks Vida to open the door. In the door frame, the two women recognize their faces in the image of the other. Kian waves her arms in front of her (a typical gesture that Bayza'i uses to connect and edit shots and to guarantee the continuity of actions in the film) to confirm that the face she sees is not one of her nightmares, or a mirror image she has mistaken for herself. She collapses into the door frame as Vida backs up toward her husband, who is inspecting a photograph of twin girls in an album (see figure 6). Sobbing, Vida

5 In the antiquarian's apartment in *Maybe . . . Some Other Time*.

explains that when she was a very young child, she had a sister and that every time she asked about her, people said that she had gone on a long trip.

As Vida recollects her tale, Kian turns and looks toward the camera. The reverse shot shows that the space previously positioned as the place of the documentary camera and the sound recording equipment for the film on antiques in the antiquarian's apartment has transformed into the imaginary space of the cellar of the antique store. This technological reorganization of space is attributed to Kian's act of looking; in effect, the shot reads: "This is what Kian is seeing." In the antique cellar the globe again is the center of the image. The wall of the cellar opens to the wall of an old building, the orphanage in old Tehran. The space of the documentary film and sound equipment is replaced by the space of memories and of history, whose walls, in turn, open to a space of births. All these transformations of space and time are made possible by the technologies producing our film. We the audience share Kian's visual re-arrangements of these spaces. The camera moves past the globe to the dusty oil painting on the floor of the cellar. As if participating in the same space of fantasy and remembrance, Vida points directly at the camera (our screen), and screams: "Mother!" The fourth wall of the apartment, which has been the space of the recording of our film, has thus been identified.

The next shot shows Kian crying with her back to the camera. In tears, Vida recollects that their father had died and that there was hunger ("nan nabud" ["bread no was"]). Photographs of their mother bent over wash-basins and behind a wheel preparing and spinning wool with other women flash on the screen. In the subsequent shot the film takes us back to the cellar of the antique store, and the space adjacent to the painting of the mother is stretched into an anaphoric mirror to reveal a reel of black-and-white film. The cinematic screen, which had previously been recognized as Mother, is now transformed into the site of screen memories.

Screen Memories: Take One

The black-and-white film sequence shows Kian's and Vida's mother leaving a child by a house and shooing off a dog and a shabbily dressed, disabled man who is willing to take the child with him. The film then cuts back to Haq-Negar's apartment and to a medium shot of the shadow of a carriage wheel projected onto Kian's crouched and moving body. This shot, in the filmic present, anticipates the next shot of Mother watching a

horse and carriage stop near the crying baby in the past. A wealthy couple appear, and Mother is anxious that they take care of her child.[32]

The remainder of the black-and-white shot sequence, which shows Mother struggling to hang onto the back of the carriage as it crosses town, is interspersed with shots of the actress Susan Taslimi (who plays the roles of all three women) grasping to hold onto a metal frame as it moves toward the camera. These scenes of Taslimi are shot in the antiquarian's cellar and are intercut with other shots of her pursuing the same bracing in Haq-Negar's apartment. The sequence thus shows Mother in present filmic spaces acting out past events. Other shots show what Mother sees (in black and white) from her place on the back of the carriage in her own temporal reality. The process of narrative production and narrative time merge in the editing of these shots.

When the carriage finally arrives across town, Mother realizes that it is empty and her child is gone. She assumes that her child has been left at an orphanage, and we see her running in despair past the entrance of the orphanage (see figure 7, page 64). Another shot shows her running back to where she had deposited the child (shot 1), and a medium shot (shot 2) shows that it is empty. The reverse shot (shot 3) shows Kian in the present of the apartment looking down, as if looking at that empty space, and turning in despair. This is a conventional reverse-shot pattern that places Kian filmically in the time and space of Mother's experience. Kian's recognition of her own absence in the place where her mother left her as a child happens before her mother's recognition, as if to drive home the filmic mediation of time and space. In shot 4, Mother arrives at the empty spot where she "sees," in shot 5, that her child is gone. Her gestures evoke shock and confusion.

The intercutting of these shots, from color to black-and-white, from the space of the old city to the antiquarian's large cellar and his small apartment, collapses time and space, and mother and child become one in the body of the actress Taslimi. This sequence of intercut shots reiterates the formal aspects of the film in which the characters and their actions motivate the transition from one shot to the next, effectively fusing the time and space of the film's production (enunciation) with that of the film statement, the narrative.

The film crew then turns off the lights, puts away its equipment, and bids its farewells. Vida asks the Modabbers for their address so she can send the portrait of Mother to them. Modabber thanks the Haq-Negars and says that they will talk "maybe some other time." The film closes with

a shot of Kian's restored happiness as she walks out the front door with her husband. A still close-up of the painting of Mother, looking directly into the camera, ends the film.

The Antique Cellar: Take Two

We need to recognize that the encounter of Kian with the portrait of Mother in the cellar of the antique store is not only a representation of the unification of mother and daughter, or the tale of the reconstitution of one woman's identity. The editing of the film (a subject that arises in an early scene in which Modabber asks the director of the documentary to include a voice-over of experts in the film) insists that what is at stake in the unearthing of the mother's portrait is also the excavation of the nation's past—a past that has been forgotten because of the inattention to representation and art in the history of Iran. The antique objects, the paintings, the space of filming and audio recording are all located as representational spaces in which this history is retrieved and reproduced.

While *Maybe . . . Some Other Time* sets up the two men (Haq-Negar and Modabber) as counterparts who are completely ignorant of each other's profession, their work is shown to preserve the past in similar ways. Rather than placing this recognition of similarity within the context of the narrative itself or the dialogue of the characters, the film uses editing to mediate the correspondence. More specifically, it does this by associating the camera's look and its address with the visuality of a woman, Kian, who identifies the site of her husband's documentary film equipment as Haq-Negar's antique cellar. As the following analysis elucidates further, Kian's vision, which is associated with collective indulgence in a technologically mediated unconscious, an imaginal space of sorts, compresses the distance between the professions of the two men, producing correspondences through filmic mimesis.

Kian's confrontation with the image of herself in the portrait of her mother sets up a conjunction between the work of the antiquarian and the linguistic practice of the film we are watching. As the film enacts a typical editing sequence, which according to standardized practices conventionally speaks to a moment of "communication" or recognition in the shot–reverse shot pattern between Kian and the portrait, an interruption occurs. The film stutters. The camera is confronted with a diversity of antique objects belonging to the history of Iran that the antiquarian has collected and identifies by name. This interruption of the conventional

shot pattern draws attention to the construction of the film narrative as achieved through an artificial but dominant and standardized pattern of filmic communication. In other words, the film signals its own artificiality by stalling the shot–reverse shot (see figure 5, page 51, shots 3–7) (This stammer in the film mirrors a similar stalling in the pattern at a crucial moment of exchange between Na'i and Bashu when they learn to speak each other's language and say each other's names.) By foregrounding the production of the filmic narrative in *Maybe*, the film posits its own connective linguistic tool (i.e. the edit) as the very principle of historical recollection in the antiquarian's gesture of presentation. Film is thus recognized by the metafilmic as a vehicle for writing national history through the principle of montage. In effect, the construction of national history and identity is articulated as part and parcel of the constitution of the film in a space and time that evoke the placeless and timeless site of the imaginal world.

Imaginal Space

Narrative film as we know it is constructed by connecting discontinuous shots. The more effective the transition, the more seamless the narrative appears on screen. The relay of looks between characters is one way that classical fiction film creates seamless transitions and narrative spaces. In *Maybe . . . Some Other Time*, such seamless transitions are effected less by looks than by gestures within the film itself: the waving of an arm, the movement of the windshield wiper on the car window, the removal of a folder from a file drawer, the transportation of a mirror from one side of the street to the other. These gestures are all signals from within the film that the narrative is moving from one frame of time and space to another. These actions within the film narrative motivate transitions between shots and connect times and spaces within them. In some scenes, such as the one in Haq-Negar's apartment, action and movement within the narrative itself produce a situation that calls for the conflation of narrative time and space with the time and space of film production. At such times, the narrative foregrounds the production of the film, conspicuously articulating the narrative development in time with the film's own production process. In doing so the film simultaneously collapses the time of the past (Mother's time) with the time of the film's own narrative present (Kian's time). The repetition of this mediation emphasizes its significance and draws attention to the questions raised by the film regarding national identity.

The film is persistent in its representation of glasses, sunglasses, magnifying glasses, mirrors, and symbols of surveillance. These symbols mark Kian's body as an object of clear and constant observation, as if to say: "She is to be identified!" In the scenes of Kian's narrative recognition of herself and her past, however, the film refuses to give way to a direct identification with the image of Mother in the portrait. As the camera approaches the portrait as if seeing what Kian sees, a second image of Mother is reflected in the mirror next to it. The picture frame, as an actualization of a moment that according to Metz inscribes the film's enunciation by paralleling the frame of the film screen, emphasizes a moment of reflexivity for us. This enunciative gesture accents what exceeds the moment of recognition in the image—where an identification with the past as teleological in relation to a reflected present is incomplete and is marked by a fatal degree of supplementarity. While conflating the moment of production with that of narrative unfolding, the film tears apart the desire to suture the identity of the present to that of the past in image form, emphasizing, from an oblique angle, its failure. Positioned in this way, the film narrative alerts us to the fact that our identification with the narrative screen is not total but, like the picture frame, must be supplemented at an oblique angle from a different site.

If this film is politically important for addressing the question of identity, as Bayza'i claims, then it is because it refuses to pose the question of national identity to a teleologically constructed image of the past. It is as if Persia's seven-thousand-year history must be restrained in answering the question of what Iran is as a nation today. The film narrative articulates this insight clearly, both in Kian's discovery of the past—where there is an excess to her direct identification with the mother's portrait— and in the significant objects Haq-Negar presents to the camera in the interruption of the shot–reverse shot. The past, it seems, must be represented as a history of abandonment. Only a few objects that may signal the nation's capacity to overcome the crisis of identity in the present seem to remain within the domain of public knowledge. Selected historical objects are drawn out for the gaze of the camera, configuring a scenario in which history is written by film technologies to produce signification, rather than to reflect, retain, or reproduce the past in some indexical or chronological fashion in image form. The present must be understood meaningfully, in urgent conjunction with the past—allegorically, that is

"imaginally," as a conflation of the present with the past, not as an extension or continuation of what has gone before. This insight, and not the uniform category of Islam, it would seem, must drive the nation's understanding of its identity.[33]

For the film, the past is configured as a history of a time before Shiite Islam in Iran, of reform in the modern period, of clothing policies, of Iran's relation with the Far East and neighboring Turkey. The film positions moments of irreducible cultural confluence informing Iran's past in urgent and allegorical conjunction with the present, in which the Iranian middle class plays a role. These moments are drawn up and reflected upon at points where the narrative rips open, as if in crisis, to show its seams: when it stutters in reproducing standardized film codes, as it reflects on its own coming into being, when it redoubles its own framing, and as it reveals the technologies producing it.

Forked Tongue

When the film speaks of itself, it speaks too of the nation and the national identity it is to represent. Revealing its enunciation as a product of a cultural confluence, the film "speaks" in a forked tongue, which, while clinging to the narrative theme of hoviyyat or identity expounded by the Ministry of Guidance, uncovers other tongues speaking that national identity. Put differently, Maybe . . . Some Other Time elaborates untold stories on levels that sit astride the forward movement of the narrative. The time and space of film production and of national history in the antiquarian's apartment and antique cellar stand as sites of narrative rupture, spaces through which other things are said and in which other tongues are repressed to represent a seamless narrative about a purified nation. In a very pragmatic way, these other tongues are represented by the objects held up to the scrutiny of the camera as the film stutters. But as my focus on enunciation has intimated, the significance of these forkings goes beyond what the film makes present in its thematics.

Maybe . . . Some Other Time presents the thematics of a class rejected internally by intellectuals and externally by foreign film critics. Representing the middle class, the film addresses itself to those who have been eager to identify the film industry's impulse to produce village spaces on screen as realist representations and frowns on readings that have projected a fictionalized, fetishistic image of Iran in cinema as indexical of the nation itself. Maybe . . . Some Other Time shows itself to be critical of

these postures and addresses its critique through the enunciation of the film and in its engagement with linguistics.

It is clear that the film produces meanings by engaging conventions and codes used and standardized by Hollywood. The history of the Hollywood film industry makes it next to impossible for other film industries to do otherwise. *Maybe . . . Some Other Time* uses standard shot angles, movements, and editing techniques such as wipes and shot–reverse shots, sound bridges, and sound synchronicity to suggest transitions from one time and space to the next. In this way it replicates the traditions and forms of Hollywood melodrama to represent the national search for identity in an Iranian post-Revolutionary film. But the film also undoes the very methods that it embraces. It undercuts the conventional techniques for narrative (and temporal) progression by engaging in traditional national approaches to narrative enactment—approaches associated with the Shi-ite drama of the family of Muhammad, the ta'ziyeh. Evidence of this is forcefully present in the shot sequences that refer to Iran's history and in the instances of temporal and spatial compression throughout the film.

Imaginal Body

Maybe . . . Some Other Time draws on the ta'ziyeh's narrative tools for its en-actment of the past in the present. Its frequently reminds us that Mother, Kian, and Vida are really the actor Susan Taslimi playing all of them. It blocks the identification between actor and character by blocking mirrors, and creates doubles, for example, in the doubling of the image of Mother in the antique cellar, and the doubling in the door frame sequence in which the sisters encounter one another. Not unlike the popular drama of the ta'ziyeh in which the role-carrier steps up to both name the character that he plays and deny his identity with that character, *Maybe . . . Some Other Time* shows its seams to reveal the actress as herself even while she plays all three women.

Maybe . . . Some Other Time suggests that its own spatial and temporal roots are deeply grounded in the annual national performance as well. And in perpetuating the tropes of this dramatic tradition, it rejects a no-tion of progress and closure typical of dominant narrative cinema. In-stead, the film sets up Kian's vision—the vision of a contemporary middle-class woman—as the means by which it can properly locate a temporal confluence attuned to the ta'ziyeh's temporal tropes and the na-tion's conception of the imaginal world. Although veiled, Kian's vision can bring together the present and the nation's past through cinematically

constructed correspondences, mimetically and allegorically. Kian's body articulates and makes the imaginal world present through the senses as past and present converge. Her look not only engages the other characters in the narrative in her phantasmatic rearrangement of space and time, it also draws us in as the film's audience. Yet in her vision *not all* women are veiled: Mother wears a peasant's cap and Kian's prospective adopters European headdresses. In this cinematic recollection of the past, the demands set by the Islamic regime on Iranian cinema in regard to the representation of history are seen to misrepresent the nation's past. Visually, this misrepresentation seems to surface most noticeably in the manner in which veiling is enforced on the people of other times. (Bayza'i himself underscores the oddity of this historical misrepresentation in his Paris paper.)

Maybe . . . Some Other Time's emphasis on bringing its own production to the forefront, its constant self-referentiality, highlights the enunciative complexity that is involved in the production of post-Revolutionary Iranian cinema notwithstanding all demands for its purity. To locate this complexity properly, I turn once again to the moment in the film in which the audience is situated to witness Kian's recognition of herself in the portrait—to a moment that is interrupted.

The Antique Cellar: Take Three

The interruption of this sequence serves a twofold historical purpose in the film: the first visual, the second aural. As we recall, the shot–reverse shot of Kian's self-recognition in the portrait is in the first instance interrupted by shots depicting antique objects. In effect, this sequence holds the history of Iran before Islam up to scrutiny through an antiquarian's act of collection. The visual consequences of this shot pattern have already been raised and discussed. This leaves the second historical recognition, which occurs, as noted, on the level of sound. In this scene, Modabber, whose character role is that of "the dubber of films," speaks over the crucial close-up shot of Kian that returns us to the shot–reverse shot pattern. His voice-over effects not only a transition but also, as it were, a translation, which alerts us of the presence of "the other" within a national film.

While the film complies in general with conventional and dominant techniques of camera work and editing, the sequence of shot transitions (which simultaneously denote transitions in time and space) appears to be ordered in a significantly unfamiliar manner from this point on. If we

understand narrative film as a carefully ordered sequence of shots that makes images speak meaningfully, then these images speak, certainly, but in a different tongue. The ordering of the shots, though unparalleled in Persian or English grammar, speaks to Arabic grammatical structures.

It appears that on the occasions in which past and present are constituted in confluence with one another, the shot sequences become bilingual, leaning on Arabic grammar structures for support. The particularity of this bilingualism will be discussed momentarily, but first it is worth reviewing the grammatical structures of the Arabic and Persian languages.

Film Literacy: Lesson One

According to the rules of grammar in Persian, sentences are constructed in subject-predicate-verb order: for example, *film khub-ast* ("film good-is"). In Arabic, two main grammatical sentence patterns are generally used. In the first, the nominal structure, the copula is absent, so the temporal components of the sentence can only be understood in context: for example, *Muhammadun rasulun* ("Muhammad an apostle," i.e. "Muhammad is an apostle"). In the second Arabic construction, the verbal sentence, the verb precedes the subject and predicate: for example, *Kharajati l-mar'atu* ("Went out the women").

With this in mind, I return to two instances in *Maybe* in which the film draws attention to its own editing by asserting a temporal and spatial confluence typical of the ta'ziyeh. The first of these is the carriage scene, in which we witness the arrival of the wheel of the carriage before the carriage arrives in the black-and-white shot sequence. The shot, which is staged in Haq-Negar's apartment, is of the shadow of a wheel moving across Kian's body. In the next shot we see the empty street where Kian was left as a baby. The shot depicts the arrival of a horse-drawn carriage. If we understand the moving wheel as the active element of the sentence (or shot), and the shot in black and white as representing the arrival of the subject (i.e. the carriage), then the mounting of the two shots can be read as a reverse-order sentence—first the verb, then the subject—along the lines of "Arrives the carriage." The editing of the film, then, essentially places the subject (the carriage) in the past *after* the shot of the wheel arriving in the filmic present. The correct sentence structure signaling the arrival of the carriage in Persian would be "The carriage arrives." But instead of being what one would expect, namely a Persian sentence, the edited sequence speaks puzzlingly in an Arabic verbal sentence construction, where a gendered verb in the present tense is fol-

lowed by the subject. (Verbs are not gendered in Persian; I am reading the arriving wheel as projected onto Kian's body as gendered and more specifically feminine, as in *Ta'silu* from the root verb *Wasala*.) We recall that the proper Arabic sentence reads verb-subject. This sequence could be said to forge a shot-sentence such as *Ta'silu al-arabatu*: "Arrives the carriage."[34] Puzzling. In the context of a past-present confluence drawn from the ta'ziyeh national dramatic tradition, the film seems to be speaking in an Arabic rather than a Persian grammatical structure. A similar pattern evolves in a second sequence of shots portrayed in figure 7.

Screen Memories: Take Two

The shots in figure 7 represent Mother's discovery of the child's absence by the doorstep. In this black-and-white sequence, the mother, who has been dragged behind the carriage to the other end of town, runs past the orphanage holding her head in terror and anguish. Shot 2 shows the empty doorstep (which could be read as *nist*: [there is] "nothing" or "not"), followed by a middle shot of Kian looking down, as if seeing that site empty from the present, and turning in anguish. (Shot 3 can be read as a Persian sentence where a negative copula indicates that absence in the present tense in a sentence such as "*Kian nist*" or "*Kian* not is.")[35] Mother then arrives in shot 4 to see that place barren (shot 5).

The double emphasis on the absence before Mother's arrival in search of Kian indicates a sentence structure beginning with a negative particle followed by the subject (rather, the Mother's object) and the adverb of place. This could read in an unchaste Persian as "*Nist, Kian nist an-ja*," or literally translated: "Not is, Kian not is that place." A more proper grammatical Persian structure, however, would read "*Kian an-ja nist*" or "*Kian* that place not is." According to Persian grammar, finite verbs almost always take their proper place as the last element in a phrase or a sentence. The copulative verb (is, are, was, were), however, which serves only to express a predicative state and not existence, may follow other parts such as adjectives that modify the predicate (e.g., *Iran dar mashreqzamin-ast*: "Iran in east-is"). In this sentence structure, dealing with the nonexistence or nonpresence of the child in the place where the mother left her, we have a finite copula preceded by a negation. According to Persian grammar, this places the negative copula (*nist*) as the final word in the sentence (e.g., *in mashin khub nist*: "This car good not-is").

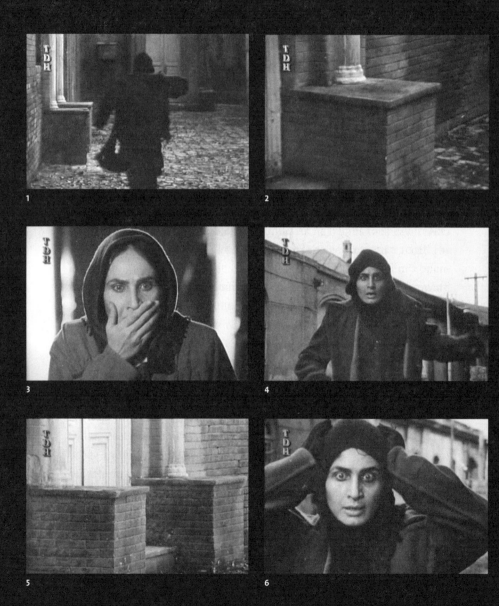

7 Screen memories in *Maybe . . . Some Other Time.*

Complicating matters more is the temporal confluence of the past (figure 7, shot 2) and present (shot 3) in the editing of the film itself. The inter-cutting of past and present in this segment of the film indicates an atem-poral construction that is not cogent in Persian grammar. A more accurately atemporal phrase would be an equational sentence, or what is otherwise known as the nominal sentence. As a linguistic structure, the nominal sentence properly belongs to the domain of Arabic, in which the absence of the copula eliminates temporal boundaries: what is said in a nominal sentence could take place in the past or in the present, unless in-dicated by context.

Now, if we read or translate the complete sequence as if reading an Ara-bic nominal sentence, things begin to make more sense. Arabic rules of grammar prescribe the proper nominal sentence as a constellation of the subject and the predicate. The subject precedes the predicate, and the verb is absent, as in the Arabic phrase "Kian honaka" or "Kian there." All that is absent are temporal markers.

In Arabic, present-tense nominal sentences are made negative by use of the verb "laysa," which means "is not," "are not," or "am not." The verb has different forms depending on the gendered subject. In a negative nominal sentence, the particle precedes the full nominal phrase, making it negative. One important thing to note about this usage is that the nega-tive particle "laysa" always affects the nominal sentence by keeping the subject in the nominative and by transforming the predicate into the accu-sative. In Arabic, the accusative marker is the marker of the past tense. The past, then, leaves a mark on the present through the negative use of the particle in the Arabic nominal sentence.

Similarly, to negate a nominal sentence in the past tense, one uses the negative particle "lam," which precedes the verb "kana": "to be" in the gen-dered and jussive form. As in the case of "laysa," "lam" affects the predi-cate in the nominal sentence, changing it to the accusative. Significantly, though, the jussive form of the verb "kana" mimics the present-tense der-ivation of the same verb. Said differently, the present inscribes itself in the past through the negative particle "lam," configuring the nominal sen-tence in its full temporal ambiguity.

The editing pattern of the shots represented in figure 7 must be said to represent a chaste Arabic nominal sentence structure operating in the space of ambiguous temporality, so that the negative particle "laysa"

precedes the a-copulative sentence, as in "*laysa Kian honaka*" or "*laysa Kian fiha*": "(There is) no Kian there." Or if negated in the past tense: "*lam takun Kian honaka*," which in a literal translation reads: "No is Kian there." Here the verb "is" is cast in the third person, jussive case, a close relative of the present tense. And "there" is not only an adverb of place; it is also marked by a temporal marker of the past (that is, it is given in the accusative case).

These two shot sequences can be read as a confluence of Arabic grammar negotiated through a uniquely national temporal and spatial configuration associated with the ta'ziyeh. This constellation is mediated through dominant cinematic models of recognition, i.e. in the shot–reverse shot pattern—a filmic grammar of sorts that signals to the audience that these objects converse with each other. Significantly, in both instances, the grammatical turn is balanced on the feminine present—the marker that is associated in the film with a reformative female vision (Kian's) in which all are called to participate.

Hence, in relation to the question of film literacy and the codes and conventions that produce the nation in film, it is clear that Bayza'i's *Maybe . . . Some Other Time*, if at all representative of what the government deems properly national, speaks of a confrontation of tongues and identities. The film "speaks," insofar as it produces messages and meanings by leaning on dominant conventions. It speaks conventional sense, one could say, but in a dialect. Dominant conventions such as the shot–reverse shot are interrupted to capture the temporal and spatial markers of the indigenous ta'ziyeh performance. Time, in this film, does not mark continuity and progression, but halts to review moments of the past in articulation with the present. Whereas on the level of narrative statements the film aims to represent the Iranian present to itself as the pure product of Shiite Islam, the film's mode of address, its enunciation, borrows from the language and grammar of others. It speaks at times in a dialect modifying classical conventions and at others in a duality of tongues that confuses the conventional temporal and spatial configuration of film. *Maybe . . . Some Other Time* speaks in Arabic grammatical structures, in Persian temporal tropes, and in dominant classical Hollywood conventions of melodrama. Against the contradicting statement of Islamic purity, and by engaging the formal, allegorical structures of the religious mourning play, the film reiterates the markers of a "foreign" enunciation in the production of a post-Revolutionary Iranian film narrative.

In light of this interplay of tongues within the film's address (a film whose script, we should recall, was recommended for production by the Ministry of Guidance itself), it may be possible to conclude that if film in the post-Revolutionary period is to be considered national in its representation of a pure national identity, culture, and language, it can be so only by virtue of the repression of an identity that is clearly delimited in the film's address and enunciation. This repressed identity is delimited in film not only by the presence of the veiled figures of Iranian women who, after all, mediate a reformed visuality as they look upon the past, but equally by "the foreign" (Hollywood) and "the others" (the Arab neighbors) from whom the Islamic Republic of Iran claims its difference in its national statements in and on film.

Back to the Reel

A similar confrontation of tongues and identities is borne out on the level of form in Bayza'i's *Mosaferan*, which was screened at international film festivals for the first time in 1992, bearing the English title *The Travelers*. The formal constitution of time in the spirit of the ta'ziyeh performance tradition animates this film as well. The correspondence the film is able to create between the past and the present functions as an allegorical tool allowing a recorded image to recede as the dead awaken to participate in the imaginal space of a festive wedding by the film's end. *The Travelers* arises, as if from a dream, from the heart of the national ta'ziyeh tradition in its redemptive will and its belief in a time that frames all time within the quotidian present. In drawing on the ta'ziyeh's temporal and spatial index as well as its vision of a redemptive future, the film reckons with Iranian cinema's cultural heritage. Recognizing the nation's belief in the ta'ziyeh's imaginal confluence of past, present, and future, *The Travelers* presents a response to questions regarding the nature of framing and visuality in post-Revolutionary Iranian cinema. If the Islamic Republic's rule of modesty is shown to transform conventional temporal and spatial relations in film, as I have argued, then these transformations are bound to have implications for the cinema's constitution of reality by virtue of its framing. In other words, the camera's framing must adapt and locate a different relation to questions of realism and fantasy and to notions of real and fictional space and time in film.

Although international critics and film festival organizers have tended to place Iranian cinema in continuity with modernist traditions (Italian

neorealism for example), there seems ample evidence in the religious, political, and historical context that animates the production of post-Revolutionary Iranian cinema to reject a purely aesthetic appreciation of this cinema's temporal and spatial tropes as a mimetic recurrence of European modernism. The deep ties to the ta'ziyeh tradition in almost all of Bayza'i's films problematize facile categorizations that would place post-Revolutionary Iranian cinema in continuity with European modernist traditions in cinema. Bayza'i's films repeatedly demonstrate how the forceful figural presence of the veiled female body unsettles the conventional causal relations that inform dominant conventions of cinematic realism. Replacing the voyeurism that gives shape to such conventions, the ambiguous deictics of the ta'ziyeh rearrange the construction of time and space, producing the nation as the site of the imaginal. This is as true for *The Travelers* as it is for *Maybe . . . Some Other Time*.

If the reliability of a representation, the realism of the cinematic image, comes to rest on the ability to make visuality take the place of witnessing, in effect making the language of the film refer to the here and now of the act of seeing, then the effect of a shifting deictic marker is to upset the foundation of realism that we have become accustomed to in film. In constituting narrative continuity and closure, the deictic markers of post-Revolutionary Iranian films rely, sometimes exclusively, on a known tradition of temporal and spatial convergence that takes its cues from the ta'ziyeh's distinct and distinguishing mourning rituals. The collusion of times and spaces without prejudice in this tradition makes every moment in time an imaginal time in which a wished-for future arrives to redeem the wrongs of a lived past on the historical Day of Judgment, a day which for Shiites is also the Day of Resurrection. The future, as an unconscious hope, as the utopian redemption of a lost time, breaks through the present, forging a now-time in which the possibilities of an infinite all-time appear in a momentary flash. The dead, who are ever-present in this infinite time of Na-koja-Abad, are active participants in this moment of magical transformation of the present.

This understanding of temporality as connecting the dead and the living and creating correspondences between past and present grounds itself in the embodied sacred visuality that informs Iranian cinema after the Revolution. In its embodiment, vision is not only tactile and unalienated, it is also affected by unconscious forces that open up spaces within the continuity of narratives: spaces that speak the unspoken, that give voice to the repressed, and that reveal the irrational collusion of hopes, dreams, and visions as they link to the actual and the everyday in utopian fashion.

The recognition of such an embodied corporeal visuality necessitates a different relation to reality, to memory, and to the repressed in this cinema. This relation, which is metaphysical in nature, necessarily shifts Iranian cinema's approach to questions of framing and realism, and does so by necessity. Bahram Bayza'i's The Travelers reckons with the question of realism and the framing of the real in post-Revolutionary Iranian cinema, embedding this question in and nourishing it from the heart of the ta'ziyeh tradition. The summary of the story of The Travelers and my subsequent analysis of technique in the film bear this out further.

The Travelers

The Travelers is the story of a family that does not arrive. Mahtab Ma'arefi Davaran, her husband Hishmat Davaran, and their two children are to bring the family's traditional wedding mirror from their residence by the Caspian Sea to the wedding of Mahtab's sister, Mahrokh, in Tehran. They die in an accident en route.

Meanwhile, in the bride's house, preparations take place for the wedding. The walls are painted white; the chandeliers are polished; tablecloths and embroidery decorate the furniture. Workers, servants, Mahtab's and Mahrokh's grandmother, their brother, the groom, and in-laws are all caught up in the spirit of the upcoming celebration.

As the wedding day draws near, news is received that the travelers have died in an automobile accident. Members of the family travel north to inspect the wreckage and to support the police in their investigations. Reports are called in. Film and photographs are taken to document the wreckage. A newspaper prints a report of the accident. Despite police efforts to systematically display evidence of the accident, Mother, who is also Mahtab's and Mahrokh's grandmother, refuses to accept the deaths. Her granddaughter, Mahtab, is carrying with her the family mirror that is vital to the marriage ceremony and the family tradition, she insists. She stubbornly holds to her truth that if the police did not find the wedding mirror in the wreckage, the family will come to the celebration and will bring the mirror with it.

From this point on, the whereabouts of the mirror in the accident's wreckage becomes the central focus of the film. Members of the family produce photographs, newspaper articles, eyewitness reports, and call on the presiding officer in their efforts to convince Mother of the death of Mahtab, her husband, and their children. Mother observes, however, that

the mirror is absent in all these reports. It has not been found, reported, photographed, or even been seen broken. This stubborn insistence on the fact that the mirror reflects—the truth that in its absence, the family must be on its way—underscores the functional role of the mirror in *The Travelers*. The mirror comes to stand for that site in which all unconscious hopes are fulfilled, for that imaginal time that redeems all time, and for a space that merges the realities of the present with utopian possibilities of the infinite.

Disregarding Mother's persistent belief in the travelers' eventual arrival, other family members dramatically transform the bride's home. The colors change from white to black, mirrors are shattered, clocks stopped, dead trees uprooted, and pictures turned to face the wall. The postman reclaims the wedding invitations one by one, and photographs of the travelers, including the driver and a rural female hitchhiker who joins the travelers on their drive to Tehran, are placed among lit candles in the yard in memoriam. Some wedding guests, unaware of the tragedy, arrive with flowers to find a mourning ceremony at the house instead. The policeman in charge at the site of the accident attends the ceremony as a witness to the death of the travelers and to speak to the guests assembled at the wake.

As the wake proceeds, and at Mother's insistence, Mahrokh, the bride, changes into her wedding gown, and the seated mourners, drying their tears, frustrated and confused, rise from their chairs to applaud the bride and groom. As the ululations and celebrations bubble up, the deceased travelers suddenly and unexpectedly come through the open doors, bringing with them the family's wedding mirror in a magnificent and enchanting scene of celebration. The wedding takes place in the midst of the funeral wake.

Ta'ziyeh Qasim: The Imaginal World

In its alternations between celebratory joy and pathetic mourning, *The Travelers* mirrors one of the most popular ta'ziyehs in the annual passion play cycle, the *Ta'ziyeh of Qasim: The Bridegroom*. This ta'ziyeh enacts a simultaneous wedding and funeral. In the performance, Imam Husayn, the grandson of the Prophet Muhammad, orders his nephew, Qasim, to marry Fatima (the Imam's daughter) instead of going to battle against the caliph's troops to avenge the deaths in the Prophet's family. Obedient to the will of Imam Husayn, Qasim, like Mahrokh in *The Travelers*, accedes to the wedding. The wedding of Qasim and Fatima occurs while people

gather to mourn the deaths in the family. Before consummating the marriage, Qasim persuades Imam Husayn to allow him to enter the battlefield. The Imam agrees, and Qasim dies in combat. The Imam then returns to the stage to announce Qasim's death and to commence the mourning ceremony. The *Ta'ziyeh of Qasim: The Bridegroom* thus pendulates between two emotional poles as participating audience members traditionally beat their breasts in mourning, raise their voices in joyous ululation, and pass around Qasim's and Fatima's wedding sweets. The final scene of *The Travelers* mirrors this scene of mourning and joyous celebration in the *Ta'ziyeh of Qasim: The Bridegroom* with tears and ululations.

Having seen his first ta'ziyeh performance at the age of twenty, Bayza'i muses that he had no choice but to write ta'ziyeh—a contemporary ta'ziyeh for film. With this as given, Bayza'i argues that it is important to ask how one writes, assuming that if ta'ziyeh continued on its historical course, it would become what one has written, meaning, Bayza'i reflects, "that it would speak to contemporary concerns."[36] Although, as I show here, there are obvious and fundamental differences between the plot and characters of the ta'ziyeh and those of the film, *The Travelers* arises from the imaginal world created by the performance of the *Ta'ziyeh of Qasim: The Bridegroom*, inscribing the deepest perceptions and hopes of a nation that lives with its dead. The film adopts the belief in the imaginal as its frame, enframing moments of lived time as they merge with flashes of an infinite time. This spatiotemporal framing materializes as Iranian cinema's antagonistic response to the melodramatic codes of realism in dominant cinema.

The Overture

The overture to *The Travelers*, like the opening scenes of *Bashu* and *Maybe . . . Some Other Time*, establishes the questions that are important to our understanding of the film. What emerges here is the question of visuality and the status of the real (and of evidence) in Iranian cinema. Thirteen shots in total, the overture follows a rhythmic pattern of cuts. It alternates between script and images that lay the groundwork for the issues that become relevant to the film and its unfolding narrative.

The film's title appears in the first shot on a black screen, followed by a second shot carrying the director's signature (see figure 8, frame 1). Shot 3 opens to the sounds and sights of the sea, locating the narrative's beginnings on the shores of the Caspian Sea (frame 2). Shots 4 and 5 list the names of the film's cast textually, again reminding us of the status of the

film as a product. These two textual stills are accompanied by a sound bridge. The murmur of the sea from shot 3 bridges the overture to the movement in the filmic image itself. Thus shot 6, in which the camera rests on a mirror on the ground. In shot 9, the Davarans' driver picks up the mirror from the ground and turns it toward the camera (frames 3 and 4). Instead of reflecting the camera that stands before it, the mirror reflects the trees. Another abrupt cut to text in shot 10 is followed by shot 11, which centers on the mirror as it is turned from side to side, reflecting the sea (frame 5). The cut to shot 12 textually credits Bayza'i as the film's auteur (frame 6). This pointedly occurs before the mirror's frame and the film frame line up. The cut in effect defers this alignment between mirror and film frame in shot 11, establishing instead the film's authorship. The mirror continues its motion, and in shot 13, as the film melds the camera's look with the mirror's gaze, it brings the two frames together to configure a single point of view (frame 7).

This alignment of the edges of the film frame with the mirror frame reconfigures the status and meanings of the mirror for the film. The mirror is no longer a mere reflecting device. In its merger with the film frame, it too becomes a framing device. Like the camera, it looks, and in looking it constructs and produces the film's visual narrative. The mirror joins the film's technologies in determining the scope and the limits of *The Traveler's* address. The mirror's correspondence with the gaze of the camera sets the film plot in motion. The cut to shot 14 reintroduces diegetic sound synchronized to the moving image of the Davaran children playing on the grass and running toward the car that is to drive them with their parents to the wedding in Tehran (frame 8).

Keeping in mind that overtures are generally the moments in which films reflect on the process of their own coming into being, we note that this overture sets up a problematic relation between the status of visuality and the production of narrative truths. We see the sea, but what mediates it? The mirror reflects, but does it reflect back? It faces the camera, but shows instead the surrounding trees and the sea in its frame. It tilts and moves like the camera, directed by a hand, and ultimately becomes the very frame of the evidentiary lens that produces both the truths within the film and the fictions the film is to narrate to us. In this overture, then, the status of truth and of the real, the processes by which "the real" is framed, and the roles of evidentiary and visual identification are problematized and posed as questions for reckoning within the sequences that follow: How may "the real" be framed by the post-Revolutionary

THE TRAVELLERS

1

2

3

4

5

ایرج رامین فر / پوشاک و پس آرائی
مهرداد فخیمی / تصویر
بابک بیات / موسیقی
بهرام بیضائی / نوشته، کارگردانی، تدوین

Writer, director, edit:
Bahram Bayzaie

6

How long does it take to get to Tehran.

8

8 The overture in Bahram Bayza'i's *The Travelers*.

Iranian camera? What configures "the real" for this cinema? How may it be defined and produced? These are questions that the overture frames reflexively for the film as the narrative is set in motion.

The Travelers: Scene One

The most unsettling shot of the film arrives early. As Mahtab Davaran opens the car door to get in, she suddenly turns to the camera and addresses the audience directly: "We are going to Tehran to attend my younger sister's wedding. We will not arrive. We will all die," she asserts (figure 9, frame 1). This shot introduces another sequence of rhythmic cuts in which the various members of Mahtab's family and the driver look at the camera to introduce themselves by name and age, identifying their professions. The sequence is intercut with shots of the twisting road, framed by the side and front windows of the car and by its mirrors. The shots alternate to capture the receding road from the back of the car. The final identifying shot in the car is of Zarrinkolah Sobbhani, who hitches a ride to Tehran along the way (frame 2).

Although the film anticipates the accident by the rhythmic intercutting of shots, the pulsating musical track, and the intensifying tension produced by the characters' direct address to the camera, it does not actually show the accident taking place. The nondiegetic voice of the reporting officer projects over the image of a fire on the road in the following shot. The officer introduces himself as Lieutenant Fallahi, reporting twenty-five kilometers from Karaj. His identification on the police radio follows the formula set up by the sequence of self-identifications that preceded his (frames 3 and 4). His report to headquarters describes the site of the accident and the reasons for it in detail. His voice is cut to the identifying shots of the wreckage: a bloody window screen, the slippery road (frames 5 and 6), shots of workers covering the street with sand, and shots of the drivers of the tanker, who are isolated by the lens as the men responsible for the wreckage. The camera work itself takes on a documentary quality immediately after Mahtab's direct address to the camera and continues in this vein as the family settles in for the long, winding drive to Tehran. The film's relentless emphasis on the documentary character of the filming is especially conspicuous at the site of the wreckage, as the two tank drivers look directly to the lens to protest the camera's intrusion on their privacy and to convey their regret for what has taken place.

The film folds back on itself in the scene of the wreckage to reveal the nature of its address as documentary and evidentiary, as still and film cameras

1

I'm Zarinkola Sobbhani. Age 33, job: farmer.

2

This is Lieutenat Fallahi reporting, 25 km from Karaj.

3

...to move. The police has taken charge of the site of accident.

4

5

I'll repeat the licence plate of the car and the tanker,...

6

The heaviness of the tanker's prevented it from falling...

7

8

9 The travelers don't arrive in *The Travelers*.

appear in the film frame (figure 9, frames 7 and 8). These cameras peer into the bloodied car windows and move behind Lieutenant Fallahi as he delivers his report. Their presence reminds the viewer self-reflexively of the technologies and processes that have enabled the production of the images on the screen. The film reminds us, through the presence of these technologies, that it is itself a produced fiction. It is as if the film is saying to its audience, "That camera you see before you produces what you see on screen. Don't ever believe otherwise." The technologies' documentary presence within the frame of what the film emphasizes is a produced fiction simultaneously reminds us of the evidentiary role of the camera and its realist framing in the preceding sequence of the film and in the history of visual technologies generally. This self-reflexivity reemphasizes the radical ambivalence that structures the film's framing, the ambivalent polarity set up in the overture that remains unresolved until the end.

Credits: Take Two

When the camera and the mirror combine in the overture, the mirror becomes an equal partner in the narration of the film's story. In the film, the camera-mirror both frames the fiction and becomes the central yet absent figure around which the film comes to revolve. The absence of the mirror is dramatized in the narrative itself when the search for the mirror emerges as the main focus of activity for the family members who become increasingly concerned with the problem of convincing Mother of the irrationality of her beliefs regarding the arrival of the travelers after the accident. From the very beginning, then, the film reflects on itself, on what frames it, on the process of its own coming into being, and on the erasure and absence of its own mediating technology (by which I also mean the absent mirror). This gesture not only problematizes the fundamental role of production and the erasure of the process of enunciation as the structuring process of the narrative and characterization in the film image; the initial presence and subsequent absence of the mirror as film frame also moves to question the status of fact as it is linked to evidence in film.

In the scenes that bear witness to the accident, these questions of constitutive address and framing are further elaborated to probe the link between the image of actuality and the imaginal. They are widened to embrace the specificity of the nation's collective relation to the real, especially when the trope of the newspaper arrives to function as the textual counterpart of the documentary lens used by the film and actualized

within its narrative in the scene of the wreckage. The film halts to ask itself, reflexively: "How may post-Revolutionary Iranian cinema define and frame the nation's real?"

It is important to note that although Bayza'i continues to reflect on questions that relate to the status of Iranian cinema, its enunciation and address, and its language, framing, and mode and technology of production in these scenes, this film, The Travelers, is no less in pursuit of an articulation of female visuality and the relation of the veiled female body to the process of national film production. Here the figure of Mother enters to carve what will emerge as the film's address and, in particular, Iran's uniquely national configuration of cinematic enunciation. As the narrative unfolds, Mother emerges as the film's central character—a character capable of articulating the embodied vision of post-Revolutionary Iranian cinema.

Imaginal Space: Take Two

Mother's constitution as a central character-in-waiting occurs in a sequence of articulated shots not unlike those in the overture—shots that configure the mirror as the film's framing device and mark the mirror's frame as the film's own. Following the police officer's report at the scene of the wreckage, the film opens to a sequence that introduces the film's other major characters in Mother's home in Tehran. Here workers, servants, brothers, and in-laws joyously prepare the house for the wedding and await the impending arrival of the family members from the north.

In Mother's home, the characters are in constant motion. They cross each other's paths in the upstairs-downstairs configuration of the home. The camera follows bodies around pillars, behind sofas, and across floors to create a sense of the space in which the wedding will take place. The film edits and bridges shots by linking its transitions from shot to shot, from space to space, to the movement of the bodies and to sounds. Significantly, the house appears, by way of this movement, as the circular space of the takiyeh, the building that is traditionally selected as the setting for ta'ziyeh performance. In Mother's home we become more and more aware of a different temporal and spatial constitution of reality than that which shaped the documentation of the family's road trip south and the subsequent report on the wreckage at the site of the accident. The camera's evidentiary logic and realist lens is upset by its new motion and new constitution of space that are no longer unidirectional or causal. The camera takes its cues from its setting in Mother's home.

The first shot of Mother herself occurs relatively late in this sequence set at her home. Preparations are under way. Mahrokh, the bride, walks toward a cabinet to open it. Mother's hands appear in a close-up within the frame to lift out the wedding linens that lay folded on the shelving inside the cabinet. Mother's hands transfer the white linens, ironed and ready to cover furniture and tables, to Mahrokh's hands. Mother thus makes her first appearance (figure 10, frame 1).

Mahrokh's sister-in-law, Mastan, enters the scene to adjust the clock hanging on the wall close to the cabinet. Moving across the frame, she announces, "We are about to enter a very historic day!" When Mahrokh responds that yes, she keeps saying that, her sister-in-law recalls that that is how things were on her wedding day as well; that is, people kept reminding her of the importance of that day. Turning to Mother, who has entered the shot once again with her back to the camera, Mastan asks if things were not that way at Mother's wedding, too. We do not hear Mother's response. Rather, she does not respond (frame 2). We only see her back turned to the camera.

Mother enters next facing the camera, a medium-long shot. Mahrokh complains that she will just about die if she has to wait any longer for the travelers to arrive (frame 3). Holding linens in both hands, Mother cautions, "Don't speak of death," as if her first words had to be deferred to this moment, to this shot that prepares and presages her role in the film fiction and configures her vision as the ground for the film's own address.

In sum: so far three shots have introduced Mother to us, and a fourth will complete her. Yet, as if to anticipate the importance of this character through a further delay, five shots interrupt the completion of her characterization. When the camera does return to her, after the five-shot interruption, Mother places her signature spectacles on her nose and asks about the room that is being prepared for the travelers (frame 6); she insists in the same breath that there must be some good omen in their delay.

Four shots—one of her hands, one of her back, one establishing her role within the narrative, and one, at last, framing her signature presence with the round spectacles and bearing her absolute conviction of the travelers' arrival—complete Mother as the central character of a film preoccupied with the question of the real and its representation in image form.

1

2

3

4

5

6

10 Constituting Mother's body, shot by shot, in *The Travelers*.

That this introduction takes four shots affirms the weight of Mother's status for the narrative. It also reminds us, by way of the long interruption, that she is a consciously constructed figure, produced shot by measured shot.

The five shots that interrupt Mother's constitution as the central figure, breaking into and rupturing the film's continuity, link her body to a national and cultural history that gives her shape. These shots also connect her embodied presence to a political context that places her figure at the threshold of post-Revolutionary Iranian cinema's address.

Another Stutter

While all film characters go through a shot-by-shot construction process, Mother's constitution on the visual track is both consciously produced and interrupted. Like a stop sign on a long stretch of road, the interruption demands our attention. The five interrupting shots are a series of gestures, recollections, and conversations that refer not only to the family's past and the tensions of the present, but also to those things that the film almost by necessity absents.

In the interrupting sequence, Mahrokh comments on the lateness of the travelers. By joyfully mimicking the gestures of a doll on a string as she voices her concerns, she embodies a historical reference to traditions of live performance around the globe that predate cinema (figure 10, frame 4). By incorporating the bride's doll-like gestures and voice in a key sequence in which Mother emerges as the core figure, the film signals the displacement of such performance traditions by the cinematic image and within this displacement, their corresponding and unconscious influence on the production of characters and narrative realities in the cinematic medium.

While this interrupting sequence refers to the international history of film in general, it also highlights the particular historicopolitical context of film production in post-Revolutionary Iran. As Bayza'i points out in an interview about this and other sequences of play within the film, government mandates of modesty made it impossible to include any sequence of dance and music in the film to mark the joyousness of the wedding and the auspicious occasion of the guests' arrival. New modes of being and new gestures had to be invented to replace and communicate this sense of joy and celebration: "We were forced to make sure not to place the young bride and groom close to each other or alone even for a moment."[37] That is why the groom is constantly working on preparations for the wedding outside the house. The bride's own sense of anticipation of the historic

moment in her personal life is even transferred (or rather projected) onto her expression of anticipation for the travelers' arrival. Mahrokh's doll-play, her artful performance with stick dolls, the coyness of her gestures as she fans herself with the wedding invitations, and her childlike hop-scotch in long shots taken from above as she moves from room to room in her grandmother's house all elevate the mood of the film and suggest the joy in her anticipation, "of course," as Bayza'i craftily points out, "as you obviously see, all within the limits of the regulations."[38]

The point is hard to miss. The film reiterates the significance of Mahrokh's doll-like gestures by embedding a critique of the current conditions that limit the expression of joy and intimacy in Iranian cinema. The critique is skillfully framed in an observation the servant of the household, Mooness, makes in the course of the interrupted sequence. Remarking that it is unlike Mahrokh to get upset, Mooness, who has been the children's nanny all her life, reminds Mahrokh that back in her day there was music for several days before any wedding. Weaving her hands and arms as if in a dance, doll-like, Mahrokh lovingly reminds Mooness that she cannot help not being born in her elder's time (figure 10, frame 5). The remark certainly expresses the joyful logic of the bride, who alternates between a state of anxiety and blissful expectation. But Mooness's reference to a time before the birth of the Islamic Republic and the bride's whimsical and playful response also point out what is sorely missing in a film about a happy conjugal union because of political censorship and Islamic rules. This stuttering interruption that displaces Mother's constitution for the film thus simultaneously articulates the film as a displaced allegory of the conditions of film practice in the Islamic Republic.

Interrupting the key sequence that is to create the central female character of the film, these shots unseam the film to self-reflexively reveal the cultural influences and political forces that animate the film's enunciative landscape and that thus set the limits of its representation. The historical conditions of the film's enunciation reveal an international lineage in the performing arts and a kinship with the art of puppetry, where characters hang doll-like on a director's guiding string. Elaborating on the duality of the film's inheritance, these interruptions make note of the film's national constitution under the Islamic Republic as well, exposing the political context that requires its cinema's purity from voyeuristic pleasures, from heterosexual intimacy, from music and dancing, even in a film about a joyful wedding. The forces involved in the constitution of identity in the film are identified as dual, at once national and global.

Mother stands on this ground as the figure around whom narrative closure comes to revolve, whose vision the film adopts as its grounding address. Her vision will emerge as that act of witnessing that can fix the deictic markers informing the spatial and temporal constitution of reality for the film. The centrality of her role becomes painstakingly clear when the news of the accident reaches her home. The news is delivered as a documented fact, which her own vision of reality will reject with the force of a conviction that ultimately makes her visuality the embodied logic of the film's own address.

Evidence: Scene of the Police Report

Having seen the wreckage, members of the family decide that they need to convince Mother of the death of the travelers. The family invites the police officer in charge to Mother's house to bear witness to the accident and to deliver the evidence that supports his thorough investigation. The scene of the police report is shot from the perspective of Mahrokh, who stands with her sisters-in-law at the door of the house, looking onto the yard. This important scene sets up the antagonistic relation between the documentary realism of the narrative and the imaginal address associated with Mother's vision.

In "the scene of the police report," the film captures the visiting police officer reading a newspaper in a long shot (see figure 11, frame 2). The camera follows Mother from a distance as she walks toward the policeman and then frames him talking to her. The first close-up in the scene is of the news report as the officer hands Mother the newspaper (frame 3). Sound enters here, indicating through its correspondence with the visual track that we are now within the scope of Mother's hearing and vision—her vision, this time, not Mahrokh's. This is the first shot in the scene that attaches itself to Mother's perspective. The old woman questions the police officer about the whereabouts of the mirror (frame 4). The officer, who had been in charge at the scene of the accident, is somewhat confused and tells her that there was no evidence of a mirror in the wreckage. Looking at the paper again, Mother concurs: yes, she does not see it in the newspaper photograph either. It is at this point in the conversation that her grandson interrupts to suggest that Mother give up her stubbornness (frame 5). After all, he saw the wreckage with his own eyes. The camera pans to a close-up of the policeman, again from Mother's perspective, linking the grandson's eyewitness report on the sound track to the policeman bearing forensic evidence on the visual track. The juxtaposition of

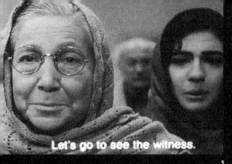
Let's go to see the witness.

1

Did you find a mirror there?

4

صادف جاده شش

3

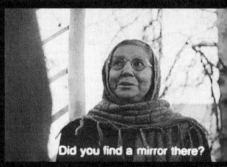
The juxtaposition of the particulars verifies the...

6

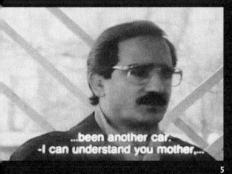
...been another car.
-I can understand you mother,...

5

They started yesterday and they haven't got here yet.

7

I told you that report in the newspaper isn't true.

8

11. "Did you find a mirror?": The investigator reports in *The Traveler*

the data verifies the facts of the case, the policeman tells Mother: "There is no doubt," he remarks (frame 6).

Continuing Mother's perspective uncut, the camera pans again to focus on a close-up of Mr. Davaran's brother, Hikmat, who interrupts the police officer. Turning to Mother, Hikmat confirms his emotional attachment to the family and attempts, in this way, to reason with her (frame 7). "They were to arrive yesterday," he says. "They didn't. So where are they?" His emotional plea is interrupted on the visual track by cuts that place the various members of the family, the women, the bride and the groom, looking on and listening to the conversation. All of them are set up by the camera in continuity with each other and in juxtaposition, in a manner that poses Mother's visuality in antagonism (frame 8). Which of these positions—the one aligned with the documentary realism of the police report, or the one associated with the utopian will for the emergence of a different reality—will come to shape the temporal and spatial landscape of the film's enunciation? Which reality will ultimately ground the film's address? Only in the film's conclusion, when the camera's framing separates from the mirror's frame, does The Travelers move toward elaborating its own answer to this question on the level of the narrative and through the spatiotemporal tropes that the film draws on to configure its address.

Re-reel: A Ta'ziyeh for Our Time

In the concluding scene, which represents the reunion of the dead with the Ma'arefi family, the mirror, absent and sought after for ninety minutes, returns with the travelers to frame a number of shots in the final montage. But in contrast to the opening sequence, the camera gaze and the mirror gaze separate here, and move to represent the wedding-wake.

In the scene that concludes the wedding, the wake, and, in effect, the film itself, the assembled guests rise to celebrate the bride and groom in the midst of the wake, as Mahrokh—who is finally persuaded that the travelers will arrive with the wedding mirror—steps down from her room in her wedding attire (see figure 12, frame 2). The guests are alternately shocked, puzzled, and delighted (frame 3). The film shows their collective assent to the reality of the wedding as they celebrate the bride, albeit with a measure of confusion. Their ultimate submission unexpectedly prompts the arrival of the dead travelers (frame 4), who bring the wedding mirror with them and joyously greet the guests. In this final scene, the guests' belief in Mother's vision is set up as the force that resurrects

12 "The wedding in mourning and joy": The final scene of *The Travelers*.

the dead, a force that allows the imaginal world to participate in and affect the lives of the living. Together, the living and the dead create the imaginal body of the nation.

The separation of the camera gaze from the mirror gaze, as the travelers carry the mirror through the crowd, signifies the end of the film fiction, the end of a mirage. This separation, which corresponds to the early merger of camera and mirror, signals the conclusion of the film as the space in which questions regarding the nature of the filmic reality, and hence the constitutive address and enunciation of the film, untangle and resolve themselves. The mirror-as-camera that has framed its own being and absence within the film frame returns and separates from the camera. It does so in response to the collective will of the guests attending the wake. Its return as a framing device, now detached from the camera's framing, unsettles cinematic conventions of realism, which depend on standardized representations of temporality and spatiality dictated by dominant strategies in American melodrama. The mirror's reappearance on screen, as that which has framed the film, conjures other temporal and spatial tropes, so that the dead, those who had inhabited the past, join the living in celebration. The temporal tropes of the ta'ziyeh, tropes that create correspondences between the past and the present, merge the infinite time of the dead with the finite life of the living on that circular stage set up as Mother's home. The mirror, freed from the conventional evidentiary frame of the camera, reveals itself to support a reality more real than any evidence, at least for the imaginal body of a nation whose force of conviction is capable of resurrecting the fullness of the past in the now-time of the present.

In its play between camera and mirror, and more specifically, in its use of the mirror to represent the nation's imaginal vision of time, The Travelers shifts the terms that dictate the theory and practice of realism for post-Revolutionary Iranian cinema. While the documentary camera captures the scene of the wreckage, that is, the reality of the Davarans' death, this evidentiary reality is shown to be flawed and incapable of locating the family mirror in its footage. Our camera, the film's own framing device, fails in this regard as well. The juxtaposition of facts and of visual evidence in image form, based in arguments that follow the chronological passage of time (that "the travelers would have arrived by now had they left yesterday morning" [figure 11, frame 7]), is unable to dislodge the countervailing measure of reality that is Mother's own. It is ultimately Mother who convinces her family and the guests of that other vision's inadequacies. The mirror's frame alone can capture reality for the film.

Mother's role in *The Travelers* reaches beyond her narrative function as the nagging questioner who motivates the plot. She is the only character whose body emerges on the visual track bit by bit. Four shots produce her, and even these are interrupted for emphasis. Mother's body, though emphatically called upon to motivate a narrative in search of its frame, is the only body within the film that is consciously linked to the mechanized body of the film itself. Whereas the bride's body emphasizes its own malleability, like a doll hanging on the directorial string when she plays about the house, Mother's body merges with the reel and emerges as real—real for the film—as a product of deliberately articulated individual shots: a close-up of her hands, a medium-long shot of her back, then her front and voice, and finally a medium shot in which she dons her signature spectacles. Her body is integrated into the process of film production itself, actualizing one shot at a time, as the source of the film's address, and as one piece with the mechanical geography of the film's enunciation. In fact, Mother's body is the very ground of the film's enunciation. Her home dictates the space of action. Her vision and voice direct the film's conception of the temporal and its spatial deictics.

Moreover, Mother's body is consciously produced against the backdrop of cinema's international history. Her final emergence as a body on the film screen is equally informed by the political context of the national present. The interrupting five shots make this dual history relevant to the production of Mother's character. Her body embodies the foundational beliefs of the nation, its heritage, its political, religious, and revolutionary history. This national heritage coexists, indeed merges, with cinema's international history within the film's enunciative landscape, just as the mirror frame merges with the film frame as *The Travelers* opens to the body of the film itself.

The film's narrative and its characters are choreographed by Mother's forceful utopian vision. They are motivated by this enunciative force. Thus while seeking the mirror, the film's framing device, the film's characters also seek the deictic markers informing the film's address. But it is only when *The Travelers* and its subjects succumb to that utopian vision that the dead will arrive—that the dead are connected to the living, that the past lives within the present and can be resurrected within it—that the unbroken mirror returns with the family presumed to be dead. Mother's forceful presence emerges—in this assent to the imaginal—as the enunciative source of the film itself.

The self-reflexivity in the conclusion of *The Travelers* lays bare the film's address and extends the scope of cinema's vision regarding the nature of realism in Iranian fiction film. The conclusion, in effect, articulates the elements that configure post-Revolutionary Iranian cinema's framing, the source of its enunciation, its deictic markers, and the consequences of the embodied visuality the industry's films must necessarily embrace. The veiled figure constitutes the film's enunciative topography, overturning by its presence the temporal and spatial markers that lend direction and continuity to dominant cinema. The deictic markers gain in ambiguity as the past and the present, the living and the dead, the tangible and the imaginal worlds merge—an effect of this enunciative shift in Iranian cinema.

While Bahram Bayza'i's post-Revolutionary oeuvre grounds Iranian cinema's enunciation in the female body and the cinema's narrative tropes in an ambiguous deixis corresponding to the ta'ziyeh, Abbas Kiarostami's work shows the gendered configuration of the cinema's newly purified technology as one that must come to adopt the gestural modesty of the veiled female body and of her averted gaze.

Born in 1940, Iranian director Abbas Kiarostami received a Bachelor of Fine Arts at Tehran University. He served for some years as an officer in the Department of Traffic Management in Tehran and worked as a designer in an advertising firm. He later worked at a leading film agency, where he made over 150 television commercials, before starting his work for the screen at the Institute for the Intellectual Development of Children and Young Adults (Kanun-e Parvaresh) in 1969. This state organization, popularly referred to as "the Kanun," was established in the 1960s by Queen Farah Diba, the wife of Muhammad Reza Shah Pahlavi.

The director of the Kanun, Firuz Shirvanlu, invited Kiarostami to collaborate in setting up its film unit. Having accomplished this, Kiarostami went on to make his first film with the Institute in 1970, a humorous short in black and white entitled Bread and Alley (Nan-o Kucheh). The Institute has since produced most of Kiarostami's short and feature-length films, including The Traveler (Mosafer, 1974), Two Solutions for One Problem (Do Rah-e Hal Baray-e Yek Masaleh, 1975), Orderly or Disorderly (Be Tartib Ya Bedun-e Tartib, 1985), First Graders (Avaliha, 1985), and Homework (Mashgh-e Shab, 1988), as well as the work of several other accomplished Iranian filmmakers, including Bahram Bayza'i and Amir Naderi, the director of The Runner.[1]

Kiarostami's last film with the Institute was made in 1991. Entitled Life and Nothing More (Zendegi va Digar Hich), this autobiographical fiction film reflects on Kiarostami's own experience as a film director returning to the district of Gilan in search of the young lead actors from his film

Where Is the Friend's Home? (*Khane-ye Doost Kojast?* 1987).[2] Kiarostami recalls that he left for Koker shortly after his fiftieth birthday when a massive earthquake shattered the lives of 50,000 Iranians in Gilan in 1990: "The Earthquake happened inside my life." "From that moment onwards my view of life changed. Up until that day I had never quite understood the meaning of life and death in that way. . . ."[3]

In the West, Kiarostami is possibly the best-known post-Revolutionary Iranian filmmaker. With twenty-four films to his credit by 1993, he made his international commercial debut in February 1995 with the U.S. film distributor Miramax. Several retrospectives of his work had already been presented, at the New York and Chicago film festivals, for example, but Miramax's purchase of *Through the Olive Trees* (*Zir-e Derakhtan-e Zeitoon*, 1994) placed Kiarostami's name on the international film festival map. *Through the Olive Trees* was Iran's official entry in the foreign language film category for the 1995 Oscars. When the film finally was released in February 1995, the *New York Times* hailed it as comparable to Truffaut's *Day for Night*, while J. Hoberman of *Premier* enthusiastically identified Kiarostami as "an old-fashioned humanist film intellectual" and credited *Through the Olive Trees* with "complicat[ing] one's view of life in Iran."[4]

The forty-eighth Locarno International Film Festival dedicated a complete exhibition to Kiarostami's work in 1995. Taking advantage of this occasion, the French film journal *Cahiers du Cinéma* published a dossier on the auteur and invited important figures in film circles all over the world to make tributes to Kiarostami. In 1997 Kiarostami won the Palme d'Or at Cannes for his film *Taste of Cherry*. This honor added more fuel to the fires that had brought international attention to Kiarostami's work in response to the cover of the *Cahiers* dossier lauding the auteur as "*le secret magnifique.*"[5]

Responding to the New York Film Critics Circle's proposal for a tribute to him on the occasion of the centenary of cinema, Jean-Luc Godard wrote a highly publicized open letter listing his own worst mistakes. One of the mistakes he regretted was his failure to convince the Academy Award selection committee to award the Oscar for best foreign language film to Kiarostami rather than Krzysztof Kieslowski. This, he said, was one of the greatest sins for which he would have to atone: "Film begins with D. W. Griffith and ends with Abbas Kiarostami."

Principle of Subtraction

Known for the enigmatic endings that crown his films—endings that are often captured in what the Chicago-based film critic Jonathan Rosenbaum has perceptively called Kiarostami's Tatiesque "cosmic long-shots"—Kiarostami's work for the screen has left many critics unsettled, indeed "deprived of a compass."[6] Finding the films "entirely elusive" and lacking narrative closure, critics claim that they never quite succeed in getting a "sufficient overview."[7]

Kiarostami's is an "interactive cinema," Rosenbaum writes, "predicated on an unalienated view of art that seems rarefied only when one privileges the domestic grosses of blockbusters and willfully ignores the number of people across the planet who clearly enjoy what Kiarostami is doing."[8] Kiarostami's films work on the "principle of subtraction," suggests the Argentine film critic David Oubína.[9] This understanding of cinema as subtraction construes an approach to film that rejects the classic shot–reverse shot technique, which Juan Miguel Company has pointed out as "the organizing principle" of film.[10] What is left on Kiarostami's screen "after eliminating surplus images," such as the reverse shot, is the magical world of nature in which men contemplate the nature of reality and the film's relation to it.[11] "The cinema is a subtraction," Oubína reflects; "it is a little less than life."

True as this might be, a consciousness of cinema as "less than life" has often led Kiarostami to associate the eliminated "surplus image" with the veiled female figure. "Woman" is what is subtracted from the screen in his *ouevre*, and yet, as I attempt to show, this palpable absence in the actual narrative and on the visual track has given the figure unbounded significance in Kiarostami's post-Revolutionary work.[12] The puzzling "absent presence" of women on the auteur's cinematic screen is this chapter's true nucleus. To investigate the significance and the specificity of this absent presence, I turn directly to the spectacular subterranean milkmaid sequence of Kiarostami's 1999 feature film *The Wind Will Carry Us* (*Bad Mara Ba Khod Khahad Bord*).

Where Are Kiarostami's Women?

The scene opens with the lead character, Behzad, descending into the cellar where the heard-but-never-seen ditchdigger's female lover milks her

cow (see figure 13). Behzad goes to her to get milk for his crew, which has traveled with him from Tehran to Siah Darreh to document the rituals associated with the death of a hundred-year-old villager. We should note immediately that though the ditchdigger and ten other characters (including Behzad's crew) are outside the frame throughout the film, in the cellar scene the ditchdigger's lover, Zeynab, is not. Rather, she is lit in such a way that her face, though presumably in the cinematic frame, is never seen by Behzad, or by us. Though framed, she is unframed by the cinematic apparatus, by film technology's play in light and shadows.

In the darkness of the cellar, Zeynab appears carrying a gas lamp that lights up her long red skirt and slippers. She makes her way past the camera to a corner of the cellar where her lamp illuminates the hind legs and teats of the cow. The lamp lights Behzad's face, but not hers. We do not see her face. As she milks her cow, Behzad recites memorized fragments of poems to Zeynab—among them, this one:

> In my small night, ah
> The wind has a date with the leaves of the trees
> In my small night there is agony of destruction
> Listen
> Do you hear the darkness blowing?
> I look upon this bliss as a stranger
> I am addicted to my despair.
> Listen
> Do you hear the darkness blowing?
> Something is passing in the night
> The moon is restless and red
> And over this rooftop
> Where crumbling is a constant fear
> Clouds, like a procession of mourners
> Seem to be waiting for the moment of rain.
> A moment
> And then nothing
> Night shudders beyond this window
> And the earth winds to a halt
> Beyond this window
> Something unknown is watching you and me.
> O green from head to foot
> Place your hands like a burning memory

In my loving hands
Give your lips to the caresses
Of my loving lips
Like the warm perception of being
The wind will carry us
The wind will carry us.[13]

Some of the fragments that Behzad recites, including this last stanza from which the film takes its title, are from the poetry of Forough Far- rokhzad, the modernist poet and filmmaker of *The House Is Black* (*Khaneh Siah Ast*, 1963), an avant-garde documentary on a leper colony that "coter- minously" blends actuality and fiction.[14] Farrokhzad's untimely death has imbued her life and work with revolutionary potency, and hence infamy in contemporary Iran.[15]

Speaking to Zeynab about Farrokhzad, Behzad asks Zeynab to lift up the lamp so that he can see her face. He claims that he has not seen her lover Yusuf's face but would like to be a witness to Yusuf's taste. Without a word, Zeynab denies Behzad visual access. She falls silent when he asks her name. Instead she asks about "Forough," the poet, and her schooling. When Behzad recites the lines that motivate the film's title, "The wind will carry us . . . ," Zeynab cuts him short and tells him that his milk pail is full.

This scene has been the subject of much fascination and debate among film critics. Some have celebrated it as breathtaking; others characterize it as frightful and evocative. Hamid Dabashi singles out the subterranean scene in *The Wind Will Carry Us* as "one of the most violent rape scenes in all cinema," a scene that signals Kiarostami's downfall from the high ground of "a genius" because, in Dabashi's view, "he begins to particular- ize a universal indignity." Identifying Behzad as Kiarostami's auteurist alter ego in the film, Dabashi writes: "The blank-faced, wide-eyed, imitation-cool, made-in-Tehran protagonist, who may think that his un- buttoned shirt, dirty blue-jeans, unlaced boots, Japanese station wagon, and Tehrani accent tellingly distinguish him from the Kurdish villagers, does not realize, in the depths of his own depraved nativism, that, for the global audience, he is as much part of the Third World as the villagers." In this misrecognition of himself, Behzad and hence Kiarostami, Dabashi argues, "casts the deadliest, power-basing global gaze on [the Iranian particular], the gaze of the First at the Third World, of the powerful at the powerless, of the center at the periphery, of the metropolitan at the

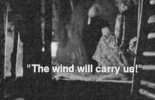

13 The cellar scene in Abbas Kiarostami's *The Wind Will Carry Us*.

colonized, of the Tehrani at the Kurd, imitating the Europeans at the height of colonialism." In his attempt to rescue "the naked Iranian reality," Dabashi goes on to argue, Kiarostami instead subjects it "to a more debilitating globalism." Little differentiates Iranian cultural colonialization of the Kurds "and global relations at large." In such films as *The Wind Will Carry Us*, Dabashi maintains, "Tehran simply replicates what London, Paris and Washington have done to their satellite peripheries."[16]

Film critics in Iran have criticized Kiarostami's earlier film about the earthquake in the Gilan district, *Life and Nothing More* (also referred to as *And Life Goes On*), on strikingly similar grounds. Kiarostami's filmmaker-protagonist, Farhad, adopts in *Life and Nothing More* the "vision of foreigners who have not seen the earthquake in Rudbar in a close-up," they argue. This dehumanized vision is Kiarostami's own vision, behind his signature dark sunglasses. Looking on like foreigners on an Iranian tragedy, filmmakers like Kiarostami and his protagonist "thank God that they were not there when it happened." Continuing in the same vein as Dabashi, Massud Farasti calls Kiarostami an "identity dealer" who puts the nation and himself up for sale at a time when the West is afflicted by a "New World Order epidemic." The New World Order, in Farasti's words, is bent on a politics that eliminates borders in order to confront the deep global economic crisis: "This new politics demands its own culture, a culture that engages in the elimination of ethnic and national boundaries. Lack-of-identity is the new strategy of the new world order." Predicting the future of Iranian filmmakers like Kiarostami, Farasti writes that such "self-lost and talentless culture sellers will not benefit from [the sale of the self] and shall earn nothing but shame. All the prizes and praises will not last but a short time. Art shall be victorious once again. Because life, as art, continues. But not under the new cultural order; instead via a return and proudly so to one's origins and roots."[17]

Similar calls for a purified Iranian cinema persist. Critiques of Kiarostami's work also persist with each success in reviews by both national and foreign-based critics, even as Western scholars and reviewers, unsettled and awed by the radical difference of Kiarostami's work from dominant cinema, attempt to place him as an auteur alongside Rosellini, De Sica, Bresson, and Godard and situate his work squarely within the neorealist and New Wave traditions.[18]

To this point, Dabashi's specific argument raises important questions, especially with regard to the ways in which national cinemas make their address in the cross-cultural encounter. I take up this subject in more

detail to address realism as a problematic in cross-cultural encounters in chapter 3.

Rinsing Out the Eyes

In the more immediate discussion of Kiarostami's work, I will attempt to tease out the ways in which Dabashi's (and to some degree Farasti's) purportedly liberal and anticolonial objections may in fact explain why *The Wind Will Carry Us* was delayed (by censors) from participating in the 1999 Fajr Film Festival in Tehran. For if Dabashi is right in his assessment of the cellar scene, it is because the scene strikes at the two issues that are central to the laws governing the production of films in Iran formulated since the establishment of the Islamic Republic: the intent to make Iranian culture independent of other cultures, Eastern or Western, and the attempt to do so by focusing a stringent censorship on the representation of women and on heterosexual relations. That the laws have succeeded in these attempts is clear in the overwhelming attention given by critics to the question of censorship in the Iranian cinema of the 1980s and '90s. But as my analysis will also establish, Kiarostami's efforts to claim an "*arte povera*" against Hollywood's domination of cinema screens aligns his work more properly with national traditions. Rather than bypassing the national context, his cinema accentuates the Islamic government's demand to radically purify the senses through the medium of film.

This reading stands in contradistinction to Dabashi's and Farasti's claims regarding the imperialism of Kiarostami's work and also contrasts with calls for his inclusion in the neorealist tradition. In fact, it is important to note that in referring to his five shorts in the film *Five* (2003), Kiarostami himself suggests that the function of his film is one of audiovisual detoxification along the lines of Khomeini's call for the purification of vision in his anti-imperialist talks in the early Revolutionary years: "audiences can go to see it and rinse out their eyes with it, as if it were a drop of water."[19] Kiarostami's "investigations" in film, investigations "that sculpt in light and shadow," his signature "cosmic long shots," and his "lyrical abstractions," all terms used by foreign reviewers to describe his work, are cued, I will argue, by the government laws prescribing modesty in heterosexual relations in post-Revolutionary Iranian cinema, even, or rather especially, in those films that deal with the lives of women, films that thematize the eroticism and sexuality of heterosexual love.[20] Because of their narrative emphasis on such issues, Kiarostami's films *Through the*

Olive Trees, The Wind Will Carry Us, and *Ten* are the main subjects of my analysis here. Brief examples from three others—the short film *Dinner for One* and the feature-length fictions *Life and Nothing More* and *Taste of Cherry*—are given to establish the association that his films create between the veiled female body and the productive technologies of cinema.

The Proscription of Vision

Regardless of where critics stand on Kiarostami's work, the significant difference that the "commandments for looking" (*ahkam-i nigah kardan*) and modesty laws have made for the look of the Iranian screen has left few critics unaware that this inspiring vision—the spectacular rhythm and poetic language by which Iranian cinema addresses its audiences—in some way quotes the limitations placed on the global medium by the theocratic government. The New York–based film critic Godfrey Cheshire suggests that both liberals and religious hard-liners may have been all too willing to comply with the restrictions put on the industry by the Islamic regime and that, indeed, both sides have understood the consequences of this acquiescence. Cheshire writes that the remarkable difference of Iranian cinema "owes in large part to Iran's deliberate isolation, its sense of its own cultural separateness and its suspicion of Western influence, a wariness which cuts across the political spectrum: where hard-liners worry about the incursion of anti-religious values, liberals worry about Iranian cinematic culture being molded according to Western viewpoints and prejudices."[21] Cheshire notes that the success of Iranian films at international film festivals by the 1990s can be attributed in part to the industry's years of isolation from the developments in the film world at large:

> Though it surely oversimplifies to put it this way, the cinematic modernism that came to the fore in Europe, especially in France and Italy, in the 1950's and 60's eventually spread its seed to many countries including Iran, where it provided the aesthetic basis for the upsurge in artistic films (the "Iranian New Wave," appropriately) that made a fleeting but decisive mark in the 1970's. That much is a common story, applicable to various national cinemas.
>
> What is uncommon, and peculiar to Iran, is how that aesthetic was preserved virtually intact for future decades via the curious cultural processes that surrounded the Iranian Revolution and the early years of the Islamic Republic.

While the rest of the world was swept up in an increasing globalized and video-dominated climate, Iran shut off almost everything coming from the outside, and then, circa 1983, encouraged its film-makers to resume their former preoccupations (albeit with new restrictions on content). Thus did the modernist-cinematic '60/'70's survive to enjoy a vital afterlife two decades later, in a particularly unlikely corner of the globe.[22]

Often included among a handful of New Wave directors, Kiarostami admits to recognizing similarities between his work and "the modernist-cinematic" of Italian neorealist films, yet he himself is clearly interested in positioning his work within the social and political context of post-Revolutionary Iran.[23] The conditions in this context, he says, are in some ways "similar to those of post-war Italy."[24] While this does not amount to an endorsement of the current Islamic regime, its censorship practices, or its theocratic policies, Kiarostami refuses to see his work as a pure imitation of any tradition in film, claiming that this would involve the risk of producing "something very artificial."[25] Unlike Bayza'i and many of his contemporaries in the post-Revolution Iranian film industry, therefore, Kiarostami sees the restrictions on cinema as enabling, spurring the creative process; he incorporates, indeed he quotes, the laws proscribing vision in his shot constructions. This act of quotation becomes explicit in my analysis of *Through the Olive Trees*, which I will turn to momentarily.

The Village Film

Both liberals and hard-liners complain about censorship laws within the post-Revolutionary film industry. Censorship, they say, sets limits on the artist's freedom. The preframed face and body of the veiled woman are difficult to light. The flowing dark fabric of the veil envelops her ambiguous body. Her face floats in its shapeless folds. Thus the veiled body is difficult to frame. It is difficult to move realistically in and out of private and public spaces because the veil, which produces a preframed figure, is only fit for public spaces. The act of veiling cannot function realistically in private spaces. Iranian cinema cannot represent urban reality in the way other cinemas can. Presenting a female figure in a veil in her own home, with her own family, or in her own bed, unsettles the realist frame. Thus, some filmmakers conclude, a realist cinema, and the cinema of Iranian

everyday life, must place itself either outside the city or outside national boundaries, in more "exotic," rural, spaces, where women can be shown outdoors in nature, their purported "natural" environment, framed by fields of rice or wheat. To frame urban women's reality, the camera would have to move indoors, for urban life rarely allows women the freedom to conduct themselves outside the home. Peasant women wearing colorful garments and headscarves are more easily naturalized in the rural context, and the outfits they generally wear while toiling in the fields or tending livestock are completely congruent with the regime's dictates on modesty in dress. This argument explains, in part, the rural settings for Mohsen Makhmalbaf's *Gabbeh* (1996) and *The Silence* (*Sokout*, 1998). In these "village films," the authoritarian language of Islam that aims to shape the new language of Iranian cinema by reconfiguring vision is displaced from interior urban spaces to phantasmatic sites on which its discourse can have little ideological effect.

Several of Kiarostami's own post-Revolutionary productions can be considered village films of this sort. His adoption of this category of film, which as a genre represents an allegory of the post-Revolutionary industry in cinematic narrative form, has led critics such as Rosenbaum to gripe about the exclusively outdoor spaces and the contrived avoidance of interiors in his films, especially in *Through the Olive Trees*. But there can be no doubt about this: Kiarostami's "village films" are allegorical embodiments of the modesty system in cinema. They are displaced allegories of the conditions of the post-Revolutionary film industry in that they make the representation of "real women" possible by transporting the veiled subject and hence the narrative itself to rural and exoticized locations. In a village film a woman can be filmed constantly laboring outdoors, relieving the filmmaker of the awkward task of placing her in a familial context where the veil is deemed unnecessary, even inappropriate. The Kurdish female farmer who pauses momentarily to give the fake director of *Where Is the Friend's Home?* directions in *Life and Nothing More* is one example of this type in Kiarostami's films.

Responding to state dictates prescribing modesty, many Iranian filmmakers have chosen to eliminate women from their narratives completely. Kiarostami's films, by contrast, distinguish themselves by absenting women from the screen during major scenes, only to remind us of that absence by recovering a cloud of them in minor scenes. In *Taste of Cherry* (*Ta'ame Gilas*, 1996), for example, a brief sequence shows a school of veiled pedestrians outside the natural history museum where the film's

compassionate and heroic gravedigger teaches taxidermy. And female students represented in the prologue of the earlier film *Through the Olive Trees* (1994) appear interchangeable, dressed in black flowing chadors (long black veils) against the deep green of the grass and the olive trees (see figure 14). These veiled ghosts mark the disquieting absence of women within Kiarostami's cinematic frame. In my reading of Kiarostami I argue, evoking Pascal Bonitzer, that "the cinematic image is haunted by what is not in it."[26] The haunting presence of the veiled female body lodges itself in the gendered technology that Kiarostami adopts in producing his films. In the analysis that follows I isolate examples in Kiarostami's oeuvre in which the absent female body is associated with the enunciative apparatus, that is, with the very technology that produces his films.

If cinema were merely the sum of images represented within the frame, little would distinguish Kiarostami's exoticized representation of women in his "village films" from the work of the orientalist photographers of Malek Alloula's Algerian postcards in *The Colonial Harem*.[27] The photographers' stylized portraits of Algerian Moorish and Berber women, in veils and behind metal bars, bedecked and bejeweled in traditional outfits, standing in decorative studio spaces, or leaning on pillows in odalisque fashion looking seductively into the camera, reproduce orientalist harem fantasies as we have encountered them for centuries in the tradition of Eugène Delacroix and Henri Matisse. The shapeless moving groups of women in Kiarostami's urban films such as *Taste of Cherries* would certainly correspond to the postcard representations of urban Algerians in *The Colonial Harem* in which veiled women appear as a cluster of dots against a staged backdrop, or alternately as highly stylized objects of ethnographic and visual pleasure reproduced and circulated for mass consumption.

It is evident, however, in the multiple reflexive moments that refer to questions of ethnographic fetishism and in representations of "the exotic" throughout his work that Kiarostami is resistant to, indeed critical of, any posture that attempts to situate his characters as ethnographic tallies of dress and custom among primitive cultures in the Third World. The work as a whole seems positively wary of this "sale of culture" for Western commercial consumption. The most obvious instances of this wariness appear in *Through the Olive Trees* and *The Wind Will Carry Us*.

Through the Olive Trees

Because of its unique focus on a heterosexual relationship, *Through the Olive Trees* is the most important of Kiarostami's films in the attempt to locate the effect of post-Revolutionary modesty laws on the representation of women in Iranian cinema. To situate the film and its early critique of exoticism, I first summarize the narrative.

Through the Olive Trees is a fiction film that nevertheless claims to document the circumstances behind the making of the previous film in the Koker trilogy, *Life and Nothing More*. Rather than proceed in documentary form, as if to say it were a "behind-the-scenes look" at the film that went before it, *Through the Olive Trees* functions within what David Oubína calls "a complex system of permutations."[28] Woven tightly into the narrative frame of *Life and Nothing More*, *Through the Olive Trees* delves into a detailed exploration of a developing love affair between the young set assistant, Husayn, and a local student, Tahirih. The entangled relation between the two films may be the grounds for Kiarostami's rejection of the idea that

the two films belong together in the way of an evolving trilogy; although they are frequently referred to by critics as "the Koker trilogy" or "the Rostamabad trilogy" merely to suggest their unity by pointing to the location of their filming.

In giving the backstory to the film, Kiarostami explains that during the shooting of *Life and Nothing More*, he noticed an undercurrent of tension between the two young people chosen to play the couple who were married just days after the earthquake. Husayn, who played the role of the groom in that film, was attracted to the schoolgirl, Tahirih, who played the role of the bride, and had been courting her without much success. *Through the Olive Trees* focuses on this undercurrent of love between two young actors during the shooting of the previous film. The director's curiosity about the role of cinema in the construction of life and as a catalyst for human relations draws him to Husayn's and Tahirih's story. Their story becomes the narrative base of *Through the Olive Trees*.

In *Through the Olive Trees*, the character of Husayn is illiterate, and Tahirih is a high school girl whose parents have died in the earthquake. She owns her own house; Husayn owns nothing. Husayn earnestly pursues the girl and courageously asks her to marry him, but her grandmother forbids the marriage and Tahirih is forced to resist the proposal. For Kiarostami the film is a reflection on stifling traditions and social injustice: "Now people tell me that I've made a love story, but at first that wasn't clear to me. [Husayn] finds himself in a dead-end street, and his thoughts turn to God, a higher power who shows his solidarity by destroying houses . . ."[29] The earthquake levels the playing field for Husayn who, though without means, loves Tahirih beyond measure.

Riding in the van with the director of the film-within-the-film, Husayn reflects on his personal views on social justice. To his mind, he observes, the cultured should marry the illiterate, the rich should marry the poor, and people with houses should marry those with none. In Kiarostami's words:

> The young man [Husayn] has believed the earthquake. For him it is like the Final Day of Judgment. Where all the houses are destroyed and everybody appears in an apparent and evident equality, it is only natural that in the face of this superior fate this futile thought should occur to the young and inexperienced mind of the young man that now, on the Day of Judgment, it is the day of salvation for those who have survived [the earthquake]. It is the day of equality and equanimity. But an experienced and worldly old woman corrects this illusion on his part . . . [30]

Feeling frustrated and powerless against Tahirih's wall of silence, Husayn begs Tahirih: "I want your answer, not your grandmother's." But Tahirih resists. Her grandmother reminds Husayn "that the only thing that has happened is an earthquake and all the old and ancient principles and values continue to be valid. That people are still alive, and, so far as we are alive, we will not permit for these principles to be turned upside down."[31]

As the filming of the film-within-the-film ends, marking the end of *Through the Olive Trees*, Husayn follows Tahirih home, declaring his dedication to her and insisting on her own answer to his proposal. The two walk amid the olive trees as the camera holds back, motionless, in a wide "cosmic long shot." Tahirih and Husayn move farther and farther into the deep green of the olive trees. We can hardly see them, nor can we hear them. In this fearless exercise in "lyrical abstraction," the lovers become two white dots moving to the classical concerto by Domenico Cimarosa playing distinctly on the sound track. This is a love scene, as Oubína observes, shot from high up and in long shot "as though it were a shot of armies preparing for battle."[32]

A Displaced Allegory

The closing scene of *Through the Olive Trees* is a textbook example of a love scene made under the rule of modesty in the Islamic Republic of Iran—and thus a displaced allegory of the conditions of the film industry itself. Rather than divulge the nature of the conversation between the young couple, Kiarostami reflects on the impossibility of heterosexual love in post-Revolutionary cinema.[33] "Cinema inasmuch as it shows things off, restricts the gaze." Such is the nature of the voyeurism that informs the structure of classical Hollywood narratives as well, though we rarely take note of it. "These holes, these moments of 'failure' are what makes for the construction," Kiarostami comments in conversation with Jean-Luc Nancy.[34] The spectator intervenes imaginatively to fill the void.

The final scene of pursuit is only one instance of what Laura Mulvey has identified as a "point of uncertainty" in Kiarostami's oeuvre. Another appears somewhat earlier: While Husayn is giving the director in *Through the Olive Trees* an account of his life after the earthquake, there is a flashback to a scene set at a crowded cemetery where Husayn watches Tahirih and her grandmother. Mulvey notes that "it is only later in the film that [Husayn], in one of his impassioned speeches to the silent [Tahirih], says that she had returned his look in the cemetery and that he had taken it as a sign of encouragement." Mulvey continues:

During the flashback, the camera registers [Husayn's] intense gaze but gives no indication of [Tahirih's] look. This missing moment becomes a crucial point of uncertainty in the film. It inscribes [Tahirih's] impossible position, caught between family and suitor. But it also bears witness to the guidelines for the cinematic depiction of relations between the sexes established by the Ministry of Culture and Islamic Guidance.[35]

The absence of Tahirih's look, as a problem for the resolution of the final scene among the olive trees, points up the conditions informing the post-Revolutionary film industry. Her look's absence from the cemetery scene is an allegorical displacement of the "commandments for looking" informing the industry and its products. In fact, as Hamid Dabashi suggests, "The story of the film in the film (the fantasy) is never anything more than a would-be sequence of innumerable, mostly unsuccessful, cuts. . . . The strategic necessity of this 'interruption' is evident throughout Kiarostami's vision of this paradise-like village. 'Intrusion' and 'interruption' are the operative modes of this vision."[36] It is precisely from within the constant interruption that these cuts represent that this "village film" as a continuous whole emerges as a narrative that mirrors the structuring conditions of a film industry riddled by a stance against voyeurism.

Reality Effects

In an early scene of Through the Olive Trees, the assistant director, Shiva, goes to pick Tahirih up at her home. Tahirih has been selected to perform the role of the new bride in Life and Nothing More. Given that the documentary genre is a fictional device in Through the Olive Trees, Tahirih ends up acting out her own love affair in the film—a love affair that is at the heart of the illusory world of "the documentary." In line with Kiarostami's fascination with cinema as a medium that Laura Mulvey has coined a trompe l'oeil, a medium in other words that fosters ambiguity through a simultaneous play on reality and illusion, Tahirih's fictional role as the new bride in the "documentary" puts her in the place of an uneducated peasant who is played by a seemingly "real peasant woman" in "the original" Life and Nothing More.[37] Put side by side, the two films do not correspond: Tahirih, in other words, appears only in one of them, namely the documentary "copy" of Life and Nothing More within Through the Olive Trees.

If we were ever in doubt about the authenticity of cinematic representations, "the original" and "the copy" challenge us here to question notions

of authenticity and actuality in both films. Neither the characters nor the geographies within the films match up. As reproductions that follow upon the other, as if following the pattern of film frames entering the projector, they undo our sense of temporality and spatiality, certainly, but more importantly go a long way in destabilizing *any* notion of a real, sustained, and unified identity in film—an identity and authenticity, I should add, that audiences are more willing to attribute to a peasant than to an educated city dweller. For as Rey Chow argues regarding film, "by intensifying reproduction numerically, the processes of mechanical reproduction change reproduction from being a technique to a technology. This is the technology of repetition, which radicalizes every type of social relation in the form of 'copies' or 'simulacra.'"[38] The play on the original/copy, the tension between reality and fiction and fictional realism within the narrative of *Through the Olive Trees*, creates self-reflexivity in a technology of repetition (film) that in doing so radicalizes our reliance on the cinematic visual as an image commensurable with and indexical to a real world, whether this real be considered exotic or otherwise.

The concomitant effect of self-reflexivity in Kiarostami's films is to raise questions that are important to the film itself. In the case of *Through the Olive Trees*, these are questions of class and power relations within the limits of the national. These issues, as I suggested in the summary of the narrative, ultimately become central to the unfolding heterosexual drama of *Through the Olive Trees*, and they are carried through and intensified in Kiarostami's film, *The Wind Will Carry Us*.

Sartoriality in Question

Through the Olive Trees takes up issues of class and power in the narrative by pursuing a sartorial point in scene two. When she arrives at Tahirih's house, Shiva finds Tahirih missing, so she chats instead with the girl's grandmother. When Tahirih finally appears, she refuses to cooperate (see figure 15). Although she auditioned for the role of a peasant in *Life and Nothing More* with no small degree of excitement in the prologue of the film, she now refuses to put on a peasant dress. She has another outfit in mind. Tahirih firmly declares that all she needs to do to get ready for her role as Husayn's new bride is to tailor her friend's urban black skirt to fit (figure 15, frame 1). When Shiva perseveres in her request, Tahirih insists that no one wears dresses like the one she's being asked to wear anymore and that those who once did wear them were peasants and were illiterate—unlike her (frame 4). Her status as a student, she believes, is

15 Tahirih and Shiva quarrel over a skirt in *Through the Olive Trees*.

obviously above theirs: an educated woman cannot also be a peasant in dress and custom, she argues.

Because this scene is one of staged realism in a Kiarostami fiction film, it is certain that such women, the "real" peasants of whom Tahirih speaks, will appear on the narrative screen. She appears as one of them. In fact, women speaking in dialects appear in Kurdish and Gilani dress in *The Wind Will Carry Us* and throughout the Koker trilogy (see figure 24). While, as we shall see, Kiarostami embeds a critique of this kind of orientalist representation in his oeuvre, the scattered presence of fictive "peasant women" produces "reality effects" and casts a spell of realism and authenticity on the stretches of field captured by his patient camera.[39] In Kiarostami's films, these "authentic" and "inauthentic" women become associated with the very apparatus that constructs Iranian cinema in its new purified form. They stand to mark the threshold of the post-Revolutionary cinema's address.

Staged somewhere between actuality and fiction, the minor discussion between Tahirih and Shiva regarding the peasant dress undercuts any sense of realism associated with the "fictive primitives" that are represented as real subjects peppering the rural landscapes in Kiarostami's work. Any attachment the audience may have to the authenticity and identity of the Iranian peasants represented there is unsettled in the quarrel over the urban black skirt, making it difficult to claim a correspondence between Kiarostami's camera and the consumer-oriented documentary realism of the orientalist lens.

To respond to Farasti's critique of Kiarostami for "identity dealing" in orientalizing representations only fit for European consumption, cinema must be regarded as more than a staged or framed visual image and narrative identity in film cannot be indexical. Rather than simply assert that Kiarostami is not interested in creating a cinema of realism when it comes to the representation of Iranian women and ethnicities, or that he is only interested in selling a fake identity to please the imperialist consumer, I will focus in the rest of these reflections on Kiarostami's application of the restrictions placed on the representation of women and heterosocial relations to the development of a woman's cinema that situates the framed figure of the post-Revolutionary Iranian woman and the perpetual movement and transformation of fabulous ethnic subjects as the impetus capable of unframing the established voyeuristic codes of cinema in general. These codes are unequivocally associated with the Hollywood film industry, whose dominance and power, Kiarostami suggests in

his final lesson in 10 on Ten, are even greater than America's military might.

Women and Enunciation

In Jamshid Akrami's short documentary Kiarostami 101, Kiarostami admits that he avoids themes that demand close interaction between men and women, such as love and courtship, to dodge the issue of censorship altogether. Nonetheless, his later films seem to pay particular attention to how the restrictions placed on the representation of women in the Iranian context affect formal components of representation in cinema. For example, in Ten (2002), a film about the lives of urban Iranian women, he radically omits the director's role altogether to foreground the lives and preoccupations of Tehrani women. Though Kiarostami may have shied away from the visual representation of women within his narrative screen, his signature is, I believe, to cede the very texture of his films, the landscapes of his films' address, to the figure of the veiled Iranian woman, thereby granting this modest body the power to affect every syllable of his cinematic language by associating it with cinema's productive technologies. The veiled female figure is imprinted in the film as the productive principle of each of Kiarostami's frames.

The ability of this body to construe a new grammar for film is revealed through the systematic linkage Kiarostami's films create between the veiled body and the technologies of filmic production at moments of rupture within the narratives. Such moments reveal the cinema's enunciative sources and processes, and more importantly the film's productive technologies. These technologies are gendered feminine through the association of the veiled female figure with the clapper, the camera, the lighting, and the sound recording and editing equipment in moments of narrative rupture in Kiarostami's post-Revolutionary oeuvre. Indeed, one of the absences on which dominant narrative cinema turns— the absence of the cinematic apparatus—is here emphasized and in effect "signified through woman" by the conscious absence of women from the narrative itself.[40] The association of the absent enunciative technologies, the productive apparatus of film, in other words, with frequently absented veiled female bodies in Kiarostami's films foregrounds what other film cultures, especially classical Hollywood cinema, repress. In dominant cinema the process of production is repressed in favor of narrative continuity and closure.[41] In Kiarostami, narrative emerges rather

as a displaced allegory of the conditions regulating these processes within the national industry.

Dinner for One

The most concentrated instance of the association between the female body and the technology of film in Kiarostami's work appears in the fifty-two-second short he produced for the centennial of the Lumière cinematograph, *Dinner for One*. This film is included in the ambitious multinational production *Lumière and Company* (1995). Thirty-nine filmmakers from all over the world were each asked to film a short piece on the original Lumière equipment without sound or artificial light. Significantly, although *Dinner for One* is filmed in natural light, it breaks the sound rule. Sound plays a major role in the short film, and is, in fact, associated with an absent female body.

As an obviously male hand enters the screen to melt some butter and crack two eggs into a hot frying pan, the phone rings and a female voice speaks on an answering machine outside the frame.[42] The eggs are ready, and the man takes the pan off the heat. The machine beeps to mark the end of the message and the end of the film. While the male body is at least partially present within the frame, the female body, neglected by the male body and erased and absented by the film, is associated with the technology of sound recording and projection.

The association between the film's sound technology and the absent female in *Dinner for One* is not unlike the way that the contemporary ta'ziyeh performance links female characters and sound technology. In contemporary live performances in Tehran, for example, a loudspeaker stands in for a female figure who speaks to her loved ones as they go off to fight the historic battle Imam Husayn mounts against the caliphate on the plains of Karbala. One could argue that *Dinner for One*, Kiarostami's cinematic celebration of Lumière's primitive camera, simultaneously unearths another history of representational technologies, one that is indisputably national in form. It links the primitivism of the early Lumière camera with the performative tradition of the ta'ziyeh passion play, revealing Kiarostami's own art's primitive roots.

The recorded female voice on the sound track of *Dinner for One* is also a reminder of representational history. The reverberating recorded message recalls the gramophone's historical displacement of live translators and live orchestral music by mechanical sound in film theaters around the

world. Kiarostami's short film, then, stands as a cinematic memento of how other bodies, including technological bodies, have displaced and re-placed embodiment, "the grain of the voice" so to speak. It is a telling re-minder of the erasure of the embodied female form in the history of representational arts and the body's convergence with the technological body of film production in the post-Revolutionary era in Iran.

Who Is Seeing This?

By associating the absent presence of the female body with the technolo-gies of both sound and vision, scene one of *Through the Olive Trees* provides a further, poignant example of the association between the absent pro-ductive technology and the absent female body. Following the prologue, the scene opens in typical Kiarostami fashion (see figure 16, shot 1). We know we have entered his auteurial world as the long take/long shot from the interior of the truck captures the scenes and settings of the film that came before it in the Koker trilogy, namely *Life and Nothing More*. Typical of Kiarostami's later films, *Taste of Cherry* and *Ten*, the long shot from the front window of a moving car "effectively makes camera and car seem inter-changeable."[43] Like most of Kiarostami's "philosophical long shots," this shot in *Through the Olive Trees* asks us to reflect—a shot closer to a question than an answer.[44]

The shot is presumed to be from the perspective of the driver (shots 1 and 2), who until about a minute into the scene remains unidentified (both visually and aurally) and receives her first reverse point-of-view shot a long three and a half minutes into the opening sequence (shot 6). The car window frames the rural landscape; a sound track accompanies the vi-sual track with the news on the radio. There is a sense of unease here. The shot is uncontextualized. Without the conventional enframing establish-ing shot to position the viewer in relation to what is taking place on screen, the shot feels unsettling in ways that are similar to the opening shots of "the scene of Father's letter" in Bayza'i's *Bashu: The Little Stranger* (see figure 4, page 36).

This shot sequence is the first of many in Kiarostami's post-Revolutionary films that refuse to identify the subject of the point-of-view shot. Typically in point-of-view shot sequences, cutting the reverse shot disorients the film viewer's positioning in relation to what is seen. As the audience, we lose any sense of who is seeing or hearing in this shot, and we cannot find our own place in the scene. Our relation to the representational

1

– Hello.
– Hello.

2

Why do you need chalk then?

3

I see,
a board for the shooting.

4

I remember,
you were very good in that film.

5

6

زیر درختان زیتون
کارگردان : عباس کیارستمی
فیلمبردار : حسین جعفریان
سکانس ۴ پلان ۱ برداشت ۱
شماره کاست ۲
تاریخ ۷۲٬۳۹ شماره حلقه ۳

Scene 4, shot 1, take 1.

7

16 Opening scene of *Through the Olive Trees.*

technologies of sound and vision is in effect unmediated by a character appearing on screen. Our eyes and ears are set up as technological—that is, of a piece with the technology that records and projects. The shot thus exposes the film frame and prohibits, for more than the conventional length of time, any identification with the look of a character on screen. Here, the presence of the car window's frame within the camera frame reminds us that our view is also always framed. What we see is obviously mediated, and also limited, by the camera's framing. The camera exposes itself as that which sets the limits of our vision in the film. This scene reflects on the production of the visual image before us, alerting us self-reflexively to the film's enunciation and address: "Who is seeing this?" we wonder. The camera is. This is because the visual image cannot for the moment be identified with a character in the plot.

Linked to the productive technologies of the film, the rural landscape seen through the vehicle's window not only functions as the setting in which the plot is to unfold, the film's geographical location or address, but also marks the site of the film's enunciation. The film's geographical address is emphasized as the narrative ruptures to expose its processes of production and the role of its representational technologies. We become aware of our own look and our hearing as they are mediated by the film's productive technologies in this landscape and in this location. "The dissociation and disorder of the materials of cinema is so revealing," writes Gonzalo de Lucas on Kiarostami, "since it opens our eyes" and makes "cracks in the prevailing order."[45] As the film narrative "cracks open," enunciation emerges as the productive bridge between national location and narrative setting.

Countering cinematic conventions, the technology of production exposes itself and jolts us to reflect on the mediation of our vision and hearing (figure 16, shot 3). This technology becomes the topic of conversation when the camera's look becomes identified with the voice of a crew member (Shiva) moments later (shot 2). Though her face is still outside the frame, we come to assume that the voice we hear is that of the driver of the truck. The linkage between the viewpoint of the driver and Shiva's look begins to take shape at this point, through sound, as the truck stops to pick up a local schoolteacher (who played the role of a schoolteacher in *Where Is the Friend's Home?*). The schoolteacher delivers chalk, which Shiva explains she will use to write on the clapper board (shot 4). By now her voice is identified with the point of view looking out the front window in the scene (shot 5), but the reverse shot that will identify the viewpoint

with her look is yet to occur. Recognizing the instrument from the film he played in previously, the schoolteacher reminds Shiva of his part in that film and encourages her to find a role for him in this film as well (shot 5). The point-of-view shot from behind the car window (shot 1) is linked to Shiva's voice while her face continues to be outside the frame in the interaction (shot 2). In the course of the conversation with the teacher, however, Shiva's point of view and her role in the film are gradually associated with the clapper board and chalk, the filmic apparatus, that comes to mark the beginning of subsequent scenes (shot 7).

The first reverse shot of Shiva in the driver's seat occurs after she drops the schoolteacher off at the intersection where he catches the school bus (shot 6). Three minutes have passed. The long delay in the visual representation of Shiva's veiled face has driven home her unsettling absence from the image track, which is immediately and then repeatedly tied to the technologies of film production. On the level of filmic enunciation, Shiva's veiled body (and principally her speech and vision) becomes associated with the absent apparatus that produces what we see and hear in the theater long before she herself appears as a character, with a body, within the narrative itself. Her mostly absent body is first intimately linked to the film's address, to the enunciative technologies that produce the film, as her framing look is tied to the geographic location on which the film plots the vectors of its own address.

When the continuity of narrative space is interrupted, when the film stutters to disrupt chronos, and when the filmic apparatus itself is exposed, such moments of narrative rupture reveal the coordinates of the film's address. They mindfully alert us to the enunciative labor involved in the production of the images we see on the screen. Such moments of self-reflexive narrative rupture or enunciative breach occur in Kiarostami's films time and again. At such times, the processes of production, and hence the technology of the film itself, are gendered and associated with the otherwise unframed figure of the veiled, modest body of the Iranian woman. Kiarostami's oeuvre ties the very techniques and technologies of filmmaking in the post-Revolutionary Iranian context to this figure while excluding her image from the narrative screen.

Life and Nothing More

Two further examples illustrate how Kiarostami's films base post-Revolutionary Iranian cinema, its language and address, in the veiled

and modest body that the Islamic government has issued to stand at the threshold of its cinema's address in the global marketplace. First, in *Life and Nothing More*, the second film in the Koker trilogy, the fictive director of the film *Where Is the Friend's Home?* drives to Rostamabad after a massive earthquake in the Gilan region has destroyed the homes of many residents and left them destitute. In his quest to find those who played parts in his earlier film among the survivors, the director realizes that nature continues its course, undeterred by the turbulence of the quake, and that, indeed, life goes on. "In June 1990," Kiarostami writes,

> an earthquake of catastrophic proportions jolted northern Iran, killing tens of thousands of people and causing unbelievable damage. Immediately I decided to make my way to the vicinity of Koker, a village where four years earlier I shot *Where is the Friend's Home?* My concern was to find out the fate of the two young actors who played the film but I failed to locate them. However there was so much else to see. . . . I was observing the efforts of people trying to rebuild their lives in spite of their material and emotional sufferings. The enthusiasm for life that I was witnessing gradually changed my perspective. The tragedy of death and destruction grew paler and paler. Towards the end of the trip, I became less and less obsessed by the two boys. What was certain was this: more than 50,000 people had died, some of whom could have been boys of the same age as the two who acted in my film. . . . Therefore, I needed a stronger motivation to go on with the trip. Finally, I felt that perhaps it was more important to help the survivors who bore no recognizable faces, but were making every effort to start a new life for themselves under very difficult conditions and in the midst of an environment of natural beauty that was going on with its old ways as if nothing had happened. Such is life, it seemed to tell them, go on seize the day. . . . [46]

A conversation between the director's son, Puya, and a young boy they pick up on the road to Koker captures the sense of vitality and pleasure in living that permeates the narrative of *Life and Nothing More*. The young boy tells Puya how the earthquake started while he and his friends were watching the Brazil-Scotland match in the World Cup on television. "Tell us what happened," the director asks the boy, curiosity trembling in his voice. "Scotland scored first," the boy answers. "I meant the earthquake, not the match," the director rejoins. Similar conversations take place between the director, his son, and the affected locals who recognize that life must go on despite the catastrophe.

But it is the conversation between the director and the old man from *Where Is the Friend's Home?*—a conversation that is to capture the scene and setting for the love story that is the subject of Kiarostami's next film, *Through the Olive Trees*—that becomes the film's decisive moment. Here the narrative halts to reflect on the nature of life and its relation to the cinema. Driving toward the town where he had last seen the two young boys who played the main roles in *Where Is the Friend's Home?*, the director, Farhad, comes upon an old man carrying a bathroom fixture up a steep hill. The old man introduces himself to us as a character in *Where Is the Friend's Home?*—Mr. Ruhi, the old carpenter, who guided the young hero of that film through the streets of Koker. Following the old man to his home in *Life and Nothing More*, the director expresses surprise and says that he had expected to see the artisan and door maker in his old home (see figure 17, shot 1). This comment is the start of a long discussion between the two men regarding the nature of reality in film. The old man replies that that home in *Where Is the Friend's Home?* was his "film" home and that in fact this home, too, is not really his home. His real home was destroyed in the earthquake, he remarks (shot 2). He tells the director that he actually lives in a tent at the bottom of the hill where the director picked him up. In this way, the old man reveals himself as an actor playing a part in *Life and Nothing More*, even as he acts his part for the audience sitting before the screen. As Laura Mulvey observes regarding Mr. Ruhi, "he stands for the way that even an insistence on real locations and local non-professional actors grounded faithfully in a social reality and in keeping with the camera's potential for inscribing a realistic aesthetic may well involve distortion."[47]

And so, as this peerless carpenter from *Where Is the Friend's Home?* starts talking about the fakery of his ornate home in that film as well as the one we are watching, he abruptly breaks the fourth wall of the narrative (shot 3). He looks directly at the camera from the upstairs veranda of his fictional home and addresses the camera and presumably the film crew. He is unable to find the prop he needs to deliver his next line, he says, looking frustrated behind his little round glasses. At his request, a female crew member, Miss Rabbi, runs into the frame to help him find a bowl for his water and then quickly runs out again (shot 4).

The film ruptures, then, in the midst of a conversation regarding reality in film, and it does so by linking the production process of the film we are watching to the modest figure of a veiled female body. This is the only instance in this film in which the crew and the technology of filmmaking

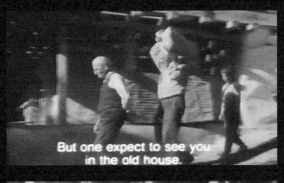

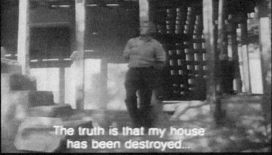

17 Old man from *Where Is the Friend's Home?* in his "film home" in Abbas Kiarostani's *Life and Nothing More.*

(though not of film distribution: the French film poster for *Where Is the Friend's Home?* appears in an earlier scene) are exposed, but the scene blurs the boundaries between fiction and the process of its making and reveals the constructedness of the fictional world of *Life and Nothing More* as tactile and immediate. The scene uncovers a world that is beside the world that is on screen, a world living and breathing just outside the frame.

That the veiled body of a female crew member appears at this moment of narrative rupture is highly significant. She is associated with the process and the technology of the film's enunciation. Her veiled body marks the site on which the film's narrative landscape is produced. The narrative ruptures to identify the body associated with the enunciative processes involved in the film's framing. Its veiled presence is amplified in the next film in the trilogy (*Through the Olive Trees*), when every retake of the scene of exchange between Tahirih and Husayn is associated with the clapper and chalk that enter the screen in tandem with the veiled body of the assistant director, Shiva. This is one of many examples that illustrate how the modest and veiled female body breaks through to mark the site of enunciation and to signify alongside the apparatus that makes our visual access to the film narrative possible. Kiarostami's post-Revolutionary work unfailingly associates the film's enunciation with this body and genders the cinematic apparatus feminine in association with it.

Taste of Cherry

The second example of the association between film technology and the veiled female body articulates one of the ways in which post-Revolutionary Iranian cinema emerges from this oeuvre as a woman's cinema—a cinema produced by going through this veiled figure. Kiarostami's 1997 film *Taste of Cherry* revolves around a middle-aged man's intention to commit suicide. Unwavering in his intention, he searches for a compassionate stranger who is willing to bury him. We first encounter the lead character, Mr. Badii, in a long opening sequence as he approaches various groups of workers who are waiting along the road to offer day labor. The dialogue between Mr. Badii and the workers has sexual undertones, and this creates a sense of uncertainty about what is actually taking place. This tension is maintained for some time, unsettling us from the start. We eventually realize that Mr. Badii is driving about the city in his car in an attempt to find a sympathetic soul willing to cover him with soil the morning after his suicide. In his desperate search for a friend who is prepared

to do the dirty work, Mr. Badii initially propositions a construction worker in the prologue and then, in successive scenes, picks up a Lorish soldier, an Afghani theologian, and a Turkish taxidermist, Mr. Bagheri. Mr. Bagheri, an elderly researcher, finally agrees to show up the next morning to give Mr. Badii a proper burial.

In the course of his encounters, Mr. Badii (and the audience) develops a taste for the splendor of life. Attempting to console him, the old taxidermist tells Mr. Badii how the sweetness of a freshly harvested mulberry mended his marital differences after a fight with his wife. He describes how a mere mulberry at dawn stopped him from hanging himself. What was wrong was not his marriage, in fact, but his own attitude toward the world. The miracle of nature is but one of the wonders of living and reason enough, Mr. Bagheri thinks, for Mr. Badii to live on: "The world is not as you see it. Change your way of thinking and you will change the world. Be optimistic. Look at things in a more positive way," Mr. Bagheri counsels. His story and advice fall on deaf ears, finally. Mr. Badii follows through with his plan and arranges for 20,000 tomans to be paid to Mr. Bagheri once he has ensured the morning burial.

The suicide takes place in total darkness. The camera captures Mr. Badii in profile resting himself down into a ditch by a lone tree. A prolonged black screen, lasting a minute and a half, follows. Then there is a cut to light and color. A coda captured by a video camera shows the crew and Mr. Badii standing on a verdant hill next to the tree under which he was buried. The crew and Mr. Badii watch a troop of marching soldiers in springtime. The soldiers hand each other flowers, smoke cigarettes, and rest peacefully to admire the beauty of nature. "I wanted to remind the spectators that this was really a film," Kiarostami remarks, "and that they shouldn't think about it as a reality. They should not become involved emotionally. This is much like some of our grandmothers who told us stories, some with happy endings and some with sad ones. But at the end they repeat a Persian saying which goes like this: 'But after all, it is just a tale.'"[48]

Kiarostami is not making a Brechtian gesture here. For in many ways, as Jonathan Rosenbaum puts it, the joyful video sequence at the end of *Taste of Cherry* is the "precise opposite of a distancing effect":

> Though it invites us into the laboratory from which the film sprang and places us on an equal footing with the filmmaker, it does this in a spirit of collective euphoria, suddenly liberating us from the oppressive solitude and

darkness of Badii alone in the grave. By harking back to the soldiers who remind us of the happiest part of Badii's life and a tree in full bloom that reminds us of the Turkish taxidermist's own epiphany—Kiarostami is representing life in all its complexity. He reconfigures elements from the preceding eighty-odd minutes in video to clarify what in their ingredients is real and what is concocted.[49]

In *Taste of Cherry*, as in *Through the Olive Trees*, the car becomes a camera box, framing the movement of a diversity of people and showing us the landscapes surrounding the city of Tehran. The car, as Jean-Luc Nancy notes, is a "kinematic truth."[50] In Kiarostami's oeuvre the car that frames movement reflects on the film's own framing and reminds us: "This is a film." Typically, it reminds us of our act of looking as well. But one could also say, as Nancy does, that the film's frame-within-a-frame sets the spectator's "gaze in motion." It is a gesture of reflexivity that turns "the looking into a filming gaze." It is as if the spectator is ceaselessly fitted to the film, Nancy goes on, "not in order to reach a technique, but to open his or her eyes on to the motion that looking is."[51] In fact, as we shall see shortly in the analysis of *The Wind Will Carry Us*, it is this motion of and within the frame, and not the narrative thread, that emerges as the central focus of the camera's modest look. The margins and the marginal gain in importance with this emphasis on movement. What is centrally in the frame fades in significance.

Curiously, despite its ample representation of the marginal and of the various and multiple national ethnicities—the Lor, the Afghani, the Turk—*Taste of Cherry* bars the visual representation of more than a handful of women within the narrative frame. Registering as no more than "a concept," women fail to materialize.[52] Yet such "moments of failure are what make for the construction" Kiarostami muses.[53] A group of veiled women appear on the image track as they walk toward the classroom outside Mr. Bagheri's workplace. Here, in the only appearance of a cinematic apparatus apart from the surreal coda, a woman approaches Mr. Badii's car, our film's camera box, and asks if Mr. Badii can take a snapshot (see figure 18, shot 1). Paralleling the view of the still camera, our film camera captures the veiled woman within the visual frame as Mr. Badii rolls down the car window to take the photograph (shot 3). Surprisingly, the car frame, which is so clearly associated in the film with the cinematic technologies of framing, frames her, while simultaneously blocking our view of her male companion (shots 2 and 3).

18 Mr. Badii takes a photograph from his car window in *Taste of Cherry*.

In effect, at the moment in which the film reveals its enunciative technologies, its productive apparatus as camera, it associates the technology of framing with the body of the veiled woman (shots 1 and 4). This body approaches the car and then directs what we see in the enunciative breach. Here, once again, as the film becomes preoccupied with its own process of production by exposing its technology, it forges a direct link between the techniques of framing, the technologies of filmmaking, and the veiled female body. The veiled and modest figure dictates the composition of shots and their framing. This body, not the male companion's body, is clearly recognized by the film as the constitutive body that produces the visual track and the film's narrative landscape. Even though the film is about a man who wants to die, its address is directed by this female figure whose fleeting appearance alongside the camera in the body of the narrative reminds us of the film's fictional, mediated status. As with the shot of the old carpenter's address to the camera in *Life and Nothing More*, where the production process ruptures the narrative veil, this scene is the setting for an enunciative breach in which the techniques and technologies of filmmaking are directly associated with the veiled female presence. The veiled body becomes signified alongside the apparatus and the framing process that make our watching of the film narrative possible.

While Kiarostami's films seem to abide by the early restrictions placed on the industry with respect to the representation of women, barring them from central roles in the narrative, women are inseparable from his production process and the very texture of his films' address. Studying Kiarostami's post-Revolutionary films chronologically may give us some insight into the pattern by which a cinematic grammar has developed in the post-Revolution period in Iranian cinema through this association of the filmic apparatus with the figure of the veiled Iranian woman and its averted gaze. I turn now to consider how this gendered technology produces codes of perception, indeed a cinematic grammar, that is aligned with the rule of modesty as imposed by the Iranian government on its cinema.

The Averted Gaze

In my earlier reading of *Through the Olive Trees*, I left questions of power and authenticity in order to pursue the sartorial thread. Let us return to the third scene of the film to follow an averted gaze, which I will argue is informed by the post-Revolutionary regulations prescribing visual modesty.

For in my reading the association between the veiled female figure and the filmic apparatus in Kiarostami's work is developed alongside a subtle undoing of the quest for the authentic and the exotic in the ethnographic project. This undoing is the result of the camera's adoption of a modest and averted gaze in accordance with "the commandments for looking." This modest and averted gaze implicitly rejects the orientalism that is sometimes attributed to Kiarostami's representation of ethnic subjects in his "village films."

Hamid Naficy explains that when the direct gaze of desire was prohibited in Iranian cinema after the Islamic Revolution, the averted and unfocused look, signaling modest relations between men and women, began to dominate the screen.[54] Cinematic grammar shifted henceforth as shot–reverse shots between men and women (signaling close heterosexual communication between nonrelatives) became less frequent and women appeared instead in long, static shots that translated the desexualization of cinema into the terminology of an emergent cinematic grammar based in the "commandments for looking." Though some filmmakers satisfied the government demands for desexualization by simply following the guidelines in their shot constructions and editing patterns, Kiarostami, I suggest, took the modest, averted gaze quite literally, quoting the "commandments for looking" in his shot constructions in ways that undo the voyeurism embedded in the conventions of dominant cinema.

In scene three of *Through the Olive Trees*, Shiva drives off from Tahirih's home to find a suitable "peasant outfit" for the educated girl. The camera enters the truck with Shiva. But it does not shift. The camera acts as if it has come in the driver's side door, lens first, and remained there facing the passenger side window. The car moves forward, so we assume that Shiva has taken her place in the driver's seat facing forward and that she is once again driving the car. But this time, when the car moves, the camera resists the conventional point-of-view association with the look of the driver (or car). Rather than look ahead with Shiva as she drives forward, the camera looks out the side window at the greenery passing along the roadside. It maintains an "averted gaze" (see figure 19, shot 1).

The camera captures a pair of children in the side window as the sound track captures their voices calling Shiva's name. The car backs up and Ahmad Ahmadi, the young hero of *Where Is the Friend's Home?*, appears in the car window frame, followed by his fictional friend (shot 2). Throughout the conversation between Shiva and the village children, the camera looks

19 The camera looks out Shiva's truck window in *Through the Olive Trees*.

out the window on the passenger's side. While we can now assume that the camera has adopted Shiva's look as she looks at the boys outside the car's side window, the sequence refuses to provide the conventional reverse point-of-view shot from the perspective of the children looking at Shiva. This reverse point-of-view shot would consolidate this assumption on our part. That linkage fails to materialize, and as the car moves on again to its destination, the camera captures fields of green, children, and the villagers' new school tent in the side-view mirror, stubbornly maintaining its averted gaze (figure 19, shot 3). The camera never looks forward, not once. Clearly something is amiss.

Drawing on the debates on the question of suture in the pages of *Cahiers du Cinéma* and in the film journal *Screen*, the authors of *New Vocabularies in Film Semiotics* explain how our relation to space and time in a film narrative is unsettled when a reverse point-of-view shot fails to actualize according to dominant codes:

> The spectator's ability to construct a mentally continuous time and space out of fragmentary images is based on a system of looks, a structured relay of glances . . . glances that bind the viewer in a position of meaning, coherence, belief and power. It is these traversing gazes that are primarily negotiated through the reverse-shot and point-of-view structures, the central means by which "the look" is inscribed in the cinematic fiction.[55]

In these shot patterns, they argue, the viewer identifies with someone who is off screen, Shiva for example. They call this "someone" a site, or rather, the site of an "absent other." The main function of this site is to signal the virtual space that the spectator is to occupy within the narrative as the camera looks. But this act of looking requires a link to a character, someone who looks on within the narrative on behalf of the spectator, who in other words stands as an alibi for the camera's look and ours too. Conventionally, we see this character looking, in a reverse point-of-view shot. In the scene of the schoolbook in *Bashu: The Little Stranger*, for example, Na'i watches the exchange between Bashu and the village children (see figure 3, page 33). The next shot, a reverse shot, shows her looking. "The reverse-shot structure enables the spectator to become a sort of invisible mediator between an interplay of looks, a fictive participant in the fantasy of the film. From a shot of one character looking, to another character looked at, the viewer's subjectivity is bound into the text."[56]

The point-of-view shot, the reverse point-of-view shot, and the shot–reverse shot, in other words, perform a semiotic and an ideological

function. They work to immerse the spectator in the film narrative. They structure the narrative and the subject's place within it. The glances signaled by the point-of-view and reverse shots create a structure of relations through the exchange of looks that suture the spectator into the film text. The reverse point-of-view shot to the driver's seat, for example, would allow the spectator to link his or her look to Shiva's as she looks at the boys, or as she drives ahead on the road. In the exchange of looks that would occur between the point-of-view shot and the usual reverse shot, the spectator would become part of the process that moves the narrative toward closure. This happens because, as Daniel Dayan maintains, the reverse-shot structure renders the discursive construction, the site of filmic enunciation, invisible. The spectator identifies himself or herself as the source of the narrative, as part of the cinematic sinew linking character looks, thereby erasing the camera's enunciative role in the structuring of the scene and the setting of the narrative. This process of association and erasure produces a mystified subject who "absorbs an ideological effect without being aware of it."[57] The spectator thus becomes embedded in the structure that produces the time and space of the narrative as continuous and whole.

The scene in which Shiva is driving counters these ideological functions of suture by dissociating the camera from the look with which the narrative has identified since scene one. The camera assumes an independence that it grants by extension to the spectator. While the film's address is seamlessly associated with Shiva's veiled figure through the voice of her character, the viewer's identification in this scene, like the camera's, is dislodged. The spectator is no longer anchored as an invisible mediator on whom the closure of the narrative depends. He or she is thereby released from dominant narrative cinema's ideological and discursive constructions and rendered autonomous in relation to the images and sounds unfolding on screen: "Claim your independence from the narrative," the camera whispers to us. "See anything you like!" "Be anywhere!"

The camera thus averts its look from the direct linear gaze that moves forward with the car and that looks ahead with the driver. It only rises to the alert as the next cut moves Shiva's body into the frame, clapper in hand, to identify the numbered scene and take for the first exchange between the newlyweds of Life and Nothing More (figure 19, shot 4). As usual, Kiarostami plays a trick on us. The clapper board identifies the scene that is being recorded as scene 4, shot 1, take 1 of Through the Olive Trees—the scene we are about to watch on screen.

The averted gaze assumed by the camera in the 1994 film *Through the Olive Trees* brings Kiarostami closer to what he termed "the half-made film" when five years later he produced *The Wind Will Carry Us*. The half-made film, he explains, demands that the audience be an equal participant in the making of the narrative. "I can't bear narrative cinema," Kiarostami exclaims in an interview with Jean-Luc Nancy:

> I leave the theatre. The more it engages in storytelling and the better it does it, the greater my resistance to it. The only way to envision a new cinema is to have more regard for the spectator's role. It's necessary to envision an unfinished and incomplete cinema so that the spectator can intervene and fill the void, the lacks. Instead of making a film with a solid, impeccable structure, one should weaken the latter—yet keep in mind that one mustn't drive the audience away! The solution may lie precisely in stimulating the viewers so that their presence is active and constructive.[58]

The Wind Will Carry Us

As in many of Kiarostami's post-Revolutionary films, the narrative thread in *The Wind Will Carry Us* is worn thin. Behzad, the film's lead, travels with his Tehran-based crew to the remote village of Siah Darreh to record a ritual performed by village women after the death of an ailing hundred-year-old village elder. The death fails to take place. In fact, little happens on the level of the narrative. Behzad and his young guide, Farzad, become the visual locus of "what goes on." The conversations between the two repeat and revolve around Behzad's inquiries into the old villager's vital signs. The obsessive return to this issue leaves no doubt about the film's morbid narrative reality: the hero of our film wants this woman to die so that he and his crew can return to their worn urban lives having amassed some great ethnographic material.

As for our film, it would seem that what is outside the frame (and indeed what is centrally in it) is of no significance whatsoever. There is no story per se. There is no reason for the viewer to follow Behzad's quest. And though the central question of the film is the hushed "When will she die?" the old villager does not die, and the crew does not leave. Neither the villager's death nor the ethnographic project is able to provide the film with narrative closure. In fact, narrative closure is uninteresting, even morbid. The film repeats itself as the conversations repeat and as Behzad repeatedly gets into his car to drive to the top of the hill to find reception for his cellular phone.

Meanwhile, the film itself delivers the undoing of the crew's ethnographic fascination on a silver plate. In one of the many scenes in which Behzad asks Farzad about the old woman's health, he also asks if Farzad thinks he is a bad person, presumably for wanting the old woman to die. Farzad responds shyly that Behzad is not a bad person, though it is clear that he is not being quite forthright about what he thinks Behzad is doing in his village.[59]

Similarly, in a scene in which Behzad gives Farzad's schoolteacher a ride, he asks the teacher what he, as an educated man, makes of the ceremony that Behzad's crew is there to document. The teacher responds by narrating the pain and horror that the ceremony represents to him as a resident of the village and as someone who has observed the effects of the ceremony on his own close family. The ceremony's roots are bound to economic needs, he says. Women mutilate themselves in the ceremony so that their husbands can keep their jobs or be promoted. The severity of the mutilation depends on the power that the deceased had held in the community. "For you who look at it from the outside, it may be interesting," he tells Behzad, "but this kind of thing doesn't interest me." What is central to the ceremony is economic power, he concludes.

In this film, the narrative elements that would move the film forward are instead forced into a cyclical repetition of questions and responses: "How is she?" Behzad asks Farzad. "Who?" the boy responds. "You ask 'who?' again . . . Our patient, of course." The scenes of Behzad and Farzad walking through the village, discussing Mrs. Malek's health, repeat over and over again (figure 20). We know the flow of the conversation. We know the sites where they take place, we know Behzad's and Farzad's pattern of movement through the streets. What is there to follow in these scenes? And who?

Like the drive up the hill to the graveyard that provides Behzad the altitude he needs to make the cellular phone connection, the discussions between Behzad and his crew become excruciatingly predictable. The crew members want to return home. They want to know when the villager will die. They want to know how Behzad knows that it will happen soon. They sleep long hours, eat strawberries, and long for fresh milk. And even though the exchanges between Behzad and his crew become rote, the crew members only appear (in an establishing long shot) within the film frame once. The audience learns to recognize their voices and their complaints, but their faces remain unknown to us. As in the scene in *Through the Olive Trees* where the camera separates from Shiva's look as she drives

20 Benzad and Farzad walking through the village in *The Wind Will Carry Us*.

the car, the camera here refuses to react to Behzad's point of view when the crew members appear outside his passenger side window on a strawberry-picking excursion. Going against all standard convention in dominant cinema, the camera again and again dissociates its look from the characters' looks. Looking in, Behzad speaks to his fellow travelers through the doorway to their bedroom. When he peers in, the camera holds back. The camera even fails to associate itself with the crucial reverse point-of-view shot from the vantage point of the groggy crew when Behzad speaks to them in their bed. While Behzad is ostensibly obsessed with death, we are visually confronted with a dead end: What are we to look at when our vision is so proscribed? What are we to follow when the narrative stubbornly repeats itself and resists closure? What is the film saying to us?

A return to the subterranean sequence discussed earlier, one of the most evocative sites of enunciation inscribed in the visual track of the film, may provide some clues. In this scene, Behzad asks Zeynab to lift up the gas lamp so that he might appreciate the ditchdigger's taste. In the dim cellar, she rejects his desire and we do not see her face. Instead we become acutely aware of the framing shadow that unframes her and of the frame that has likewise prohibited our access to all that the camera has insisted on keeping outside our view throughout the film.

This sequence should be recognized for its self-reflexivity, where our inability to see Zeynab's face is reflected upon in the exchange between

the characters. The scene pointedly reveals how the film technologies produce the visual track, sculpting the film in light and shadow. Behzad wants to see Zeynab's face, but like the spectator, he is visually blocked by the technology of film production (by lighting). While it would seem that the ban against close-ups of females has been lifted, the ditchdigger's lover is never represented in a close-up. We realize that Kiarostami does more than merely abide by the 1982 restrictions on the representation of women; he quotes and then applies the regulation differently. He veils the scene, framing it with the productive technologies of the film, technologies associated throughout his oeuvre with the veiled and modest female body. This framing technique is not only commented upon in the film narrative, it is actively used to absent and unframe ten other characters critical to the continuity and closure of the narrative itself.

Behzad's extensive conversations in medium shots and close-ups with other female characters in the film reassures us that Kiarostami's work is not about bowing to censorship or turning it into a form of orthodoxy. Rather, he seems to be interested in developing a cinematic grammar, a language, and a filmic technique in relation to early state demands to create Iranian cinema's address as primarily national—a cinema, in other words, that speaks in a dialect but in the global context: "Without doubt . . . [my films] have deep roots in the heart of Persian culture. Where else could they have their source?"[60]

Recognizing the impossibility of closure for the receivers of a desexualized cinema, the film structures an enunciative landscape that ignores closure by averting the camera's look. In so doing it rejects the voyeurism of dominant cinema. This gesture unmoors the quest for the authentic and the exotic from the voyeurism of the look in films on the global market. In its stance against voyeurism, the averted gaze also overturns a notion of progress that is embedded in the framing and editing conventions that militate the ever-forward march of the narrative plot in film.

This is not to say that Kiarostami's films are constructed as a direct affront to the West or to the domination of Hollywood conventions per se. The articulation of such East versus West binaries would go against Kiarostami's fundamental indifference to such dichotomies, as he continues to maintain an ambivalent stance in relation to both national and global demands in his post-Revolutionary films. As Chow suggests, "When critics concentrate their analyses overwhelmingly on the

complexities of the 'dominant' Western gaze in the process of deconstructing it, what they in effect accomplish is a superimposition upon 'West' and 'East' the great divide between seer and seen, active eyes and passive spectacle—a great divide that can as easily perpetuate as disable orientalism."[61] *The Wind Will Carry Us* seems to signal this stance immediately, as the first scene set in Taj Dawlat's coffee shop demonstrates.

Against Voyeurism

The morning after the crew arrives at Siah Darreh, Farzad leads Behzad to the village square. In this scene, Behzad ransacks his car, which is parked in front of Taj Dawlat's coffee shop, where an old man—Farzad's "young" uncle—and Taj Dawlat's husband enjoy a break. Behzad is searching for his camera, which Taj Dawlat has taken out of his car to keep it safe from curious schoolchildren. This gesture once again points up the conjoining of film technology and the veiled female body in Kiarostami's post-Revolutionary oeuvre. When Behzad sits down to have tea and comments in the same breath that he has never seen a female *ghavechi*, Taj Dawlat admonishes him for his sexism and asks him about his mother and whether she, an urban housewife, has never served anyone tea. She then asks Behzad if he is in the village to work on setting up a communications network, because, she asserts immediately, the town is well endowed in that regard. What would they need his network for? When she then plunges into a quarrel with her husband regarding the sexual division of labor, Behzad uncovers his lens to take a picture (see figure 21). As if underscoring the absence of a number of characters from the screen, Taj Dawlat cautions, "No pictures!" Her veiled body determines what is captured and how.

The appearance of the camera within the frame signals the self-reflexivity of the moment on at least two levels. On the narrative level, the quarrel between the coffee shop owner and her partner mirrors the discussion Behzad has just had with Taj Dawlat regarding the sexual division of labor. Un-self-reflexive to a fault, Behzad attempts to defend and isolate his own sexism as an issue that could only apply to the rural peasant couple. His attempt, of course, fails. The camera is blocked from exoticizing otherness by containing and framing difference. In this moment of narrative rupture, the film's own technology becomes the subject of the dialogue between the two characters, as the film pauses to tell us what it is

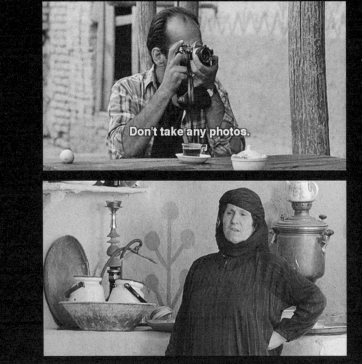

shooting for instead. As the narrative seemingly continues to fetishistically seek the exotic in the mutilation ceremony associated with the death of the village elder and as the film's central character pursues that orientalizing difference that differentiates him from the villagers, the film reveals the landscape of its own address as the quotidian, the marginal, and the ephemeral. It thwarts the narrative drive to document difference by dwelling on its own preoccupations with its own enunciative technologies. To reiterate the significance of this scene as a scene that emphasizes the camera's own address, Taj Dawlat admonishes Behzad three times and threatens to take the camera away from him. She prevents Behzad from exoticizing village life and in doing so attempts to stop him from regarding patriarchal gestures as isolated and contained within the village boundaries.

In blocking the voyeurism associated with cinematic technology, the scene challenges several assumptions, including the powerlessness of the female villager compared to the female city dweller (i.e. Behzad's

22 Farzad's "young" uncle in the scene from Taj Dawlat's coffee shop in *The Wind Will Carry Us*.

seemingly helpless mother) and the power of the urban male over the village female (she can take his camera away from him). In addition, it juxtaposes the sexism of the peasant and the sexism of the city dweller on the issue of women's labor, and finally proceeds to set up modern communication as commensurate with village technologies. Common to all four binaries is the assumed superiority of the modern city dweller behind the camera. Both power and privilege are undercut by Taj Dawlat's refusal from the outset to allow Behzad visual access.

Bundling these issues of power, privilege, and modernity together against the backdrop of everyday life and in the purview of the old man, whom Farzad refers to as his "young" uncle who is constructed in the scene as the viewer and listener of this coffee shop fable (see figure 22)—the narrative emphasizes that a simple deconstruction of the urban center and restitution of its peasant other does not eliminate disparities in the relations of power. Both urban center and rural periphery operate within dangerous ideological paradigms that in many ways mirror each other. The dismantling of one is only possible if we concede to what Johannes Fabian speaks of as the "coevalness of cultures": the Kurd, the Tehrani, and the New Yorker are peers in the age of globalism. As Chow puts it, "The 'primitive' is not 'of another time' but is our contemporary."[62] *The Wind Will Carry Us* affirms this point in the presence of the elderly "young" uncle, underscoring Kiarostami's own refusal to take on the role of the primitive genius in the global culture of cinema.

While the film clearly articulates the constructedness of the scene, imparting the story's "counsel" to the viewer-listener through the "young" uncle looking on, Taj Dawlat's resistance to the camera's freeze frame also articulates a rejection of the orientalism implied in Dabashi's critique of the film. Her emphatic gesture of resistance to the exoticization of "otherness" in this early scene is echoed in the schoolteacher's later critique of the ethnographic project—a project that casts "the primitive" as "static," "exotic," "backward," and "ever the same" in contrast to the progressive, modernized urban dweller who arrives to document a primitive ritual. The teacher's references to labor and the economy emphasize that the ethnographic object that Behzad is after is neither localized nor necessarily authentic. We are reminded that the participants feign mourning. The ritual performed at an elder's death in Siah Darreh is just another entrepreneurial ploy in climbing the capitalist ladder. Thus Taj Dawlat's rejection of the ethnographic framing of the camera and its casting of the urban male in a position of power, privilege, and progress is a simple first lesson in Behzad's "crash course" in the problematics of an ethnographic project in the later scene with the village teacher.

Guarding this interplay between the story and the film's enunciation, Taj Dawlat is associated with the cinematic apparatus itself. Her fabulous, "authentic" veiled primitive figure appears alongside the technology of film, the camera. She is simultaneously associated with what we see within the frame and with what frames the visual at the moment of enunciative rupture, thus constituting the landscape of the film's own address. On the narrative level, she is the one who grants Behzad access to images of the village everyday by handing him back the camera while at the same time denying him permission to capture certain images: "I said no pictures" (figure 21). Guarding the threshold of Kairostami's film she alerts us to the dichotomies within and between the material or real (production, enunciation) and the fabulous (story, narrative) in film. At the site of enunciation is the veiled body of the villager. She operates at the cusp of the authentic and the fabulous, "the modern" and "the primitive," and her object, what she encounters, is the dialectics of contemporary everyday life.

The old man introduced to us as Farzad's "young" uncle is the embodiment of cotemporality as signaled by the narrative, the coevalness of past and present that dissolves these binaries. His is the site that the spectator inhabits in the film text. His "young-old" vision underscores

Chow's argument regarding the alternatives to allochronism in the cross-cultural encounter. Drawing on Johannes Fabian's notion of allochronism, a term he uses to talk about a nation-centered theory of culture, Chow maintains:

> It is only through thinking of the "other" as sharing our time and speaking to us at the moment of writing that we can find an alternative to allochronism, [the position of the other, that is] the position of the feminized, ethnicized spectator as image as well as gaze, object of ethnography, as well as subject in cultural transformations is a position for which "coevalness" is inevitable.[63]

It is this coevalness that is productive of Iranian post-Revolutionary cinema's temporal address; a coevaln°ess that, I have argued, is grounded in the national tradition of the ta'ziyeh, even as the national cinema encounters the world.

"The Half-Made Film"

What is "the half-made film"? In talking about *The Wind Will Carry Us* as well as his work in general, Kiarostami has referred to his notion of the "half-made film" in which the elements that are erased or left incomplete invite the viewer's "imaginative participation."[64] In *The Wind Will Carry Us*, what we see when we do not see is what we see with a modest and averted gaze. In Kiarostami's films, the averted gaze, linked to the camera's framing,

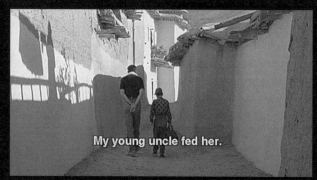

23 Bodies cast shadows as they drape clothes on lines in *The Wind Will Carry Us*.

24 Fictive primitives in *The Wind Will Carry Us.*

captures movement—and perhaps brings it into sharper focus. The movements of everyday life are going on at the conspicuous edges of repeating scenes, alerting us to what is important to the camera itself. Here bodies cast shadows as they drape clothes on lines to dry (see figure 23), herds of sheep fill the unpaved roads (see figure 24, frame 1), and baby chicks litter stairwells. The modest look of the camera frames a world where balls appear followed by running children, apples roll in the dirt and get brushed off and passed on to rest next to an elbow in a coffee shop (see figure 25). Green hay moves as if on its own, on the back of the disembodied voice of an "ethnic" subject (see figure 24, frame 4). Time passes here as if yesterday were a month ago, and an old villager lives to be one hundred and fifty, or one hundred with a discount. This fabulated world shows technology's capacity to dream and its own continued wonderment at capturing motion. Unlike the direct voyeurism of dominant narrative cinema, Kiarostami's is an exhibitionist cinema of the kind discussed by Tom Gunning—one enraptured by the magical possibilities of cinematic technology itself.[65]

In our mystified craving for narrative closure, we tend to forget that movement was the fascination of primitive cinema. And it is this primitive fascination that Kiarostami turns to in order to capture the fictive primitive with a newly gendered lens. It is as if the new form, the emerging grammar of Iranian post-Revolutionary cinema, must retrieve an ur-form lodged in the ur-history of the contemporary technologies of film in order to take shape. The fictive primitive, appearing alongside the productive technologies of cinema, reflexively reminds us of the primitivism of the camera's obsessions and of the historically redemptive turn of the camera itself. Lodged in this way, Kiarostami's camera frames and fabulates peripheral movement as the object of its fascination, ignoring its contemporary audience's naturalized quest for the forward push of the narrative, even a narrative that deems closure morbid if not impossible.

As Gunning argues, the viewer of primitive cinema was "positioned less as a spectator-in-the-text, absorbed into a fictional world" by the relay of gazes that presuably suture him or her into the narrative. Although the move to position the spectator in certain scenes is unavoidable, Kiarostami's camera assumes the audience to be its equal most of the time, modestly "held for the moment by curiosity or amazement."[66] In Kiarostami's half-made film, the narrative is the viewer's artisan craft, for the most part. What we weave together from the scraps of everyday life and the peripheral movement of objects and subjects framed by the veiled

25 An apple rolls and comes to rest next to an elbow in a coffee shop in *The Wind Will Carry Us.*

body and directed by the fictive primitive is our part in the filmmaking. In its self-absorbed wonderment at its technology's magical capabilities, the camera cuts the cord and frees us to reflect on what *we* bring into the darkened theater with us. In these moments we may recognize, for example, a conditioned homophobic reflex that has us wondering if Mr. Badii is trying to turn a trick on the dirt road in the opening sequence of *Taste of Cherry.* The "half-made film" leaves us room to self-reflexively ponder the unconscious dreams we knot around the scraps of fabulated everyday life, conditioned as we have become by the standardization of a particular cinematic language to weave ourselves into a narrative we think might be progressing on screen.

Coda: *Ten*

Kiarostami's *Ten* (2002) screens ten conversations between an urban visual artist and photographer, Mania Akbari, and the passengers she picks

up as she drives around Tehran. Many critics, including Roger Ebert, have expressed frustration with *Ten* and surprisingly exited long before the penultimate segment, in which one of Akbari's passengers unveils her shaved head. Admittedly, the film appears to have nothing worth watching. The series of often repeating dialogues that sustain a long and averted camera gaze in the closed quarters of a mini-SUV becomes tedious even if taken, as many have, as an ethnography of the life of urban Iranian women. But as I have tried to point out throughout this chapter, the decisive underlay of Kiarostami's cinema is a critique of the morbid effects of ethnography, a critique that is brought to the foreground emphatically in both *Through the Olive Trees* and *The Wind Will Carry Us*.

Setting aside, then, the possibility of ethnographic realism as the narrative motive of the film, *Ten* seems to appear as a coda to Kiarostami's oeuvre, the filmmaker's reflection on his own filmmaking culture. As such it exposes the logic of his film language, the cinematic landscape of his films' address, and the productive link between the body of the veiled woman and the cinematic apparatus in his post-Revolutionary films.

Each sequence of Akbari's conversations with her passengers is cut in between a numbered countdown reel. Wedged in this way, the ninety-four-minute film fiction plays as scraps of film reel that screenings generally edit out. One cannot help but hear that trickster whisper, "Here is a film about women that the projectionist should have wound into the receiver reel minutes before you entered the theater."

Jonathan Rosenbaum has described *Ten* as a "daring enterprise," not because of this formal intimation about the nature of the film project, but because of the film's attempt to eliminate the directorial role altogether.[67] Kiarostami's obvious absence from the set in a film he has coined the "non-made film" points up the impossibilities of heterosocial interactions between female actors and their male director. Women have been taken off the screen in the era of post-Revolutionary modesty. Thus to show women as central characters, in this logic, means absenting the male director altogether.

In the opening sequence of *Ten*, a small DV camera, fitted on the dashboard, turns on to a close-up of a young boy in conversation with his divorcée mother, Akbari. Fifteen long minutes later, as if to relieve the viewer from the patriarchal rant of a young boy acting like a puny version of Akbari's suffocating ex-husband, the camera cuts to a medium close-up of Akbari, fully made-up and in Islamic garb—a contradiction in bearing that has taken media-focused Western audiences by surprise. From

this point on, the camera associates its view with this photographer's veiled body, gives itself to the claustrophobic environment she has long tried to escape, and attends to her tempered frustration with the erasure of women from Iranian societal laws.

As a feature-length coda to Kiarostami's post-Revolutionary work, *Ten* does more than merely expose the frame in order to show the reality behind the fiction, which admittedly is part of the function of the controversial coda to *Taste of Cherry* discussed earlier. Instead, *Ten* reads as the exposure of the now de-auteured auteur's literal quotation of modesty laws in his post-Revolutionary work. His films are *only* movies, and though imbued with an air of realism they are *also* movies, as Rosenbaum has said.[68] But as Kiarostami's films *Close-up* (1990), *Life and Nothing More*, and *Through the Olive Trees* have amply demonstrated, his films are also about the processes of *making* movies in post-Revolutionary Iran. As such, what *Ten* reflexively reveals in formal terms is Kiarostami's films' attempt to allegorize the restraints and the possibilities of cinematic enunciation under the stringent laws dictating modesty in the Islamic Republic. *Ten*, as a whole, represents a displaced allegory of the conditions of the post-Revolutionary industry itself.

In *Ten*, the film that should have been reeled forward, past the countdown to the overture of an actual film, shows not outtakes but the veiled female figures that are constitutive of the address and grammar of Kiarostami's cinema. As formative technologies, the bodies are consumed with the contradictions of a Republic that is outwardly Shiite and inwardly secular. These bodies, structured by and projected as practices of Islamic law, are forces that have become constitutive of the landscape of a cinema of contradictions, in which life on screen must appear somewhere in the wedge between presence and absence, between realism and fiction, between the original and the copy—in short, between a dead-end narrative and the magical signature of peripheral movements—articulating itself as the deferred allegory of the conditions of film production in Iran. It is perhaps this, Kiarostami's allegorization of the structuring conditions of the Iranian narrative screen that accounts for the bewildering association many of the cinema's reviewers have drawn between Iranian cinema and a European modernist inheritance.

Negative Aesthetics

Post-Revolutionary Iranian Cinema and 1970s Feminist Film Theory

What might post-Revolutionary Iranian cinema contribute to a feminist critique of international films? While this concluding chapter continues the book's concern with strategies of representation in Iranian cinema, the framing questions considered here also situate feminist analytical practices in relation to cinematic representations that travel. Travel, that is, to international film festivals, art houses, and commercial theaters as representatives of "national" cultures, as "national" cinemas. How does an analysis informed by feminist film theory and alert to the materiality of culture and the power differentials associated with the intervention of colonialism, imperialism, and global capitalism in national cultures reckon with representations of women and nations on screen?

How does a feminism conscious of the interrelation of modernity and postcoloniality account for the fact that for many non-Western cultures, becoming modern means returning to or *inventing* traditional cultural practices that are grounded in "the national"—which, as Jean-Luc Godard remarks, "no longer knows what it is" in national cinemas—but nevertheless conditioned in relation to Western modes of modernization and capitalist processes of globalization?[1] How does one move beyond the visual impulse to read representations of both woman and nation as signs of "realism" or "authenticity" in the historically sedimented terrain of a global medium such as film? To proceed, let me identify some of the concerns that give rise to these framing questions.

Although the Iranian film industry predates the establishment of the Islamic Republic, it experienced substantial growth after the Revolution

of 1979. Winning the Grand Prix at the Nantes Film Festival, Amir Naderi's *The Runner* (*Davandeh*, 1985) introduced post-Revolutionary Iranian films to the world screen, and Iranian cinema thereafter gained wide popularity on the festival circuit. In 1992, the Toronto International Film Festival called Iranian cinema "one of the pre-eminent national cinemas in the world," a verdict echoed some years later by a *New York Times* reviewer who called it "one of the world's most vital national cinemas."[2] With sixty to seventy films in production annually in the late 1990s, Iranian cinema ranked tenth in the world in output, surpassing Germany, Brazil, South Korea, Canada, and Australia and far exceeding the Middle East's traditional high-volume film producers, Egypt and Turkey.[3]

Perhaps the most stereotypical marker of post-Revolutionary Iranian cinema on the film festival circuit is its description as an industry attached to color—that is, to the abundant use of color in representing sweeping landscapes, peasant life, and nomadic existence. These cinematic representations, promoted by the national industry in such films as Mohsen Makhmalbaf's *Gabbeh* (1996), *The Silence* (*Sokout*, 1998), and *Kandahar* (2001); Abbas Kiarostami's Koker trilogy and *The Wind Will Carry Us*; and Majid Majidi's *Color of Paradise* (*Rang-i Khoda*, 1999) and *Baran* (2001), have come under scrutiny both within Iran and in the diaspora. Watching the success of the industry at film festivals around the globe, critics repeatedly argue that the industry's depiction of Iran and its "way of life" is unrealistic.[4]

Central to these critiques is the industry's problematic representation of women. In Iran, and increasingly in the West, a particular mode of critique introduced by Iranian feminists articulates the shift from pre-Revolutionary cinematic depictions of women as "unchaste dolls" to the "chaste dolls" of the post-Revolutionary period. Shahla Lahiji's work is at the forefront of these critiques and suggests that the "unchaste dolls" of the pre-Revolutionary cinema were banished from the cabaret stage and are now chastened and confined within the interior walls of the kitchen and engaged in domestic chores.[5] While these critiques of stereotypical representations of women may be seen as progressive in the context of a national industry that is charged by its government to propagate proper standards for Islamic life through film, they become problematic as they make the rounds of international film festivals. What is key in this context is the critical appeal to *realism*.

Lahiji maintains that the stereotypical depiction of women on screen in post-Revolutionary Iranian films has recently been challenged by the

work of female filmmakers who "chose to object to the unrealistic image of women in Iranian cinema" by presenting them in a more realistic light. She claims that "the international reception of [their] approach [to representation has] finally persuaded their male colleagues to reappraise their own work" and attributes the realistic portrayal of women and their role in Iranian society to the widespread positive reception of post-Revolutionary Iranian films around the globe.[6] The stereotype is thus countered by realism, and realism is posited as the condition for the industry's economic success internationally.

I raise Lahiji's critique of the industry here because to me, the critical issue in cross-cultural readings of representations as truth is reliance on the category of "realism"—a realism which, as I have indicated throughout this book, is deeply embedded in the "grammar" of classical narrative cinema, its dominant codes, narrative structures, and genre conventions. The "cinematic is never a neutral window onto the representational," as Chris Berry argues; "rather it interacts with it in various ways to produce meaning, whether through framing, angle, editing or whatever."[7] In part because of its attachment to the representational strategies of fiction films, realism in film cannot be thought outside the history of Hollywood classicism and its enunciative procedure, regardless of the film's national origin. "If we say that, at one level, Americanization operates by fusing national values with what cinema studies has called 'production values,'" then it is important, as John Mowitt emphasizes, that one become cognizant of "the film language that constitutes the grammar of such production values."[8] The language of classical Hollywood film gives shape to the grammar of fictional realism and is therefore implicated in demands for realism such as Lahiji's.

Voyeurism is central to Hollywood classicism, as are the deictic conventions of temporality and spatiality that produce the key components of continuity in realist film traditions. Dominant conventions of realism are determined by continuity editing, spatial arrangements, and the use of color. As David Desser's reading of Japanese fiction films shows, these are precisely the tropes that the Japanese film industry rejects, instead, he argues, looking for its roots in traditional nonrealist art forms.[9] Japanese cinema is only one of many examples in which a resistance to realism signals a rejection of the imperialism of dominant cinema by rooting its resistant representation and production values in extant national art forms. Post-Revolutionary Iranian cinema, as the examples from the work of Bahram Bayza'i and Abbas Kiarostami demonstrate, follows a similar

conscious trajectory that by necessity rejects the dominant spatial and temporal codes of fictional continuity and grounds new codes of production in the enunciative deictics of indigenous cultural traditions. In Chinese cinema, which attempts to cultivate an "anti-individualistic aesthetic, contrary to the Western paradigm," Berry shows that films adopt American production values to signal "transgression, failure and collapse" in certain segments. Hollywood codes are used to represent the "assertion of individual interests" above "a concern for the group," individualism being a notion foreign to traditional Chinese values.[10]

The insistence on difference on deictic rather than iconic grounds in such "national cinemas" suggests that reflexive properties, belonging to the level of enunciation and production, inscribe themselves in the narrative. Here, as Mowitt argues, the enunciation reiterates the conditions of narrative production, reflexively making "the circumstances of transmission part of the message transmitted."[11] Enunciation inscribes the space and time of the narrative while rendering present the moment and place of the film's production. Thus we learn, following Mowitt, that "within the logic of enunciation is encompassed a mode of reflexivity that allows filmic statements to act upon themselves by linking them to the condition of their production, understood not in terms of the cinematic apparatus as such, but in terms of cinema's relation to the geopolitical genealogy of its own emergence."[12]

Taking examples from a cinema concerned with its difference from imperialist and capitalist values, my close readings of films by Bayza'i and Kiarostami have attempted to show that focusing on production values not only profiles the difference of the national from the global but also places in stark relief the historical stamp of Hollywood on the international film industry and America's role in the conditioning of the senses everywhere. If we accept such global effects of Americanization as historical givens, or in other words if we come to understand the convention of realism as a historical imprint of an imperialist logic, indeed a marker of American melodrama, on nondominant cinemas, can "realism" still stand as the measure of feminist approaches to international films? In the context of Hollywood's imposition of what constitutes value in film, namely narrative realism, a feminist critique of international films cannot proceed merely by reading narratives for realistic representations or by suggesting that stereotypical representations be undercut and replaced with more realistic ones.

In the global circulation of colorful "fictive primitives" on screen, what films offer to knowledge is not access to the real beyond representation

but "a negative return on an absolute investment" in representation as truth.[13] While a simplistic articulation of this formula would have it that if a camera is there, what you see on screen cannot possibly be real, its corollary in a feminist analytics of international cinemas must be the recognition that "realism" stands as a discursive alibi for "an authentic encounter with difference," be it with the female body on screen or the other's nation in effigy. Attentive feminist film analyses must proceed in full recognition that "fictive primitives" in national films are just that: fictive products of "formal systems active in film texts."[14]

Recognizing the imperialism of the cinematic gaze does not mean that a feminist analysis of international films can mindlessly appropriate the idea that women have an innate ability to judge the authentic representation of women in other national cinemas or in their own. A feminist study of international film must assume that a native subject (be it a filmmaker or a film critic) is as likely to create "inauthentic" representations of his or her own culture as any other national. Assuming otherwise reifies essentialisms that only feed the impulse to orientalize, stereotype, and fetishize other cultures. Furthermore, representations in national cinemas cannot be relied upon as authentic ethnographic specimens to be considered in multicultural curricula for gender or cultural studies. This process by which knowledge of the other is produced at Western universities is just one example of the kind of paradoxical practice that Ranjana Khanna points to as threatening a breakdown of transnational feminism because of a "fetishization of the local at the expense of coalition."[15] Operating on a global terrain, national film cultures represent neither real identities nor uncoded realities. They create worlds. They screen *fictions*—fictions inextricably linked in their enunciation to dominant codes of representation, whether in opposition to or in tandem with them—while simultaneously developing a grammar of film as a national tongue.[16] The "transnational history of the cinema," as Mowitt has amply demonstrated, is "a history in which production is as much about product as empire."[17]

It is the specificity of this encounter with empire that is laid bare in our reading of enunciative strategies in national cinemas. As Mowitt argues, "Because enunciation insists on the so-called formal systems active in film texts, it allows one to think the complexity, indeed the heterogeneity, of this history without . . . reducing the film to its themes. In effect, enunciation provides the means by which to mend the gap between text and industry."[18] My emphasis on the fundamental importance of enunciation in

reading Bayza'i's and Kiarostami's work highlights the role played by production practices in underwriting the national address in the narrative. It is here, on the level of enunciation, that the nation meets empire.

Realism and Foreign Sound

My aim thus far has been to put forth a dual argument with regard to realism and the representation of "woman" and "nation" in film. One side of this argument returns to issues I raised in my analysis of Kiarostami and Bayza'i concerning the effects of standardized codes as inscribed in dominant production values and in enunciative strategies that adapt, adopt, and counter in response. The other side of the argument is entangled in notions of truth that attach themselves to "realistic" and "unrealistic" representations of "the woman" and "the nation" in cross-cultural encounters, especially on the international film festival circuit.

In pursuing the logic of this latter thread, it is critical to note that a reliance on the category of "realism" as some measure of truth presupposes that cross-cultural encounters in film follow a universal protocol. Orientalist travel discourses and imagery, however, precede and pervade the field of contact. Thus the meaning of realism in the framework of Western cinematic representations varies in the reception of third-world films, regardless of the similarity of codes and conventions used in their enunciation or in the standardized processes involved in the production of their portrayals. Even in the "autoethnographic" projects of fifth-generation filmmakers in China, certain films gain "transnational status" because, in the words of Sheldon Hsiao-peng Lu, "they are seen as possessing an authentically 'national,' 'Chinese,' 'Oriental' flavor by Western audiences. In the meantime, the domestic Chinese audience dismisses the same films as 'misrepresentations' and 'mystifications' of China."[19] My discussion in chapter 2 suggests that the reception of Kiarostami's post-Revolutionary films has similar features.[20] Consider the reflections offered by Bill Nichols on the reception of new cinemas in the film festival circuit. He writes: "We learn about other portions of the world and acknowledge the ascendancy of new artists to international acclaim. Like the anthropological fieldworker, or, more casually, the tourist, we are also invited to submerge ourselves in an experience of difference, entering strange worlds, hearing unfamiliar languages, witnessing unusual styles."[21]

True, the images we encounter at international film festivals show the unfamiliar, but where in these images lies the truth by which we can

experience "other portions of the world" or "submerge ourselves" in their strangeness? How can these representations of "other portions of the world" be taken to express a real and tangible difference in the first place?[22] And what in these representations can justify the comparison of the festivalgoer to the tourist or, more formally, the ethnographer?

Nichols's evocation of the "unfamiliar language" as part of what makes the film festival experience ethnographically valuable is unnerving, because historically speaking, recorded sound was identified as precisely what distinguished "national cinemas" from Hollywood. As John Mowitt's genealogical analysis of the regulatory discourse that has linked film, language, and foreignness in the United States demonstrates, "sound served as a decisive locus for the coordination of domestic and 'foreign' industrial strategies." "This coordination," he writes, "vital in certain respects to the capitalist aim of vertical integration, did not simply standardize a certain technological system; it also displaced the infancy of the pre-linguistic era, of the cinema. In other words, with the exportation of standardized sound practices, the cinema entered language, or, as Fitzhugh Green famously put it, film found 'its tongue.' "[23]

In the international history of cinema, we see that sound gave the European film industries a "new weapon against American domination."[24] Foreign films could talk; indeed they could talk back. In this way they could compete with American films for market share. Yet according to Mowitt, the Academy of Motion Picture Arts and Sciences, like many other national institutions in the 1930s, '40s, and '50s, explicitly intervened in the "domain of indigenous cultural practices not only to impose the capitalist logic of standardization, but also, in effect, to eliminate foreignness from the cinema . . . foreignness [was] obliged to gravitate toward the speech audible on the soundtrack."[25] This intervention in cultural practices, which "expels" national difference (in the grammar of film, in particular) and forces it to return instead as *foreign sound*, identifies precisely the site of struggle for many Iranian filmmakers, a struggle that we should also recognize as any national cinema's struggle against the homogenization and Americanization of the medium itself.[26]

National Film and Tourism

The film festival experience, Nichols writes, evokes the act of travel and the dreamlike "possibility of losing oneself, temporarily, of 'going native' . . . Iranian films, for example, usher us into a world of wind, sand

and dust, of veiled women and stoic men, of unusual tempos and foreign rhythms."[27] Setting aside for a moment the question of indexicality, of the "thereness" of the site in which one "goes native," Nichols's meditations on the film festival experience presuppose a difference of worlds so radical that the spectator and the screened "exotic" represent civilizational others to one another. The film festival teaches us to know the other, Nichols claims, while staying alert to the ways in which knowledge shifts in the global context. "We encounter such works," he writes, "as participant observers in a process that makes what would otherwise be unavailable available but in a form and context that simultaneously alter its local meanings and confer new, global ones. The festival context adds a global overlay to more local meanings."[28]

Azadeh Farahmand has incisively argued that the Iranian films presented at film festivals and later selected for art house screenings are "realized in a web of relations between international and Iranian politics."[29] Economic and political, national and international forces frame the conditions for the production of "the real" and "the national" for the international screen. Film festival politics, she argues, inhabit the core of the interests shaping the production and reception of "national cinemas" and hence of the specific kind of realism one encounters and reads in terms of the national as films travel. In the case of Iranian cinema, only a particular type of art film is permitted by the Farabi Cinema Foundation (the film branch of the Ministry of Guidance in Iran) to enter international film festivals.[30] And the films that are screened are directed by a handful of acclaimed filmmakers.[31] In the context of extreme power differentials, the selection of films for French, Italian, British, and North American festivals, while formally grounded in the argument of "aesthetic brilliance," is shaped as much by the products' relation to (or borrowing from) known avant-garde and modernist film traditions as by the potential for commercial profit derived from the films' attachment to a "national" context. It is from within this complex network that an Iranian auteur such as Abbas Kiarostami can emerge and be hailed as nothing less than a genius, his primitivism the marker of a difference that situates him in a genealogical relation to the metropolis as a direct descendant of Truffaut, Godard, and Rossellini.[32] The film festival encounter with difference and the shaping of knowledge in that experience are governed fundamentally by decipherability, profitability, and festival politics.

While it is undeniable that Iranian cinema has been appropriated into the canons of global cinema, it is also clear that this reception and

recognition have to do with "the forms of engagement" induced and "made available" by these films and the complex process through which they enter the film festival circuit.[33] Such engagements are radically informed by the conflictual histories and struggles of the cinema on other political turfs that have as much to do with standardized codes as with the resistant practices of a national industry in its encounters with dominant cinema around the globe. Here the historical dominance of what Miriam Hansen has called cinema's "vernacular modernism" inscribes not only representational practices but also the standard interaction between film technologies and the senses globally. Thus whether these cross-cultural encounters situate a national cinema such as Iran's in stereotypical orientalist terms that appreciate the products' abundant use of color, sweeping landscapes, and peasant women toiling outdoors or fetishistically look to the screen's "realistic" representation of assertive, engaged, and self-sufficient Iranian female characters, what needs to be carefully attended to are the ways in which both approaches promote the conception of a "universal" knowledge derived from differentially situated conceptions of truth.

Ellen Strain's 1996 article on the prehistory of cinema and its posture of distance and objectivity in relation to cultural difference—a posture that Strain argues was appropriated from the popularization of the touristic experience as well as the professionalization of such fields as anthropology—is instructive in this regard. She writes that "the notion of touristic viewing as an historically-specific phenomenon which developed in the decades immediately preceding cinema's inception" was imported into cinema in its formative years: "While fascination with imagined beasts and fantastic human oddities inhabiting the globe's furthest corners stretches back over centuries, touristic experience—whether simulated or actual—brings the Western subject face to face with the spectacle of difference, the exotic landscape dotted with wondrously 'alien' human and animal faces."[34] Situating this distanced and indirect relation to difference in a worldview that was to mature by the turn of the century, Strain links the development of tourism with the professionalization and popularization of anthropology, the consolidation of capital, and the cultural ascendancy of the mechanically produced image. Her historical study unambiguously positions the ethnographic posture within voyeuristic strategies that situate difference in relation to both academic knowledge production and mechanically produced images of the other. This implicates not only feminist film ethnographies but also feminist practices in multicultural curricula.[35]

A mindful feminist approach to the study of international films is thus not only forced to move beyond the early feminist analyses of the misrepresentation, stereotyping, and fetishization of screen women, "exotic" or otherwise, but also must abandon the comparative practices that read films ethnographically to study the differing and similar ways in which contrasting national and ethnic perspectives shape the representation of gender. This cautious deflection of a sociological or ethnographically inflected reading of representation may not only avoid the presumptions that follow on the heels of a relativist valuation of realism or authenticity in both dominant and national cinemas but may also forgo the voyeurism that is so congruent with dominant cinematic practice. Lest we forget, it is precisely the critique of this practice that has been formative to feminist debates regarding the cinematic gaze. In the case of national cinemas, this gaze is turned on a presumed civilizational other on the screen.

Woman and Nation as Spectacle

Rey Chow argues that orientalism, as "the system of signification that represents non-Western cultures to Western recipients in the course of Western imperialism, operates visually as well as narratologically to subject 'the Orient' to ideological manipulation."[36] But, if we are to believe Armand Mattelart on this matter, the other's culture is not only subject to ideological manipulation, it is also a world made and unmade by the technologies of communication.[37] In this process, other cultures, "much like representations of women in classical cinema," become the produced and fetishized objects of a masculinist and voyeuristic Western gaze.[38] This "racist combinatoire,"[39] which involves fantasies of racial sexual domination, is only amplified by the fact that, as Mattelart explains, the networks as well as the media of communication are the first materialization of the notions of "progress, civilization, the universal and universalism."[40] This implicates the invention of cinema in the power dynamics that have sustained the colonial enterprise and imperialism itself. At risk are not only the constitutive problematics of voyeurism, objectification, and fetishization in relation to the spectacle of the other and her nation; as Claire Johnston emphasized in early critiques of the female stereotype in Hollywood representations, the very assumption of representation as truth hangs in the balance.

Writing in 1976 for the first issue of *Camera Obscura*, the journal's collective outlined its concerns for a feminist analysis of classical cinema and for the construction of a theoretical framework for a feminist practice in

film: future film practice must concern itself with "the problematic place of the woman-image in the space of the representation, in the time of narration, and, more specifically, problems of filmic enunciation, construction of the subject/spectator, and the procedures foregrounding the signifying processes of film."[41] Confronting classical patterns and procedures in film, feminist "negative aesthetics" insisted on elaborating a new cinematic syntax that could "speak the female body differently."[42] Developing a new set of cinematic codes and conventions would involve, as Peter Wollen and Laura Mulvey suggested in their own feminist films, a firm stance against "the canonical codes of dominant narrative cinema, cinema law."[43] This stance, centered on cinematic grammar and syntax, became vital to feminist film theory, which was forced to acknowledge that "cinematography itself," as Wollen incisively put it, "is a form of inscription, rather than a capture and reproduction of the world."[44] The intricate play of fetishism, where "representations are mistaken for perceptions," ignores "the fact that 'realism' as a mode of cinematic production involves a complex inter-play of techniques and devices—that it has to be produced and is not simply evoked by the intention to be real or true."[45] Far from recording the world as it is, the apparatus itself is involved in the production of sexual difference for the screen:

> Lighting, camera angles, the cutting between actors and use of close shot v. long shot—all techniques of filming are used to differentiate radically the presentation of men and women on screen . . . techniques normally used . . . for women in films . . . essentially produce a specularity in relation to the character in a way which places her role in the film as iconic rather than diegetic; i.e., the classical sexual objectification of women in films.[46]

For feminist film theory, then, film analysis would be destined to chart the landscape of enunciation. Any recourse to the realism of the image itself as the capture of the world "as is" would necessarily be supplemented by attending to the function of production. Cinematic realism, based on the conventional movements that produce continuity in time and space, especially in Hollywood classicism, had to be interrogated as part of any feminist engagement with the image. The *Camera Obscura* collective insisted on the determining function of female representation in close readings of dominant narratives:

> Classical representation cannot be understood without an analysis of the role of woman-image in relation to its determining function in the space of

representation and in the time of narration. The place of woman and the organization of her representation are fundamental to the whole machinery of the classical film at every level, from lighting, camera movement and framing, to the large movements of the narrative.[47]

Feminist analysis intent on the study of international films, if true to its own historical agenda and cognizant of the parallels between the spectacle of the female image and the fetishization of the constituted image of the other's nation in effigy, cannot but be attentive to the determining role of enunciation in a film's address, and furthermore to the role of enunciation in the apperception not only of the representation of women but also of "the nation" in "national cinemas." In recognizing the role of production in the arrangement of the cinematic image, be it the fictional image of "the woman" or that of "the nation" in effigy, enunciation is formative ground. Reflexively inscribing the conditions of narrative production, filmic enunciation also charts the film's national signature as audiences allow themselves (in Nichols's words) to be enraptured by the pleasures of "the world of wind, sand and dust of veiled women and stoic men" on screen. Enunciation is that site that bridges industry and the film text, marking the address of the nation, its geography, its limits, and hence its place in relation to dominant cinema. [48]

Chris Berry discusses two examples of Chinese films that delineate national limits in relation to dominant cinema: the disruption of the 360-degree pan by "a jerky, uneven pace" in segments of The In-laws (Xi ying men, 1981) in which the collective is on the verge of breaking up, and the adoption of the Hollywood shot–reverse shot structure in Li Shuang-shuang (1962) as "the family group collapses into warring individuals." When conflict or crisis disrupts the harmonious coexistence of the characters in Li Shuangshuang, the filmic enunciation articulates shots in ways that signal "foreignness," i.e. Americanness. The film's syntax employs Hollywood codes to produce the effect of "foreignness in values" within the national narrative. The shift in national values on the level of the film text is inscribed within the syntax of the enunciation itself, thereby revealing the difference of the national in a "national cinema." Such moments signal the pollution of national and cultural values, not so much in the dialogue or on the level of narrative and thematics but more fundamentally by the film's adoption of dominant Hollywood production values.[49]

The Islamic Cyborg

Khomeini's call for the purification of cinema from practices that he articulated in terms of imperialism recognizes the conjunction between dominant cinema's production values and the imperialist power of its enunciative strategies over the national body. In fact, as Mary Ann Doane points out, "the cinema presents a spectacle composed of disparate elements—images, voices, sound effects, music, writing—which the mise-en-scène, in its broadest sense, organizes and aims at the body of the spectator, [the] sensory receptacle of the various stimuli. This is why Lyotard refers to classical mise-en-scène . . . as a kind of somatography, or inscription on the body."[50] The reinvigoration of the national sensorium in Khomeini's utopian vision of cinema and of cinema's future role in the constitution of the purified national body suggests a fully cognizant understanding of cinema as a technique and a technology in the management of the total body through the senses. Of course, as Abdelwahab Bouhdiba notes with regard to purification practices in Islam, the subject is "never ultimately purified," and Khomeini's goal was not to seek a "primordial innocence" that existed before the shaping of sense experience by dominant cinema's voyeuristic codes but rather to produce a homosocial, heteronormative culture within the national body by means of film technologies.[51] Purified, the national body would be Islamic down to its senses. The nation would thus emerge as the resurrected imaginal body.

This investment in film technology for the regeneration of the sensorium suggests an emphatic belief in the reversibility of technology and in its purificatory capacity in relation to sense perception. Thus Khomeini's emphasis on the reversibility of technology articulates one of Judith Mayne's chief arguments regarding representational technologies, namely that "there is no simple division between the cinema that functions as an instrument of dominant ideology, and the cinema that facilitates the challenge to it."[52] Cinema technologies are machines. They both build and destroy "identities, categories, relationships, spaces, stories."[53]

Khomeini's vision for cinema recognized the historical role of film technologies in the construction of the body, and within this history redeemed the utopian possibility of technologies in the constitution of a citizen-subject distinct from the supranational subject. Khomeini's vision for film technology essentially involved the production of a purified, technosensorial national body (a "disassembled and reassembled postmodern collective and personal self") that Donna Harraway termed "the

cyborg."[54] In Islam such "purification is not gratuitous," Bouhdiba contends; "it is a state that makes possible a dialogue with the sacred."[55] Purification can be seen "precisely [as] an overcoming of anxiety . . . a 'resumption of control' " over the body and the forces that create "delusion, mystery, overflowing, [and] ecstasy."[56] For Khomeini, the purification of film technologies as organs for the collective meant the possibility of national purification and regeneration on a collective scale. Control over the rapture of a sensorium raised on Hollywood's voyeurism meant the technological reconstitution of a body that would be modest and sacred, hence homosocial, heteronormative, and Islamic. Purified, the body would take control of its senses. It would come back to life through its technologically modified organs. The nation would ingest technology's purified senses of seeing and hearing as its own. Sanctified and freed from global influences, the collective body would return to national labor by mimetically adopting the posture promoted by the newly purified gaze of the film camera. In repeated exposures of the nation to purified technologies, not unlike the regular, rigorous, and precise attention given by the believer to the purification of the body through the rituals prescribed in Islamic law (fiqh), cinema's purified grammar would gradually become second nature, instrumental in the national body's tactile appropriation of the world.[57] Cleansed from a voyeurism whose object was the spectacle of the female body, and modest in their approach to representation, film technologies would provide the national body with organs that could become the sites of moral and political differentiation and distance. In the closing passage of his Artwork essay, Walter Benjamin refers to this transformation of culture in terms of a sensorial revolution. Film technologies' role in culture was to participate in "the politicization of art," a process Benjamin associates with a revolution in collective aesthetics, in sense perception.[58] For Khomeini, the transformation of cinema technologies was a cultural revolution initiated beneath the skin[59]—a revolution by means of a collective "innervation" of technology.[60] Detached from the global sensorium, the Iranian national body would sense the world through mechanical organs, modified and calibrated to Shiite modes of being, seeing, and hearing—that is, to modesty. The association of the modest female body with film technologies, especially in Kiarostami's oeuvre, emphasizes the consequences of this melding of "organism" and prosthetics in Iranian post-Revolutionary cinema.

While the imposition of the "commandments for looking" (*ahkam-i nigah kardan*), the rule of modesty, and the regulations on veiling in cinematic spaces represent the Islamic government's move to reject the imperialism of dominant narrative cinema by blocking the effects of voyeurism on national vision, the post-Revolutionary camera's adoption of the averted and modest look—a look associated with the veiled female figure—suggests the industry's recognition of the softness and malleability of vision. Feminist gaze theory's focus on the voyeurism and fetishism of the male gaze in film has overshadowed this aspect of visuality.

Carol Clover argues that Christian Metz's discussion of vision in *The Imaginary Signifier* involves cinema as a duality. This conception of duality was lost to feminist film theory and to the elaboration of its analytical procedures in debates that focused on the pleasures of female spectatorship.[61] For Metz, such oscillations between voyeuristic and introjective looking are crucial to the functioning of the apparatus. They form the basis, as well, for any sense of newness that may emerge in the codical systems inscribed in cinematic enunciation: "In cinema, as elsewhere, the constitution of the symbolic is only achieved through and above the play of the imaginary: projection-introjection, presence-absence, phantasies accompanying perception etc."[62]

Metz's effort to associate the spectator's primary identification with the look of the camera may have suppressed the crucial duality of the gaze in cinema: the look of projection-introjection. It is this duality of vision, however, that is the ground for arguments regarding the role of the apparatus in reconfiguring visuality through cinema technologies, a role ascribed to them in arguments that draw on (Althusserian) notions of ideological interpellation to suggest the entrapment (or suture) of the spectator in an ideological machine (such as the film narrative) in order to ensure the reproduction of the social order. A similar process through film could enable the reconfiguration of the social order in accord with the kind of utopian vision that the call for politicization of the aesthetics represents in Benjamin. Instead the duality of vision came to be read purely in light of spectator-camera identification:

> When I say I "see" the film, I mean thereby a unique mixture of two contrary currents: the film is what I receive, and it is also what I release, since it does not preexist my entering the auditorium and I only need close my eyes to suppress it. Releasing it, I am the projector, receiving it, I am the

screen; in both these figures together, I am the camera, which points and yet records.[63]

As several examples in my readings of Bayza'i and Kiarostami have stressed, the camera is the point of identification for the spectator's look. Yet meaning is grafted onto perception and is associated with the receptive aspect of the spectator's look. On the one hand, this look is mimetically identified with the camera's look and conditioned by (and habituated to) the codes and conventions of dominant cinema; on the other hand, precisely because of its mimetic attachment to the look of the camera, the spectator's look can be reeducated, retrained, and retooled through repetitive exposure to a reconfigured arrangement of the apparatus.

Director Mohsen Makhmalbaf's statement about the possibilities of speaking to an Iranian audience in a visual language illuminates the utopian possibilities present in Metz's notion of the dual look in cinema: "Whenever we use montage or a metaphor that denotes a single meaning, then the [Iranian] spectator is capable of grasping the meaning of the image . . . it's the effect of repetition and pedagogy and the becoming cliché [of a technique] that [allows] the majority [of the audience] to understand it."[64] The habit of film viewing has conditioned Iranian spectators to read montage as a code of meaning-production, a unit of meaning inscribed by dominant cinema in sense perception globally. Yet elaborating on the difference that proceeds from the transformation of the film industry after the Revolution and on the possibilities of conceptualizing a film grammar that differs from dominant codes, Makhmalbaf tells the interviewer: "Sometimes the language of cinema is spoken by using shadows. . . . Sometimes the language of the image rests in the use of the lens. . . . when the language of the cinema speaks through framing, by way of broken [sight] lines or direct ones, or by using color or mise-en-scène, or through the relationship between objects within the frame, or by light, or [visual] concept[s], not one person understands."[65]

Grasping meaning in visual language is a practiced habit formed in response to the spectator's repeated exposure to film technology. For as Jurij Lotman points out: "The viewer who does not know the language of cinema and who does not ask himself the question: 'What is the meaning of portraying only one eye, a head, a hand?' sees pieces of a human body and must as it happened with the first audiences in the period when close-ups were invented, feel only revulsion and horror."[66] The ability to comprehend the series of close-ups in terms of a continuity and derive a

meaning that suggests "body" from the juxtaposition of shots presupposes a history of standardization within the global film industry and a process involving the spectator's "innervation" of technology into the senses in ways that equivocate film literacy in mimetic relation to technologically motivated semiological meanings. The dominance of Hollywood and our repeated exposure to its patterns of framing, lighting techniques, editing styles, standard codes, and narrative conventions have inculcated habits of comprehension that register as both semiologically meaningful and sensorially mimetic. Metz makes this point more cogently in a statement I quoted in the section on enunciation in chapter 1: "Cinema is language *above and beyond the particular effect of montage.*" He points out, "It is not because the cinema is language that it can tell such fine stories, but rather it has become language because it has told such fine stories."[67] While Hollywood won at the beginning of the twentieth century "because it was the first to settle the formula," as Pierre Sorlin indicates, it continued its dominance by repeatedly molding film substance according to such standards.[68] Repeated exposures to these processes have mimetically solidified habits of perception and syntactical standards of film literacy for audiences everywhere.

For feminist film theory, the possibility of producing a counter-cinema by "combating form with form," by disrupting point-of-view constructions and frustrating narrative unity, suggests an unalterable though largely unmined investment in the malleability of vision and the possibilities of sensorial reconstitution through film technologies.[69] Yet as Clover has incisively argued, feminist film theory's "concern to construct a sadistic male subject led [it] to overlook the masochistic potential of fetishistic scopophilia."[70]

Newness Emerges

In studying the stance taken by Iranian cinema, it becomes clear that both the voyeurism of the gaze in dominant cinema and the malleability of the tactile vision informing it are associated with the look of a heteronormative male sitting in the theater. Responding to the presence of this subject, the veil simultaneously denies the voyeurism inscribed in global spectatorship and acknowledges the softness of the look, a punctured vision that submits the male body to the manipulation of its senses. The veil's shield stands stoically against the voyeuristic male gaze. But the Iranian camera's adoption of the averted and modest gaze, in embodying the look

of the veiled subject, also emphasizes the spectator's vulnerability vis-à-vis the inscription of voyeurism in cinematic codes, as his look identifies mimetically with the look of the camera. Acknowledging possibilities of reversal within film technologies, the post-Revolutionary camera looks awry in a gesture of purification, not only in self-defense against the subject's loss of mastery, in its becoming image, but also to produce a different relation to time and space in film beyond the commodified image. It attempts a different relation to the real in cinema. Recovering an unconscious, unhabituated relation to time, space, and identity through technology, Iranian cinema embraces the "chance to engage the senses differently." This chance, as Miriam Hansen argues, "lies in the epochal reconfiguration of 'body-and-image-space,' in the emergence of new modes of imagining that refract the given organization of space, its forms and proportions and articulate a new relation with the material world."[71] Newness emerges in response to the reconstitution of the senses in contact with the purified technologies of cinema. Thus 1980s and '90s Iranian cinema poses a "counterproduction of social vision" against dominant cinema and its historical reproduction of the voyeuristic codes that grafted American "production values" onto the global sensorium.[72] Iranian cinema's reconception of cinematic visuality suggests to me that this nationally constituted woman's cinema may reveal utopian possibilities of visual engagement with films that the hasty and early association between feminist film practice with the avant-garde tradition may have unwittingly skirted.

Mohsen Makhmalbaf's *Gabbeh*

To open up feminist film theory to such possibilities and to suggest how post-Revolutionary Iranian cinema might offer alternate modes of engagement for feminist film theory on a global track, I turn to one of Iranian cinema's most lauded commercial art films, *Gabbeh*, directed by Mohsen Makhmalbaf in 1996. The analysis that follows will allow me to work through the specifics of the argument laid out thus far. For those unfamiliar with *Gabbeh*, I begin with a brief summary of the plot.

Originally conceived as a documentary on the Qashqa'i nomads and their practice of weaving gabbeh rugs, the fiction film *Gabbeh* revolves around the courtship of a young nomad, Gabbeh, and her horseback-riding lover, who are prevented by a dominating tribal father from forming a reunion. While the lover is only seen in long shot, there are insistent

26 Gabbeh against the backdrop of a gabbeh rug in Mohsen Makhmal-baf's *Gabbeh*.

close-ups of the female protagonist, Gabbeh—certainly a "fictive primitive," though her dubbed voice-over narration reminds us that the character is played by a Tehrani-speaking actor (see figure 26).

The central obstacle to the union of Gabbeh and her distant horseback rider is the arrival of Gabbeh's older uncle. An urban schoolteacher whom we first encounter in a nomadic school tent giving a lesson on color, Gabbeh's uncle comes to the tribe to visit his mother after many years of absence and to find a suitable bride. The uncle's arrival coincides with the death of his mother, Gabbeh's grandmother. The tribe mourns her death by weaving a rug that narrates the day of the event and of the uncle's arrival. His mother lost, the uncle goes in search of a wife, and as he is Gabbeh's elder, Gabbeh's own courtship with the distant horseback rider is delayed. Gabbeh's mother gives birth. A kid goat disappears in the mountains and Gabbeh's younger sister dies in search of it. It rains and the rugs must be collected and protected. Each of these events delays Gabbeh's union. The narrative is not, however, presented in chronological order. Seen in terms of "past" or "future," each event is intercut with sequences staged in a seemingly timeless "present" taking place on a riverfront where an elderly couple engage Gabbeh in a conversation about her life. Asked about her kin, Gabbeh launches into the story that becomes the film narrative.

Gabbeh, then, is an atemporal narrative structured formally by the storytelling practices of the gabbeh weavers. The film forms constellations between past, present, and future by adopting the processes of weaving,

cutting, and dyeing the colored threads, associated in the film image and intercut throughout with the work and storytelling practices of nomadic weavers. This interweaving of times is not unlike the process by which the ta'ziyeh structures its temporal and spatial deictics. As the women and children weave the gabbehs, they intermittently turn to the camera with a sometimes celebratory cry: "Life is color!" "Woman is color!"

In Makhmalbaf's remarks to Hamid Dabashi about *Gabbeh*, the director states that it is with this film that the "light begins to enter" his work.[73] Light, perhaps; but it is more specifically color that enters. But what does it mean to say that color enters?

In the history of cinema, the use of color was seen as a "problem for realism" because, as Stephen Neale notes, "colour could distract and disturb the eye."[74] Indeed, George Méliès deliberately used color in his work to create magic and spectacle "as against the 'realistic' black-and-white-life scenes of the Lumières."[75] Color was reserved for fantasy and fiction; it certainly did not serve realism. Neale explains that because of its capacity to disrupt, color eventually had to be submitted to "rules and conventions governing the relative balance between narrative, on the one hand, and spectacle on the other, since what colour tended to provide, above all else, was spectacle."[76] Color as spectacle was thought to distract the eye from the elements that bring unity to the narrative: acting, facial expression, and the film's action.[77] With the introduction of color and its excessive use, narrative was thought to come to a halt and spectacle to take over. The containment of color ensured narrative continuity. Its proper governance became a convention of classical narrative film practice.

While *Gabbeh* is anything but a classical narrative in form, it attempts formally to produce a national narrative form. It does this by attaching the continuity of the film's own narrative practice and closure to the processes involved in the making of gabbeh rugs, the spinning, dyeing, piling, weaving, and cutting of colored threads by young tribal women. Color filmmaking in *Gabbeh* is self-reflexively tied to the craft of piling and cutting colored threads, a historical association with women's labor that recalls Méliès's practice of employing an army of young women to hand paint each of his film frames.[78]

Thus, although *Gabbeh* is a lesson on the construction of national narrative forms, one could also say that in its use of a formal practice primarily associated with women's labor (namely, the application of color to construct stories in both celluloid and rugs), the film anachronistically suggests itself as the historical enunciative site of color film production.

Furthermore, *Gabbeh* suggests formally that if color film is produced according to the same processes of color application as rugs, then the nature of its cinematic representations (like that of the gabbeh rugs) must be understood as emphatically allegorical rather than as ethnographically "realistic." While color is recognized as an integral part of both the matter being represented on screen and the rug, and thus implicated as a narrative element, it is also disclosed as a process that requires application and labor. In *Gabbeh*, color as spectacle is a consciously applied element that disrupts narrative realism and its implied indexical relation to the real world outside the film. That said, I turn directly to the narrative and the sites in which color and its relation to "weaving" are represented as an allegory not only in the processes of rug making but also, more importantly, in the processes of film production.

Perhaps the most consequential scene for *Gabbeh*'s narrative continuity and closure is one in which the daughter of Alladad accepts Gabbeh's uncle's marriage proposal. This scene, set by the side of a stream, is also structurally significant. When the uncle approaches his future bride, she sings a poem that she wrote the night before. Here, in the Turkish lyrics of the song written by Alladad's daughter (the "singing canary by a stream" that Gabbeh's uncle has seen in his dreams), we find an intimation of the way characters are constructed in the film. At the uncle's request, she recites the lyrics anew, translating them from the Turkish dialect to Persian with the following words:

> I am the beginning of the stream
> And its end too
> I am amongst the pebbles of the stream itself
> My beloved passed by and
> I was the sparrow in that lover's hand
> I was divided in three

At this moment of romantic union, the future bride reveals a split subjectivity that extends into the film itself and far beyond the singularity of her specific character.

This encounter between the uncle and his future bride is intercut with another scene of primary importance to the comprehension of the narrative, particularly in its use of color and its emphasis on the allegorical processes of rug weaving and filmmaking alike. Paradoxically, this scene both introduces and recalls the primary love story of the film. A young, blue-veiled girl sits with an old man and woman, whom we have seen at

the film's beginning fighting over who is to wash the gabbeh rug that depicts a man and woman fleeing on horseback (figure 26). The blue-veiled girl calls herself Gabbeh and tells the couple that her mother and father are the warp and weft out of which she has been woven. She is, we realize, not only the young woman in love with a wild horseback rider but also the rug, her life story woven into its sky-blue background. But as the film progresses, we grasp that she is the old woman too. We come to understand that the old man, who at once rejects his old wife and adores the young Gabbeh, is the handsome howling horseman who follows the girl's tribe and finally elopes with her against her father's wishes. Sitting by the stream, the past, present, and future form an allegorical constellation through the colored threads of the gabbeh rug. The old man, his wife, and Gabbeh are at once in an ambiguous "present," looking toward the past even as they embody the future bickering of the eloped couple. Paralleling the lover's song sung by Alladad's daughter, they are also divided in three.

In this ambiguous present by the stream, their exchange is gradually intercut with the scene of the uncle's marriage proposal to Alladad's daughter. Time and space are woven together by hope and desire. Enchanted with the young blue-veiled Gabbeh, the old man sometimes doubles the uncle's actions. The young Gabbeh, impatient to have her turn in marriage, does everything in her power within the "present" frame to move the "past" marriage proposal along. She extends a bouquet of yellow flowers out of the frame—flowers that the camera has shown the uncle bring into the frame during the school lesson he taught on color in a previous sequence. The past of the film itself intercuts the filmic present even as the narrative present intervenes in the future-past. We can come to recognize in the midst of the courting sequence, that the present is capable of influencing the past just as the past is involved in forming the future. Indeed, film technology shows itself capable of undoing the continuity of space and unsettling habitual conceptions of time and chronology. Here, once again, the time and space of a national film reflect the coordinates of an imaginal world.

Tearful, the young Gabbeh announces that it is time for the uncle's wedding and begs the old man to let go of the sparrow he holds in his hand so that it can become the singing canary in the uncle's frame—the yellow canary that in his dream will lead him to his future wife. The uncle's happiness in the future-past has an impact on Gabbeh's quest for union with her beloved horseman in the present-past.

The Turkish poem that attracts the uncle captures the tripartite division of identities in the film: Gabbeh is simultaneously the young blue-veiled girl on one side of the stream, the old woman on the other, and the soaking rug that reflects their collective narrative history. She is no less a memory of a love that still flutters before the old man as his voice an hands tremble in singing his desires. Gabbeh's life is the film's translation of the rug's narrative, its colorfully interwoven spaces and multiple temporalities.

The Question of Realism

These formal moves in the production of the film reel and the construction of the characters and the narrative have implications for our understanding of the use of "unrealistic stereotypes" in the representational strategies of this film. For while the setting of the film in rural Iran aims to produce "reality effects" that are impossible to create in interior urban spaces because of the ways in which the veil and modesty laws inscribe heterosexual relations in diegetic spatial topographies, what the representational strategies of the film seem to undo is the very notion of representational realism as the language of Iranian cinema itself. Gabbeh unsettles the realist codes of dominant cinema, its conventions of temporality, spatiality, and identity, formal cinematic strategies that are deeply embedded in the senses. Upsetting these temporal and spatial deictics, it simultaneously posits its own narrative as having roots in the narrative forms that it foregrounds. Veiled female bodies come to stand as figures of production, both individual and national, at the threshold of the film's enunciative practice as they create both rug and film in a tripartite division of times, spaces, and identities. Though they are themselves details that reconstitute fiction into narrative reality—they are, as "fictive primitives," reality-producing "reality effects" in film, in other words—their function on the enunciative level is to unsettle every known convention of realism in dominant film fiction.

Realism in dominant cinema, as I have suggested, is not only about representational strategies embedded in specific notions of indexicality, iconicity, and the narrative's overall relation to a certain truth. Realism rests on narrative continuity. As Stephen Heath has argued, narrative, spatial, and by implication temporal unity and continuity in film demand a rigid attention to specific codes and conventions and to the processes of suture.[79] In Gabbeh, these standard conventions of narrative continuity and their spatial and temporal components are interrupted by processes

27 Girls carrying bouquets interrupt Gabbeh's attempt to run away in *Gabbeh*.

associated with the use and production of color in weaving, as if the film narrative—its progression from frame to frame, shot to shot—were constituted like the patterns of the gabbeh rug out of piles of color.

In the key sequences discussed here, in which the narrative attempts to move forward toward the consummation of at least two heterosexual relationships, color is what interrupts the narrative telos. Here, a school lesson in color stalls the uncle's marriage proposal. Girls carrying bouquets, responsible for the extraction of color from prairie plants, interrupt Gabbeh's impassioned attempt to run away with her horseback rider (see figure 27). The dyeing processes undertaken by Gabbeh and the tribe's younger women hold up Gabbeh's marriage by deferring the scene of her uncle's union. The spinning and weaving of the colored threads to produce narrative patterns on the gabbeh rug cinematically suspend the consummation of the uncle's marriage to Alladad's daughter and its final celebration against the backdrop of the tent and the blackboard used in the uncle's lesson in color earlier in the film. The production and spectacle of color disrupt narrative continuity, and in doing so fracture the reliance of the film on the habitual touchstone of realism in cinematic discourse. The embodied materiality of color continuously defers time and events by disjoining and joining disparate spaces in the film narrative, reminding us that what we are seeing is, in fact, fiction.

Here the plot, which in classical narrative cinema is driven by the chronologically bound development and the consummation of heterosexual

love, is interrupted as well. Appropriating the structural form of the poem written by Alladad's daughter and its tripartite constitution of the subject, *Gabbeh* resists the visual norm. The film's rejection of seamless temporal and spatial editing techniques and, implicitly, the spatial and temporal boundaries of the worlds it narrates, undoes the work that aims to constitute unified projections of identity in dominant cinema.

The technology of film immerses itself in the world of weaving, taking the formal structures and deictics of the rug's storytelling as its own. Appropriating the repetitive processes of spinning, dyeing, cutting, and weaving colored threads as the very form of narrative construction, the cinematic narrative splits and folds back onto itself, repeating shots, cutting spaces and strands of film together irrespective of spatial or temporal continuities and unified narrative, identities that are implicated by the system of suture in dominant cinema. Past, present, and future, here and there, I, you, and she, indeed the entire deictic repertoire, merge and form constellations. The shifting, multitemporal narrative threads of the rugs create the cinematic narrative, replacing the markers that typically communicate cinematic fictions between the repressed producer of the fiction itself—enunciation—and a projected spectator produced by the fiction through the seamless—rather than obviously woven—conventions of suture associated with dominant film practice.

Thus color functions to escape, subvert, and disrupt the conventional "symbolic organization to which it is subject." As an instance of Julia Kristeva's "paragrammatic," the use of color becomes the site at which "the prohibition foresees and gives rise to its own immediate transgression."[80] In this sense, as Kristeva has argued, "colour achieves the momentary dialectic of law—the laying down of One Meaning so that it might at once be pulverized, multiplied into plural meanings. Colour is the shattering of unity."[81] But let me emphasize that what occurs in *Gabbeh* is the shattering of particular kinds of unity: the unity of identity, spatiality, and temporality on which the convention of narrative realism in dominant cinema relies. The shattering of the image is not the shattering of false illusions or of the stereotypic representation of tribal primitives and exoticized others. Nor is *Gabbeh* an attempt to represent the nomad in her true form. Rather, color is used to unsettle the ways in which the "fictive primitive" is positioned, commodified, and fetishized as a coherent, unified identity accessible beyond the fiction and the spatiotemporal limits of the film. The use of color addresses itself to the codes and conventions that drive the plot forward and that attempt

through the system of suture to create realism by way of temporal and spatial continuities.

The deliberate opening of the representational film frame onto the looms that form the warp and weft of the rugs organically suggests the nonindexical nature of representation in the film. While admittedly the film's color is photographically achieved, its reflexive association with the application processes involved in producing the narrative histories presented by the weavers of the rugs suggests its own use of color as "nonindexical" and "purely sensual." The film's color process is thus historically matched to processes of hand painting, stencil coloring, and combinations of tinting and toning in film, "whose role," Tom Gunning observes, "is less realistic than spectacular and metaphorical."[82] Thus color, as the result of a technologically achieved process, is paradoxically articulated by the film form as a narrative element that is materially integral to the veiled bodies and labor of its "fictive primitives." The association of the film's production process with the labor involved in the extraction and application of color also situates its colorful representations as visually autonomous and nonidentical to the real, a real that I have shown to be narratively constructed and colored by history, politics, and the cross-cultural encounter. The veiled bodies of the "fictive primitives" in Gabbeh are thus lifted from the realm of the real to the paragrammatic arena of color—an arena that defies and decenters logic and law while simultaneously inviting the lure of spectacle and investments in commodity fetishism elsewhere.

Gabbeh breaks with dominant production practices and more specifically with the system of suture, articulating a different approach to the narrative order altogether. As Silverman argues, "suture functions not only constantly to interpellate the viewing subject into the same discursive positions, thereby giving that subject the illusion of a stable and continuous identity, but to rearticulate the existing symbolic order in ideologically orthodox ways."[83] Born out of color, Gabbeh's narrative is not a "lure" constructed through the interlocking of point-of-view shots and first-person narration to entrap the spectator in a voyeurism that aims to erase the marks of enunciation in the film. Filmic enunciation, ripped from its fictive attachment to the voyeurism of a unitary subject, is attached instead to a panorama of dislocating perspectives associated alternately with individual, collective, and inanimate systems of production. Filmic enunciation is exposed and categorically immersed in the productive and colorful labor of the veiled female figures. This insistence on the foregrounding of color, despite the threat of narrative disintegration posed by its spectacle, fixes

the celluloid and the narrative in the weave of color just as the rug's colorful patterns that serve as the film's own loom are fixed by water (see figure 28). Color in *Gabbeh*, then, would seem to be an organic response to dominant and standardized cinematic codes, which the inscription of socially regulatory modesty laws in post-Revolutionary cinema have transgressed and subverted.

Depending on new grammar that can adequately speak the national condition for Iranian cinema, *Gabbeh* intimates simultaneity in the face of demands for narrative chronology and continuity editing in dominant cinema. Representing to Makhmalbaf the national potential for the development of a new film language in Iranian cinema, *Gabbeh* cuts spaces, times, and selves together, synthetically producing a film that subverts rigid and reified hegemonic notions of identity and culture produced under the capitalist mode of production, by which the orchestration of the sensorium on a global scale is governed and in which the codes of realism in fiction film form an integral part. In this gesture of deterritorialization and reterritorialization, the film embraces the disruptive potential of color, thus shaping its address ambivalently somewhere in the cracks of incommensurable national narrative forms—poetry, weaving, singing, and teaching—forms that, precisely for their incommensurability with dominant realist codes, become constitutive elements of a film celebrated as spectacle at film festivals, art houses, and retrospectives around the world.

If color is what Iranian films are celebrated for, then so be it. For this very strategic use of color undermines the formal structures and cinematic

28 Fixing the colorful patterns of the gabbeh rugs in *Gabbeh*.

conventions that have repeatedly lodged the stereotypical primitive in a specifically Western cinematic discourse by relying on the conventions of realism as a coefficient of cultural truth. Escaping "the lure of narrative," *Gabbeh* boldly ties itself to an unruly practice that is disruptive not only for its production of a differing *chronos* but also for its "paragrammatization," which "points to the dislocation into fragments" of realist codes and indexical expectations that are doubly inscribed in relation to representations in third-world films.

Coda

It seems rather obvious to propose that post-Revolutionary Iranian cinema's engagement with a negative aesthetics and its effective production of a woman's cinema simultaneously articulates a unique relationship to a technological utopianism that once informed primitive cinema as well. It does so precisely because of Iranian cinema's problematic relation both to the realm of the visual and to the production of narrative continuity and closure. When narrative continuity and closure become impossible because certain movements, certain ways of life, and certain interactions cannot be represented on screen, our critical attention is directed to the source materials that bring film into being—to that archeological buildup that is at once unconscious, inscriptive, and historically and geographically reflexive. Our attention, in other words, is called to the sites of production, to enunciation, rather than to the normative realism of the screened image and the continuity of the film narrative.

Critics often comment on the degree to which Iranian cinema thrives on ambiguity and contradiction. Absent presences are everywhere, from the husband-father in Jafar Panahi's *The White Balloon* (Badkonake Sefid, 1995) to the dying villager who is the subject of the ethnographic project in *The Wind Will Carry Us*. For decades, scholars have designated the coexistence of such ambiguities and contradictions without synthesis as "utopian." And it is here, at the very sites of ambiguity and contradiction produced on the basis of the history constituting the cinema's address and enunciation, that we can locate not-yet-conscious impulses that long for a different future for cinema. Creating dead ends in relation to narrative continuity and realism, these topographies of ambiguity in post-Revolutionary Iranian films point toward cinema's longings and its fascination with film's technological capacity to capture and produce movement, imagining spaces of the not-yet-possible. Caught among

these contradictions, and eschewing the voyeurism that has dictated the ever-forward movement of the narrative, we see the shifting movements of everyday life occurring not midframe but on the conspicuous peripheries of repeating and stalled scenes. The movements that escape the dead ends of contradiction and repetition alert us to what is important to films themselves and draw attention to the residual histories, national and international, that continue to inform film technologies and filmic technique, revealing themselves in moments of narrative rupture in the enunciation. Reading from within the context of post-Revolutionary Iranian cinema's contradictions of codes and deictics, we perceive both a stagnant, standardized drive to emulate the processes of an imperialist modernity that has molded the global sensorium and a disquieting utopian longing for a different relationship between cinema and "the real." There the association between machines and bodies radically shifts.

To recognize the complex ways in which representations are constituted by the dominant codes and conventions in international cinema, and to identify and encourage practices that may teach us ways to unlearn them, are tasks to which a feminist discourse on the global track could more carefully attend.

Notes

Introduction

1 Khomeini, *Imam Khomeini's Last Will and Testament*, 47.

2 This weakness forced "the young generation, men and women, to deviate from the usual way of life, work, industry, production and knowledge." Ibid., 47.

3 Commenting on the corruption of the senses through visual representations of women, Khomeini maintained, "By means of the eyes they [the Shah's government] corrupted our youths. They showed such and such women on television and thereby corrupted our youth. Their whole objective was to make sure that no active force would remain in the country that could withstand the enemies of Islam so they could do with impunity whatever they wanted." See Naficy, "Veiled Vision/Powerful Presences," 132.

4 Soon after Muhammad Reza Pahlavi, the Shah of Iran, was overthrown in the Revolution of 1978–79, Khomeini, who had been forced into exile by the Pahlavi regime, returned from Paris to assume political leadership of the nation in turmoil. Upon his arrival in Tehran in February 1979, Khomeini made his first public appearance at the Bihist-i-Zahra cemetery where those recently killed in the demonstrations against the Pahlavi regime were buried. It was here, and in the early moments of his first public address, that Khomeini laid out the new regime's relation to cinema. His concerns centered on the depletion of human resources under the Pahlavi rule (1925–1979):

> The man [Muhammad Reza Shah] destroyed all our human resources. In accordance with the mission he was given as the servant of foreign powers, he established centers of vice and made radio and television subservient to immoral purposes. . . . Why was it necessary to make the cinema a center of vice? We are not opposed to cinema, to radio, to television; what we oppose is vice and the use of the media to

keep our young people in a state of backwardness and dissipate their energies. We have never opposed these features of modernity in themselves, but when they were brought from Europe to the East, particularly Iran, unfortunately they were used not in order to advance civilization, but in order to drag us into barbarism. The cinema is a modern invention that ought to be used for the sake of educating the people, but as you know, it was used instead to corrupt our youth. It is the misuse of cinema that we are opposed to, a misuse caused by the treacherous policies of our rulers. (Khomeini, *Islam and Revolution*, 248)

5 For melodrama is fundamentally "the norm, rather than the exception of American cinema," as Linda Williams incisively puts it: "popular American cinema is still, *mutatis mutandis*, melodrama." Williams, *Playing the Race Card*, 26, 16.

6 In film theory, and more specifically "apparatus theory," the concept of *suture* defines the classical use of film technologies in the processes of editing, and in capturing and matching sightlines. The spectator is understood to first identify with the apparatus of vision and hearing, before he or she identifies with a character in the diegesis or with a site or look within it. This, the gesture of stitching the spectator-to-technology-to-character is the intricate task of suture. Suturing procedures are also lighting practices, framing, and shot constructions that produce narrative continuity. These processes fabricate the film universe as a safe place in which the spectator finds himself or herself comfortably inscribed. They facilitate a smooth transition between the space and time of one shot and those of the following shot. They do so, most commonly, through the seamless exchange of character gazes. Linked to continuity editing, suturing practices combine with other conventions to ensure that the universe of narrative film is both predictable and accessible to the gaze of the spectator. Largely dependent on a visuality that conforms to heterosexual voyeurism, these codes and conventions of cinema are inherent in classical narratological techniques; in fact, they make up Hollywood classicism. As Jane Gaines maintains, classical form works on the principle of heterosexual realism, "producing visual norm and sexual norm simultaneously through reassuring repetition of scene and frame, as well as through 'seamless' editing and other illusionistic techniques." Such conventions have long given shape to the modern vernacular in which globalized sense perception has been inscribed. On the concept of suture, see Silverman, *The Subject of Semiotics*, and Gaines, "Feminist Heterosexuality and Its Politically Incorrect Pleasures."

7 Mowitt, *Re-takes*, 103. See also Mowitt, "Sembene Ousmane's *Xala*."

8 Beeman, "A Full Arena," 368.

9 Dabashi, *Theology of Discontent*, 419.

10 Corbin, "*Mundus Imaginalis*, or the Imaginary and the Imaginal."

11 Muharram is the month in which Imam Husayn and the Prophet's family were slaughtered on the plains of Karbala by representatives of the Sunni caliphate.

12 Ronell, *The Telephone Book*, 20.

13 On "nationalism as sex education," see Gaines, "Birthing Nations," 298.

14 In the early years of the Revolution, close-ups of women and point-of-view shots, though mediated through the view of the camera, were seen to allow unrelated men (in the theater) and women (on screen) to look at each other directly. This look, however mediated, is in violation of Islamic modesty. Further, eye-line matches and shot–reverse shot patterns that conventionally locate the projected spectator in diegetic cinematic spaces constitute a threat to male piety in relation to a female body, in which heterosexual desire itself is said to reside. For the "naked" (i.e. unveiled) interrogation of the nonfamilial female body implies the disintegration of Muslim male subjectivity in public space. The owner of the look is affected by his own act of looking and is thus subjected to female sexual power outside the private familial sphere. The look gains legitimacy only within the familial setting. Thus, marriage itself is considered a "borderline institution between two antagonistic and irreconcilable entities—God and woman." (Cf. Naficy, "Veiled Vision/Powerful Presences," 142, and Sabbah, *Woman in the Muslim Unconscious*, 50.)

15 The eye "is undoubtedly an erogenous zone." Mernissi, *Beyond the Veil*, 141.

16 Ibid., 45.

17 Naficy, "Poetics and Politics of Veil, Voice and Vision in Iranian Postrevolutionary Cinema," 145.

18 Copjec, *Imagine There's No Woman*, 112.

19 On the issue of the spectator's absorption in film fiction in contemporary Lacanian psychoanalytic theory, see Joan Copjec's *Imagine There's No Woman*, 110–111.

20 Gledhill, "Klute 1," 68.

21 Doane, "Woman's Stake."

22 Doane, "Deadly Women, Epistemology, and Film Theory," 5.

23 Mowitt, *Re-takes*, xxv.

24 Mulvey, "Afterword," 259.

Chapter 1

1 Cited in Penley, *The Future of an Illusion*, 47.

2 In discussing the global effects of the dominance of North American cinema, Miriam Hansen suggests that while Hollywood film may have triggered "cognitive processes in its viewers" around the world, "these cognitive effects were," however, "crucially anchored in sensory experience and affect, in moments of mimetic identification that were more often than not partial and excessive in relation to narrative comprehension and closure." "Fallen Women," 11–12. Integral as it was to the articulation of a vernacular modernity, dominant cinema, i.e. Hollywood, traded in "the mass production of the senses." This trade took place on a global scale. Even the most ordinary American films, Hansen writes, "were involved in producing a new sensory culture." "The Mass Production of the Senses," 70–71.

3 Abdi, *The Life and Cinema of Bahram Beizaee*, 126.

4 See Abdi, *The Life and Cinema of Bahram Beizaee*.

5 Naficy, "Poetics and Politics of Veil, Voice and Vision in Iranian Post-revolutionary Cinema," 144–147.

6 Naficy, "Veiled Vision/Powerful Presences," 147.

7 For more on the link between aesthetics and instinctual responses, see Susan Buck-Morss's "Aesthetics and Anaesthetics."

8 Benjamin, "The Little History of Photography," 510.

9 Hansen, "Room-for-Play," 6.

10 Benjamin, "The Work of Art in the Age of Its Technological Reproducibility (Third Version)."

11 Ibid.

12 Weigel, *Body- and Image-Space*, 25.

13 Rahimieh, "Marking Gender and Difference in the Myth of the Nation," 239.

14 Ibid., 247.

15 Sekula, *Photography against the Grain*, 4–5.

16 Ibid., 81.

17 Metz, *The Imaginary Signifier*, 7.

18 Bayza'i, "At the End of a Hundred Years."

19 Ibid., 374.

20 Cf. Chehabi, "Ardabil Becomes a Province."

21 Metz, *Film Language*, 46.

22 Ibid., 47.

23 Ibid., 91.

24 Metz, "The Impersonal Enunciation, or the Site of Film," 150–151.

25 Ibid., 156.

26 Ibid., 159.

27 Ibid., 153.

28 Ibid., 146.

29 John Mowitt's groundbreaking discussion of enunciation in chapter 1 of *Retakes* elucidates this point further.

30 Uzun Hasan (1420–1478 CE) was the ruler of the Turkmens of the Ak Koyunlu dynasty circa 1453. He created a short-lived empire in Iran, Iraq, and Armenia. Today, his name is associated with the impetus that established Safavid Shiism in Iran. Sultan Mahmud II (1785–1839) was an Ottoman sultan whose westernizing reforms helped to consolidate the Ottoman Empire. He made primary education compulsory, established a medical school, and sent students to Europe. His name is associated with the introduction of European dress in the Ottoman Empire. Genghis Khan (1162–1227) was a Mongolian warrior and ruler. He conquered a vast area in the Asian continent and unified the nomadic tribes into what is known as Mongolia. His generals raided Persia and Russia. His

agents remained in a divided Iran after he died, deriving profits from the lack of order in some districts.

31 During Modabber's (and our) first tour of the antique cellar, Haq-Negar comments that there are generally two views of what the antique cellar represents: "the rubbish heap of memories" or "the treasury of history." Haq-Negar asks Modabber how he sees this space, but Modabber is unable to answer.

32 Incidentally, the man of the couple is wearing a hat that resembles a British bowler, while the woman is wearing an unrecognizable but clearly foreign headdress. We must presume that this incident dates to the Pahlavi reign and the enforced unveiling of women in the 1930s.

33 Significantly, even the portrait of Mother itself is fraught with excess. In one of the last shots of the film, Modabber holds a photograph of Mother up to the direct gaze of the camera. Apparently, this is the photograph on which Vida's painting of Mother is based. In this photograph Mother has one hand clasped around the wrist of the other, mimicking the tradition of early photography that necessitated the immobility of the subject for the long exposure. This gesture is transported into the oil portrait of Kian's mother.

34 Other words for carriage in Arabic—*a'jalatu*, *markabaru*, and *kurusatu*—are likewise gendered feminine.

35 Rather than "*Kian na-bud*" (past tense).

36 Abdi, *The Life and Cinema of Bahram Beizaee*, 73.

37 Ghookasian, *Bahram Bayza'i*, 149.

38 Ibid.

Chapter 2

1 Naderi's *The Runner* was incidentally the first post-Revolutionary film to win a prize at an international film festival.

2 The terms "Koker trilogy," "Rostamabad trilogy," and "Gilan trilogy" refer to the films *Where Is the Friend's Home?*, *Life and Nothing More*, and *Through the Olive Trees* (1994) all filmed in Gilan, Iran.

3 Jousse and Toubiana, "Un film n'a pas de passeport"; Culliford, "Parables and Popcorn"; quoted in Elena, *The Cinema of Abbas Kiarostami*, 93 and 233 n. 45.

4 Dabashi, "Re-reading Reality," 64.

5 The chief editor of *Cahiers*, Theirry Jousse proclaimed Kiarostami "un des plus grands cinéastes du monde" in the same issue.

6 Saeed-Vafa and Rosenbaum, *Abbas Kiarostami*, 22 and 25; Tesson, "Le Secret magnifique"; quoted in Elena, *The Cinema of Abbas Kiarostami*, 152.

7 Saeed-Vafa and Rosenbaum, *Abbas Kiarostami*, 7; Tesson, "Le Secret magnifique"; quoted in Elena, *The Cinema of Abbas Kiarostami*, 152.

8 Saeed-Vafa and Rosenbaum, *Abbas Kiarostami*, 7.

9 Oubína, "Algunas reflexiones sobre un plano en un film de un cineasta iraní"; quoted in Elena, *The Cinema of Abbas Kiarostami*, 152.

10 Company, "Espera de lo invisible," 103; quoted in Elena, *The Cinema of Abbas Kiarostami*, 153.

11 Oubína, "Algunas reflexiones sobre un plano en un film de un cineasta iraní"; quoted in Elena, *The Cinema of Abbas Kiarostami*, 152.

12 Ciment and Goudet, "Entretien avec Abbas Kiarostami"; see also Elena, *The Cinema of Abbas Kiarostami*, 134.

13 Modified translation of Forough Farrokhzad, "The Wind Will Carry Us."

14 Saeed-Vafa and Rosenbaum, *Abbas Kiarostami*, 4.

15 For a discussion of Forough Farrokhzad and her work, see Farzaneh Milani's *Veils and Words*.

16 Dabashi, *Close Up*, 254, 255, 257.

17 Massud Farasti, quoted in Elena, *The Cinema of Abbas Kiarostami*, 103–4.

18 Saeed-Vafa and Rosenbaum, *Abbas Kiarostami*, 1, 6, 7, 11. Rosenbaum's article certainly captures this sentiment, but similar comparisons to other directors and film movements appear with almost every review of Kiarostami's films in the foreign press. Hamid Dabashi's "Re-reading Reality" provides a good summary of critical responses to Kiarostami's work in the 1980s and '90s.

19 Kiarostami, in an interview with Miguel Mora, "Las películas buenas son las que se pueden ver 25 veces," 44; quoted in Elena, *The Cinema of Abbas Kiarostami*, 183.

20 Rosenbaum, "Fill in the Blanks"; Elena, *The Cinema of Abbas Kiarostami*, 183; Goudet, "*Five* d'Abbas Kiarostami."

21 Cheshire, "Abbas Kiarostami," 227.

22 Ibid., 226.

23 Laura Mulvey suggests that "an influential moment, often referred to, had been a retrospective of Italian neo-realism in Tehran in the 1960s. Kiarostami has mentioned his admiration for Rossellini: 'I often went to the cinema when I was young and I was profoundly marked by Italian Neo-realism, particularly Rossellini. There are clear connections between the ruins and the people in *Germany Year Zero* and those of *And Life Goes On*. But during the whole time of writing and filming I never thought about it.' *Positif*, 380 (October 1992), p. 32." Mulvey, *Death 24x a Second*, 203–204 (n. 5).

24 Giavarini and Jousse, "Entretien avec Abbas Kiarostami"; quoted in Elena, *The Cinema of Abbas Kiarostami*, 185.

25 Ibid.

26 Bonitzer, "Off-screen Space," 293.

27 Alloula, *The Colonial Harem*.

28 Oubína, "Algunas reflexiones sobre un plano en un film de un cineasta iraní"; quoted in Elena, *The Cinema of Abbas Kiarostami*, 109.

29 Jacques Gesternkorn, "Voyage avec Kiarostami," 84; quoted in Elena, *The Cinema of Abbas Kiarostami*, 110–11.

30 Quoted in Dabashi, "Re-reading Reality," 69.

31 Ibid.

32 Quoted in Elena, *The Cinema of Abbas Kiarostami*, 114.

33 Ahmad Talebi-Nejad concurs with this reading in the journal *Film*, no. 168, p. 104.

34 Nancy, *Abbas Kiarostami*, 88 and 90.

35 Mulvey, *Death 24x a Second*, 139.

36 Dabashi, "Re-reading Reality," 81.

37 See Laura Mulvey's "Kiarostami's Uncertainty Principle."

38 Chow, *Primitive Passions*, 94.

39 Here I am referring, of course, to Roland Barthes's notion of a "reality effect": "It is the category of the 'real,' and not its various contents, which is being signified" (Barthes, "The Reality Effect," 16). Writing on Barthes's concept, Naomi Schor suggests that "At the very moment when one thinks one is embracing the real in its concrete materiality . . . one is in fact in the grips of a 'reality effect' where what we are given is a category and not a thing" (Schor, *Reading in Detail*, 86).

40 As many feminist theoreticians of suture have argued (Mary Ann Doane, Teresa de Lauretis, Patricia Mellencamp, Linda Williams, and Laura Mulvey foremost among them), "the lack which must be both dramatized and contained" for film to maintain its continuity "finds its locus in the female body." For further references, see Kaja Silverman's *The Subject of Semiotics*, 224.

41 With the original French publication in 1977 of what was later translated as *The Imaginary Signifier*, Christian Metz attempted to shift the terrain of film analysis from a focus on the story or statement (*énoncé*) toward an analysis of filmic enunciation (*énonciation*). Drawing on the work of Emile Benveniste to situate the terms of his analysis, Metz made the famous distinction between *histoire* (story or narration), which derives from an all-knowing but unseen source, and *discours* (discourse), the act of telling or making meaning. In Benveniste's linguistics, *discours* is associated with the "I" that is representative of the agent who produces the story; *histoire*, in contrast, effaces the marks of its *énonciation*, erasing with them the very site and means of the text's production. The difference between *énoncé* (histoire or statement) and enunciation (discourse), as elaborated by Benveniste in his "Correlations of the Tense in the French Verb," centers on the mechanisms by which we can identify the sign of the speaker of the statement. In the traditional narrative or *histoire*, Benveniste explains, the sign of the producer of the utterance is unmarked, while in *discours*, the subject is present in the moment and the location of the utterance. Here, Benveniste appeals to deixis (the "I," "You," "Here," "There," "Now"), the shifters that mark the moment and the location of discourse with the personal pronoun and with the inscription of the time and place of the utterance in verb tenses. In *discours*, the pronoun is the mark of the speaker's presence, whereas in *histoire*, a disembodied voice reports on the narrative unfolding—the speaker thus effaces his or her connection to the time and location of the statement's production. This effacement

is characteristic of historiography, according to Benveniste. Transferring Benveniste's insights into the domain of the cinema in *The Imaginary Signifier*, Metz argues that in the cinema the spectator generally identifies with the characters that appear in the story played out on the screen. At the level of the story, the viewer's identification with the characters of the film has to do with *not* being aware of who and what speaks them. The spectator identifies with the film characters, that is, only insofar as the narrating discourse, that which "speaks" the characters, is repressed. Metz designates the identification that takes place between the spectator and the story world "secondary identification." Primary identification in this context occurs with the camera, which is the source of the spectator's access to the narrative. In watching film, Metz argues, the spectator must identify with the view that the camera produces; the spectator understands the narrative's meaning insofar as the camera effectively and unobtrusively represents it. Metz therefore insists that both story and discourse and both primary and secondary modes of identification are present in each instance and in every film. In cinema, an economy of relations between *histoire* and *discours* is operating. In film, as in history writing, the discourse generating the story retroactively erases the discursive in order to produce the story and generate the audience's identification with the characters in it.

42 I thank Gilberto Perez for this suggestion.

43 Saeed-Vafa and Rosenbaum, *Abbas Kiarostami*, 22–23.

44 Ibid., 11.

45 De Lucas, "The Different Scales of the World," 57–58.

46 Original press book for the film distributed by the Farabi Cinema Foundation, 5.

47 Mulvey, *Death 24x a Second*, 134.

48 Mahdi, "In Dialogue with Kiarostami."

49 Saeed-Vafa and Rosenbaum, *Abbas Kiarostami*, 30.

50 Nancy, *Abbas Kiarostami*, 28.

51 Ibid., 30.

52 "A concept" is the term Rosenbaum uses to describe Tahirih's role in *Through the Olive Trees*. See Saeed-Vafa and Rosenbaum, *Abbas Kiarostami*, 25.

53 Nancy, *Abbas Kiarostami*, 90 and 92.

54 Naficy, "Veiled Vision/Powerful Presences," 145.

55 Stam, *New Vocabularies in Film Semiotics*, 167.

56 Ibid.

57 Quoted in Stam, *New Vocabularies in Film Semiotics*, 170.

58 Nancy, *Abbas Kiarostami*, 88.

59 And lest we confuse ourselves by thinking that Kiarostami achieves what Behzad doesn't by making the ethnographic film that Behzad wants but fails to make, we read in an interview that Kiarostami himself had the conversation with Farzad in this scene, knowing full well that the boy personally liked Behzad more than he liked the film director. In other words, Kiarostami was anxious to capture

a realistic hesitation on the part of the boy with regard to what his film might be doing in the remote village of Siah Darreh, prying, condescending, and in general abusing the hospitality of the village. See Jonathan Rosenbaum's "The Universe in a Cellar," www.chicagoreader.com/movies/archives/2000/1200/001208.html.

60 Hamid, "Near and Far," 22.

61 Chow, Primitive Passions, 13.

62 Ibid., 194.

63 Chow, Woman and Chinese Modernity, 33.

64 Cheshire, "How to Read Kiarostami," 10.

65 See Tom Gunning, "The Cinema of Attractions."

66 Gunning, "The Whole Town's Gawking," 190.

67 Saeed-Vafa and Rosenbaum, Abbas Kiarostami, 100.

68 Ibid., 29.

Chapter 3

1 Mattelart, Mapping World Communication, 17 n. 23. Mattelart quotes Frodon on Godard in "L'Amérique et ses démons," Le Monde, May 7, 1992, 30. But clearly the debate about "what is national in national cinemas" continues to be a vexing question in film studies. See for example the introduction and articles in Mette Hjort and Steve MacKenzie (eds.), Cinema and Nation.

2 Quoted in Naficy, "Iranian Cinema," 175.

3 Ibid., 173.

4 See for example Azadeh Farahmand's "Perspectives on Recent (International Acclaim for) Iranian Cinema," 100–101.

5 Lahiji, "Chaste Dolls and Unchaste Dolls."

6 Ibid., 224.

7 Berry, "Sexual Difference and the Viewing Subject in Li Shuangshuang and The In-laws," 32.

8 Mowitt, Re-takes, xxvi.

9 Desser, "Gate of Flesh(tones)," 308.

10 Berry, "Sexual Difference and the Viewing Subject in Li Shuangshuang and The In-laws," 37–38.

11 Mowitt, Re-takes, 35.

12 Ibid.

13 Cf. Ganguly, "Carnal Knowledge."

14 Mowitt, Re-takes, xxv.

15 Khanna, "Ethical Ambiguities and Specters of Colonialism," 103.

16 Kristin Thompson suggests something to this effect when she writes that alternative cinemas gain their significance and force "partly because they seek to undermine the common equation of 'the movies' with 'Hollywood.' " See Exporting Entertainment, 168–170.

17 Mowitt, *Re-Takes*, xxv.

18 Ibid.

19 Lu, "Historical Introduction," 12.

20 See, for example, Mehrnaz Saeed-Vafa's "Location (Physical Space) and Cultural Identity."

21 Nichols, "Discovering Form, Inferring Meaning," 17.

22 Jane Gaines's 2002 article on Robert Ripley goes a long way toward explaining this phenomenon in relation to foreign sites in film. See Gaines, "Everyday Strangeness."

23 Mowitt, *Re-takes*, 61.

24 On this history see Sklar's *Movie-Made America*. See also Mulvey, "The Problem of America; The Problem of Sound."

25 Mowitt, *Re-Takes*, 63.

26 Ibid.

27 Nichols, "Discovering Form, Inferring Meaning," 17.

28 Nichols, "Global Image Consumption in the Age of Late Capitalism," 68.

29 Farahmand, "Perspectives on Recent (International Acclaim for) Iranian Cinema," 87.

30 The Farabi Cinema Foundation (FCF) was established in 1983 by the Ministry of Guidance to cover all aspects of the film industry. Today, FCF produces films, gives low-rate loans, supplies raw materials, lends camera equipment, provides postproduction facilities, publishes on cinema, and sponsors film festivals. It is also responsible for promoting and marketing Iranian cinema all over the world: introducing Iranian films to festivals, screening them in different countries, participating in film markets, and promoting world sales of Iranian pictures. FCF arranges coproductions with foreign producers as well, and is the exclusive importer of movies for theatrical and video release in Iran. Through years of productive activity, it has established itself as the major organization involved in domestic film production and the main representative of Iranian cinema abroad.

31 As Julian Stringer has suggested, such "distribution histories" therefore "too often masquerade as production histories." Non-Western cinemas and national auteurs "do not count historically until they have been recognized by the apex of international power," in other words the Western film festivals. Stringer, "Global Cities and the International Film Festival Economy," 135. On what Iranian cinema gets screened in the West, see Hamid Naficy's illuminating entry, "Iranian Cinema," in *Companion Encyclopedia of Middle Eastern and North African Film*.

32 As Chaudhuri and Finn argue, "The appeal of New Iranian Cinema in the West may have less to do with 'sympathy' for an exoticized 'other' under conditions of repression than with self-recognition" (Chaudhuri and Finn, "The Open Image," 57). See also Laura Mulvey's chapter on Kiarostami in *Death 24x a Second*.

33 See Ganguly, "Carnal Knowledge."

34 Strain, "Exotic Bodies, Distant Landscapes," 71.

35 Ibid., 71–72.

36 Chow, "Film and Cultural Identity," 171.

37 Mattelart, *Mapping World Communication*, 18.

38 Chow, "Film and Cultural Identity," 171.

39 I borrow this term from Ella Shohat's and Robert Stam's discussion of sexual power dynamics between the peoples of the First and the Third Worlds. See *Unthinking Eurocentrism*, 157.

40 Mattelart, *Mapping World Communication*, 27.

41 Camera Obscura collective, "An Interrogation of the Cinematic Sign," 11.

42 Gledhill, "Klute 1," 67; see also Doane, "Woman's Stake."

43 Wollen, "The Field of Language in Film," 60.

44 Ibid.

45 Gledhill, "Recent Developments in Feminist Criticism," 464; Baudry, "The Apparatus," 315.

46 Cowie, "Feminist Film Criticism," 138.

47 Camera Obscura collective, "An Interrogation of the Cinematic Sign," 12.

48 Mowitt, *Re-takes*, 35.

49 Berry, "Sexual Difference and the Viewing Subject in Li *Shuangshuang* and *The In-laws*," 37.

50 Doane, "The Voice in Cinema," 344.

51 See chapter 5 ("Purity Lost, Purity Regained") of Abdelwahab Bouhdiba's *Sexuality in Islam*.

52 Mayne, "Paradoxes of Spectatorship," 156.

53 Donna Haraway, "A Manifesto for Cyborgs," 39.

54 Ibid., 23.

55 Bouhdiba, *Sexuality in Islam*, 53.

56 Ibid., 57.

57 In envisioning the making of a technosensorial body through film, Khomeini paralleled Walter Benjamin's reading of Marx in *The Arcades Project*: "To make the technical apparatus of our time, which is a second nature for the individual, into a first nature for the collective, is the historic task of film." Quoted in Hansen, "Benjamin and Cinema," 321.

58 Benjamin, "The Work of Art in the Age of Its Technological Reproducibility (Third Version)," 270.

59 See Susan Buck-Morss, "Aesthetics and Anaesthetics."

60 See Miriam Hansen's reading of Benjamin's essay in "Room-for-Play."

61 Drawing on examples from classical narrative cinema, Metz argues that cinematic perception is voyeuristic in that it is "predicated on a distance between the spectator and the object of vision (a distance in time as well as in space)" (Quoted in Clover, "The Eye of Horror," 204). Here the spectator assumes the drive for mastery, a kind of sadism linked to an aggressive male sexuality. In *The Imaginary Signifier* Metz also gestures toward a second, "punctured" vision: a mode of perception

in which the look of the spectator appears as soft as wax. "A sort of stream called the look," he writes, "must be sent out over the world, so that objects can come back up this stream in the opposite direction . . . arriving at last at our perception, which is now soft wax and no longer an emitting source" (Metz, *The Imaginary Signifier*, 50). Metz charts the duality of vision operating in the theater similarly: "There are two cones in the auditorium: one ending on the screen and starting both in the projection box and in the spectator's vision insofar as it is projective, and one starting from the screen and 'deposited' in the spectator's perception insofar as it is introjective (on the retina, a second screen)" (Ibid., 51).

62 Ibid.

63 Ibid.

64 Makhmalbaf, "*Dastfurush*," 146–47.

65 Ibid., 139–147.

66 Lotman, *Semiotics of Cinema*, 28.

67 Metz, *Film Language*, 47.

68 Sorlin, *European Cinemas, European Societies*, 2.

69 Gaines, "Women and Representation," 363.

70 Clover, "The Eye of Horror," 204. Focused on the voyeurism of the cinematic gaze, feminist film theory has over three decades engaged in debates regarding the possibilities of pleasure in female spectatorship over and above any serious consideration of the possibilities opened up by technologies (and by their reversibility) to mimetically reeducate the senses through film technologies. As Mary Ann Doane suggests: "The impasse confronting feminist filmmakers today is linked to the force of a certain theoretical discourse which denies the neutrality of the cinematic apparatus itself. A machine for the production of images and sounds, the cinema generates and guarantees pleasure by a corroboration of the spectator's identity. Because that identity is bound up with that of the voyeur and the fetishist . . . it is not accessible to the female spectator, who in buying her ticket must deny her sex" (Doane, "Woman's Stake," 165–66). The focus on the possibilities of feminine pleasure in spectatorship, however critical, has directed feminist film theorists' attention away from a second aspect of visuality that involves a loss of mastery, indeed, a receptivity in the look that can overwhelm the viewer to the point of annihilating subjectivity before the screen. For more, see Doane, "Remembering Women," 85.

71 Hansen, "Benjamin and Cinema," 335.

72 Teresa de Lauretis discusses this possibility for film theory in "Aesthetics and Feminist Theory," republished as "Rethinking Women's Cinema" (see page 134 in the latter for the quoted material).

73 Dabashi, *Close Up*, 188.

74 Neale, "Colour and Film Aesthetics," 85.

75 Desser, "Gate of Flesh(tones)," 304.

76 Neale, "Colour and Film Aesthetics," 87.

77 Ibid., 85.

78 Desser, "Gate of Flesh(tones)," 304.

79 Heath, "Narrative Space," 168–70.

80 Kristeva, *Desire in Language*, 221; see also Kristeva's two essays on the subject in *The Tel Quel Reader*: "The Subject in Process" and "Towards a Semiology of Paragrams."

81 Quoted in Neale, "Colour and Film Aesthetics," 93.

82 Gunning, "Colorful Metaphors," retrieved at http://www.muspe.unibo.it/period/fotogen/num01/numero1.htm.

83 Silverman, *The Subject of Semiotics*, 228.

Abdi, Mohammad. 1383/1998. *The Life and Cinema of Bahram Beizaee*. Tehran: Saless Publishers.

Alloula, Malek. 1986. *The Colonial Harem*, trans. Myrna Godzich and Wlad Godzich. Minneapolis: University of Minnesota Press.

Barthes, Roland. 1982. "The Reality Effect." Pages 11–17 in *French Literary Theory Today*, ed. Tzvetan Todorov, trans. R. Carter. Cambridge: Cambridge University Press.

Baudry, Jean-Louis. 1986. "The Apparatus: Metapsychological Approaches to the Impression of Reality." Pages 299–318 in: *Narrative, Apparatus, Ideology: A Film Theory Reader*, ed. Philip Rosen. New York: Columbia University Press.

Bayza'i, Bahram. 1996. "At the End of a Hundred Years." *Iran Nameh* 14, no. 3 (summer): 363–82.

Beeman, William O. 1982. "A Full Arena: The Development and Meaning of Popular Performance Traditions in Iran." Pages 361–81 in *Modern Iran: The Dialectics of Continuity and Change*, ed. Michael E. Bonine and Nikki R. Keddie. Albany: State University of New York Press.

Benjamin, Walter. 1999 (1931). "The Little History of Photography." Pages 507–30 in *Walter Benjamin: Selected Writings, Volume 2, 1927–1934*, ed. Michael W. Jennings, Howard Eiland, and Gary Smith, trans. Rodney Livingstone. Cambridge: Belknap.

————. 2003 (1939). "The Work of Art in the Age of Its Technological Reproducibility (Third Version)." Pages 251–83 in *Walter Benjamin: Selected Writings, Volume 4, 1938–1940*, ed. Howard Eiland and Michael W. Jennings, trans. Edmund Jephcott. Cambridge: Belknap.

Benveniste, Emile. 1971. "Correlations of the Tense in the French Verb." Pages 205–15 in *Problems in General Linguistics*, ser. no. 8, trans. Mary Elizabeth Meek. Coral Gables: University of Miami Press.

Berry, Chris. 1991. "Sexual Difference and the Viewing Subject in Li Shuangshuang and The In-laws." Pages 30–39 in Perspectives on Chinese Cinema, ed. Chris Berry. London: BFI.

Bonitzer, Pascal. 1990. "Off-screen Space." Pages 291–305 in Cahiers du cinéma 1969–72: The Politics of Representation, ed. Nick Browne. Cambridge: Harvard University Press.

Bouhdiba, Abdelwahab. 1998. Sexuality in Islam, trans. Alan Sheridan. London: Saqi Books.

Buck-Morss, Susan. 1992. "Aesthetics and Anaesthetics: Walter Benjamin's Artwork Essay Reconsidered." October 62 (fall): 3–41.

Camera Obscura Collective. 1976. "An Interrogation of the Cinematic Sign: Woman as Sexual Signifier in Jackie Raynal's Deux Fois." Camera Obscura: A Journal of Feminism and Film Theory 1 (fall).

Chaudhuri, Shohini, and Howard Finn. 2003. "The Open Image: Poetic Realism and the New Iranian Cinema." Screen 44, no. 1: 38–57.

Chehabi, H. E. 1997. "Ardabil Becomes a Province: Center-Periphery Relations in Iran." International Journal of Middle East Studies 29, no. 2: 235–53.

Cheshire, Godfrey. 1998. "Abbas Kiarostami: Seeking a Home." Pages 209–28 in Projections 8: Filmmakers on Filmmaking, ed. John Boorman and Walter Donohue. London: Faber and Faber.

———. 2000. "How to Read Kiarostami." Cineaste 25, no. 4: 8–15.

———. 1997. "Makhmalbaf: The Figure in the Carpet." Film Comment (July-August): 62–70.

Chow, Rey. 1998. "Film and Cultural Identity." Pages 169–75 in The Oxford Guide to Film Studies, ed. John Hill and Pamela Church Gibson. Oxford: Oxford University Press.

———. 1995. Primitive Passions: Visuality, Sexuality, Ethnography and Contemporary Chinese Cinema. New York: Columbia University Press.

———. 1991. Women and Chinese Modernity: The Politics of Reading between West and East. Minneapolis: University of Minnesota Press.

Ciment, Michel, and Stéphane Goudet. 1997. "Entretien avec Abbas Kiarostami: Un approche existentialiste de la vie." Positif no. 422 (December): 83–89.

Clover, Carol J. 1994. "The Eye of Horror." Pages 184–230 in Viewing Positions: Ways of Seeing Film, ed. Linda Williams. New Brunswick, N.J.: Rutgers University Press.

Company, Juan M. 2000. "Espera de lo invisible: El viento no llevará." El Viejo Topo no. 137–38 (February-March): 103.

Copjec, Joan. 2003. Imagine There's No Woman: Ethics and Sublimation. Cambridge: MIT Press.

Corbin, Henri. 1964. "Mundus Imaginalis, or the Imaginary and the Imaginal." Retrieved at http://www.hermetic.com/bey/mundus_imaginalis.htm.

Cowie, Elizabeth. 1975. "Feminist Film Criticism: A Reply." Screen 16, no. 1: 138.

Culliford, Allison. 1999. "Parables and Popcorn: Abbas Kiarostami." High Life (December): 86–88.

Dabashi, Hamid. 2001. *Close Up: Iranian Cinema, Past, Present and Future.* New York: Verso.

———. 1995. "Re-reading Reality: Kiarostami's *Through the Olive Trees* and the Cultural Politics of a Postrevolutionary Aesthetics." *Critique: Journal of Critical Studies of Iran and the Middle East* 7 (fall): 63–89.

———. 1993. *Theology of Discontent: The Ideological Foundations of the Islamic Revolution in Iran.* New York: New York University Press.

Dayan, Daniel. 1974. "The Tutor Code of Classical Cinema." *Film Quarterly* 28, no. 1 (fall): 22–31.

De Lauretis, Teresa. 1985. "Aesthetics and Feminist Theory: Rethinking Women's Cinema." *New German Critique* 34 (winter): 127–48.

———. 1987. "Rethinking Women's Cinema." Pages 127–48 in *Technologies of Gender: Essays on Theory, Film and Fiction.* Bloomington: Indiana University Press.

De Lucas, Gonzalo. 2006. "The Different Scales of the World." Pages 54–61 in *From Victor Erice, for Abbas Kiarostami: Correspondences.* Barcelona: Centre de Cultura Contemporània de Barcelona, Institut d'Edicions de la Diputació de Barcelona, and Actar.

Desser, David. 1994. "Gate of Flesh(tones): Color in the Japanese Cinema." Pages 299–321 in *Cinematic Landscapes: Observations on the Visual Arts and Cinema of China and Japan,* ed. Linda C. Ehrlich and David Desser. Austin: University of Texas Press.

Doane, Mary Ann. 1991. "Deadly Women, Epistemology, and Film Theory." Pages 1–14 in *Femmes Fatales: Feminism, Film Theory, Psychoanalysis.* New York: Routledge.

———. 1991. "Film and the Masquerade." Pages 17–32 in *Femmes Fatales: Feminism, Film Theory, Psychoanalysis.* New York: Routledge.

———. 1991. "Remembering Women: Psychical and Historical Constructions in Film Theory." Pages 76–95 in *Femmes Fatales: Feminism, Film Theory, Psychoanalysis.* New York: Routledge.

———. 1986. "The Voice in Cinema: The Articulation of Body and Space." Pages 335–48 in *Narrative, Apparatus, Ideology: A Film Theory Reader,* ed. Philip Rosen. New York: Columbia University Press.

———. 1991. "Woman's Stake: Filming the Female Body." Pages 165–77 in *Femmes Fatales: Feminism, Film Theory, Psychoanalysis.* New York: Routledge.

Elena, Alberto. 2005. *The Cinema of Abbas Kiarostami,* trans. Belinda Coombes. London: Saqi Books.

Farabi Cinema Foundation. n.d. Press book for *Life and Nothing More.*

Farahmand, Azadeh. 2002. "Perspectives on Recent (International Acclaim for) Iranian Cinema." Pages 86–108 in *The New Iranian Cinema: Politics, Representation and Identity,* ed. Richard Tapper. London: I.B. Tauris.

Farrokhzad, Forough. "The Wind Will Carry Us," trans. Ahmad Karimi-Hakkak. *The Persian Book Review* 3, no. 12: 1337.

Freud, Sigmund. 1971. "The Dream and the Primal Scene." Pages 104–23 in Standard Edition of the Complete Psychological Works of Sigmund Freud, vol. 17, trans. James Strachey. London: Hogarth.

———. 1962. "Screen Memories." Pages 303–22 in Standard Edition of the Complete Psychological Works of Sigmund Freud, vol. 3, trans. James Strachey. London: Hogarth.

Gaines, Jane. 2000. "Birthing Nations." Pages 298–316 in Cinema and Nation, ed. Mette Hjort and Scott MacKenzie. London: Routledge.

———. 2002. "Everyday Strangeness: Robert Ripley's International Oddities as International Attractions." New Literary History 33 no. 4 (autumn): 781–801.

———. 1995. "Feminist Heterosexuality and Its Politically Incorrect Pleasures." Critical Inquiry 21 (winter): 382–410.

———. 1987. "Women and Representation: Can We Enjoy Alternative Pleasures?" Pages 357–72 in American Media and Mass Culture: Left Perspectives, ed. Donald Lazere. Berkeley: University of California Press.

Ganguly, Keya. 1996. "Carnal Knowledge: Visuality and the Modern in Charulata." Camera Obscura: Feminism, Culture and Media Studies 37 (January): 157–87.

Gesternkorn, Jacques. 1995. "Voyage avec Kiarostami: Au travers des oliviers." Generiques 2 (spring-summer): 84.

Ghookasian, Zavan. 1371/1992. Bahram Bayza'i. Tehran: Moassesseh Intesharat-e Agah.

Giavarini, Laurence, and Thierry Jousse. 1992. "Entretien avec Abbas Kiarostami." Cahiers du cinéma 461 (November): 32–36.

Gledhill, Christine. 2000. "Klute 1: A contemporary film noir and feminist criticism." Pages 66–85 in Feminism and Film, ed. E. Ann Kaplan. Oxford: Oxford University Press.

———. 1978. "Recent Developments in Feminist Criticism." Quarterly Review of Film Studies 3 no. 4 (fall): 457–93.

Gledhill, Christine, and Linda Williams, eds. 2000. Reinventing Film Studies. New York: Oxford University Press.

Goudet, Stéphane. 2004. "Five d'Abbas Kiarostami: Ciné-po'ems." Positif 519 (May): 55–57.

Gunning, Tom. 1986. "The Cinema of Attractions: Early Film, Its Spectator and the Avant-garde." Wide Angle 8: 3–4.

———. 1995. "Colorful Metaphors: The Attraction of Color in Early Silent Cinema." Fotogenia: Storie e teorie del cinema 1. Bologna: Editrice CLUEB.

———. 1994. "The Whole Town's Gawking: Early Cinema and the Visual Experience of Modernity." The Yale Journal of Criticism 7 no. 2: 189–201.

Haeri, Shahla. 1989. Law of Desire: Temporary Marriage in Shi'i Iran. Syracuse: Syracuse University Press.

Hamid, Nassia. 1997. "Near and Far: Interview." Sight and Sound 7 no. 2 (February): 22–24.

Hansen, Miriam. 1999. "Benjamin and Cinema: Not a One-Way Street." *Critical Inquiry* 25 (winter): 306–43.

———. 2000. "Fallen Women, Rising Stars, New Horizon." *Film Quarterly* 54 no. 1 (fall): 10–22.

———. 1999. "The Mass Production of the Senses: Classical Cinema as Vernacular Modernism." *Modernism/Modernity* 6 no. 2: 59–77.

———. 2004. "Room-for-Play: Benjamin's Gamble with Cinema." *October* 109 (summer): 3–45.

Hanssen, Eirik Frisvold. 2002. "Composition and Representation in Early Colour Film." Retrieved at www.geocities.com/frisvoldhanssen/aestheticexperience.html.

Haraway, Donna. 2004. "A Manifesto for Cyborgs: Science, Technology, and Socialist Feminism in the 1980s." Pages 7–45 in *The Haraway Reader*. New York: Routledge.

Heath, Stephen. 1976. "Narrative Space." Pages 68–112 in *Screen 3* (Autumn).

———. 1981. *Questions of Cinema*. London: Macmillan.

Hjort, Mette, and Scott MacKenzie, eds. 2000. *Cinema and Nation*. New York: Routledge.

Johnston, Claire. 1985. "Towards a Feminist Film Practice: Some Theses." Pages 315–27 in *Movies and Methods*, vol. 2, ed. Bill Nichols. Berkeley: University of California Press.

Jost, Francois. 1995. "The Polyphonic Film and the Spectator." Pages 181–91 in *The Film Spectator: From Sign to Mind*, ed. Warren Buckland. Amsterdam: Amsterdam University Press.

Jousse, Thierry, and Serge Toubiana. 1999. "Un film n'a pas de passeport: Entretien avec Abbas Kiarostami." *Cahiers du cinéma* 541 (December): 30–33.

Kiarostami, Abbas. 2004. Interview with Miguel Mora: "Las películas buenas son las que se pueden ver 25 veces." *El País* (May 15): 44.

Khanna, Ranjana. 2001. "Ethical Ambiguities and Specters of Colonialism: Futures of Transnational Feminism." Pages 101–25 in *Feminist Consequences: Theory for the New Century*, ed. Elisabeth Bronfen and Misha Kavka. New York: Columbia University Press.

Khomeini, Ruhollah. 1989. *Imam Khomeini's Last Will and Testament*. Washington: Embassy of the Democratic and Popular Republic of Algeria, Interest Section of the Islamic Republic of Iran.

———. 1981. *Islam and Revolution 1: Writings and Declarations of Imam Khomeini (1941–1980)*, trans. Hamid Algar. Berkeley: Mizan Press.

———. 1981. "Speech Given to Iranian Oil Workers February 15." In *Highlights of Imam Khomeini's Speeches November 5, 1980–April 28, 1981*, trans. and ed. Pars News Agency. Compiled by the Muslim Student Association, Albany, Calif.

———. 1980. "Speech Given to Representatives of World Liberation Movements January 10." In *Selected Messages and Speeches of Imam Khomeini*. Tehran: Ministry of National Guidance.

Kristeva, Julia. 1980. *Desire in Language: A Semiotic Approach to Literature and Art*, ed.

Leon S. Roudiez, trans. Thomas Gora, Alice Jardine, and Leon S. Roudiez. New York: Columbia University Press.

———. 1998. "The Subject in Process." Pages 133–78 in *The Tel Quel Reader*, ed. Patrick ffrench and Roland-François Lack. London: Routledge.

———. 1998. "Towards a Semiology of Paragrams." Pages 25–49 in *The Tel Quel Reader*, ed. Patrick French and Roland-François Lack. London: Routledge.

Lahiji, Shahla. 2002. "Chaste Dolls and Unchaste Dolls: Women in Iranian Cinema since 1979." Pages 215–26 in *The New Iranian Cinema: Politics, Representation and Identity*, ed. Richard Tapper. London: I.B. Tauris.

Lotman, Jurij. 1976. *Semiotics of Cinema*, trans. Mark E. Suino. Ann Arbor: Department of Slavic Languages and Literature, University of Michigan.

Lu, Sheldon Hsiao-peng. 1997. "Historical Introduction: Chinese Cinema (1896–1996) and Transnational Film Studies." Pages 1–31 in *Transnational Chinese Cinemas: Identity, Nationhood, Gender*, ed. Sheldon Hsiao-peng Lu. Honolulu: University of Hawaii Press.

Mahdi, Ali Akbar. 1998. "In Dialogue with Kiarostami." *The Iranian* (August 25). Retrieved at www.iranian.com/Arts/Aug98.Kiarostami.

Makhmalbaf, Mohsen. 1975. "*Dastfurush:* Interview." Pages 137–79 in *Gong-e Khabdideh*, vol. 3. Tehran: Nashrani.

Marks, Laura. 2000. *The Skin of the Film: Intercultural Cinema, Embodiment, and the Senses*. Durham: Duke University Press.

Mattelart, Armand. 1994. *Mapping World Communication: War, Progress, Culture*, trans. Susan Emanuel and James Cohen. Minneapolis: University of Minnesota Press.

Mayne, Judith. 1994. "Paradoxes of Spectatorship." Pages 155–83 in *Viewing Positions: Ways of Seeing Film*, ed. Linda Williams. New Brunswick, N.J.: Rutgers University Press.

———. 1981. "Woman at the Keyhole." *New German Critique* 23 (spring-summer): 27–43.

Mernissi, Fatima. 1987. *Beyond the Veil: Male-Female Dynamics in the Modern Muslim Society* (rev. ed.), trans. Mary Jo Lakeland. Bloomington: Indiana University Press.

Metz, Christian. 1974. *Film Language: A Semiotics of the Cinema*, trans. Michael Taylor. New York: Oxford University Press.

———. 1982. *The Imaginary Signifier: Psychoanalysis and the Cinema*, trans. Celia Britton, Annwyl Williams, Ben Brewster, and Alfred Guzzetti. Bloomington: Indiana University Press.

———. 1995. "The Impersonal Enunciation, or the Site of Film: In the Margin of Recent Works on Enunciation and Cinema." Pages 140–63 in *The Film Spectator: From Sign to Mind*, ed. Warren Buckland. Amsterdam: Amsterdam University Press.

Milani, Farzaneh. 1992. *Veils and Words: The Emerging Voices of Iranian Women Writers*. Syracuse, New York: Syracuse University Press.

Mowitt, John. 2005. *Re-takes: Postcoloniality and Foreign Film Languages*. Minneapolis: University of Minnesota Press.

————. 1993. "Sembène Ousmane's *Xala*." *Camera Obscura: Feminism, Culture and Media Studies* 31 (January-May): 73–95.

Mulvey, Laura. 2002. "Afterword." Pages 254–61 in *The New Iranian Cinema: Politics, Representation and Identity*, ed. Richard Tapper. London: I.B. Tauris.

————. 1989. "British Feminist Film Theory's Female Spectators: Presence and Absence." *Camera Obscura* 20–21: 68–81.

————. 2006. *Death 24x a Second: Stillness and the Moving Image*. London: Reaktion Books.

————. 1998. "Kiarostami's Uncertainty Principle." *Sight and Sound* 8 (June): 24–27.

————. 2001. "The Problem of America; The Problem of Sound." *Critical Quarterly* 43 no. 3: 3–8.

————. 1989. *Visual and Other Pleasures*. Bloomington: Indiana University Press.

————. 1975. "Visual Pleasure and Narrative Cinema." *Screen* 16 no. 3, 6–18.

Naficy, Hamid. 2001. "Iranian Cinema." Pages 130–222 in *Companion Encyclopedia of Middle Eastern and North African Film*, ed. Oliver Leaman. New York: Routledge.

————. 1998. "Iranian Cinema under the Islamic Republic." Pages 229–46 in *Images of Enchantment: Visual and Performing Arts of the Middle East*, ed. Sherifa Zuhur. Cairo: The American University of Cairo.

————. 2002. "Islamicizing Film Culture in Iran: A Post-Khatami Update." Pages 26–65 in *The New Iranian Cinema: Politics, Representation and Identity*, ed. Richard Tapper. London: I.B. Tauris.

————. 2003. "Poetics and Politics of Veil, Voice and Vision in Iranian Post-revolutionary Cinema." Pages 138–53 in *Veil: Veiling, Representation and Contemporary Art*, ed. David A. Bailey and Gilane Tawadros. Cambridge: MIT Press.

————. 1994. "Veiled Vision/Powerful Presences: Women in Post-revolutionary Iranian Cinema." Pages 131–50 in *In the Eye of the Storm: Women in Post-revolutionary Iran*, ed. Mahnaz Afkhami and Erika Friedl. Syracuse: Syracuse University Press.

Nancy, Jean-Luc. 2001. *Abbas Kiarostami: The Evidence of Film*, trans. Christine Irizarry and Verena Andermatt Conley. Brussels: Yves Gevaert.

Neale, Stephen. 2002. "Colour and Film Aesthetics." Pages 85–94 in *The Film Cultures Reader*, ed. Graeme Turner. New York: Routledge.

————. 1979. "The Same Old Story: Stereotypes and Difference." *Screen Education* 32 no. 3: 33–37.

Nichols, Bill. 1994. "Discovering Form, Inferring Meaning: New Cinemas and the Festival Circuit." *Film Quarterly* 47 no. 3: 16–30.

————. 1994. "Global Image Consumption in the Age of Late Capitalism." *East-West Journal* 8 no. 1: 64–85.

Oubína, David. 1997. "Algunas reflexiones sobre un plano en un film de un cineasta iraní." *Punto de vista* 59 (December): 20–25.

Penley, Constance. 1989. *The Future of an Illusion: Film, Feminism, and Psychoanalysis*. Minneapolis: University of Minnesota Press.

Rahimieh, Nasrin. 2002. "Marking Gender and Difference in the Myth of the

Nation: A Post-revolutionary Iranian Film." Pages 238–53 in *The New Iranian Cinema: Politics, Representation and Identity*, ed. Richard Tapper. London: I.B. Tauris.

Ronell, Avital. 1989. *The Telephone Book: Technology, Schizophrenia, Electric Speech*. Lincoln: University of Nebraska Press.

Rose, Jacqueline. 1986. *Sexuality in the Field of Vision*. London: Verso.

Rosenbaum, Jonathan. 1998. "Fill in the Blanks: *Taste of Cherry*." *Chicago Reader* (May 29). www.chicagoreader.com/movies/archives/1998/0598/05298.html.

———. 2000. "The Universe in a Cellar." *Chicago Reader*. www.chicagoreader.com/movies/archives/2000/1200/001208.html.

Sabbah, Fatna A. 1984. *Woman in the Muslim Unconscious*, trans. Mary Jo Lakeland. New York: Pergamon Press.

Saeed-Vafa, Mehrnaz. 2002. "Location (Physical Space) and Cultural Identity in Iranian Films." Pages 200–214 in *The New Iranian Cinema: Politics, Representation and Identity*, ed. Richard Tapper. London: I.B. Tauris.

Saeed-Vafa, Mehrnaz, and Jonathan Rosenbaum. 2003. *Abbas Kiarostami*. Urbana: University of Illinois Press.

Schor, Naomi. 1987. *Reading in Detail: Aesthetics and the Feminine*. New York: Methuen.

Sekula, Allan. 1984. *Photography against the Grain: Essays and Photo Works 1973–1983*. Halifax: The Press of the Nova Scotia College of Art and Design.

Shohat, Ella, and Robert Stam. 1994. *Unthinking Eurocentrism: Multiculturalism and the Media*. New York: Routledge.

Silverman, Kaja. 1983. *The Subject of Semiotics*. New York: Oxford University Press.

Sklar, Robert. 1994. *Movie-Made America: A Cultural History of American Movies* (revised and updated). New York: Random House.

Sobchack, Vivian. 2004. *Carnal Thoughts: Embodiment and Moving Image Culture*. Berkeley: University of California Press.

Sorlin, Pierre. 1991. *European Cinemas, European Societies; 1939–1990*. New York: Routledge.

Stam, Robert. 1992. *New Vocabularies in Film Semiotics: Structuralism, Post-structuralism and Beyond*, with Robert Burgoyne and Sandy Flitterman-Lewis. London: Routledge.

Strain, Ellen. 1996. "Exotic Bodies, Distant Landscapes: Touristic Viewing and Popularized Anthropology in the Nineteenth Century." *Wide Angle* 18 no. 2: 70–100.

Stringer, Julian. 2001. "Global Cities and the International Film Festival Economy." Pages 134–44 in *Cinema and the City: Film and Urban Societies in a Global Context*, ed. Mark Siel and Tony Fitzmaurice. Oxford: Blackwell.

Talebi-Nejad, Ahmad. 1994. Film, no. 168 (December): 104.

Tesson, Charles. 1999. "Le Secret magnifique: A propos de *Le Vent nous emportera* d'Abbas Kiarostami." *Cahiers du cinéma* 541 (December): 27–29.

Thompson, Kristin. 1985. *Exporting Entertainment: America in the World Film Market 1907–34*. London: BFI.

Weigel, Sigrid. 1996. *Body- and Image-Space: Re-reading Walter Benjamin.* New York: Routledge.

Wiegman, Robyn. 1998. "Race, Ethnicity and Film." Pages 158–68 in *The Oxford Guide to Film Studies,* ed. John Hill and Pamela Church Gibson. Oxford: Oxford University Press.

Willemen, Paul. 1986. "Voyeurism, the Look and Dwoskin." Pages 210–18 in *Narrative, Apparatus, Ideology: A Film Theory Reader,* ed. Philip Rosen. New York: Columbia University Press.

Williams, Linda. 2001. *Playing the Race Card: Melodramas of Black and White from Uncle Tom to O. J. Simpson.* Princeton: Princeton University Press.

Wollen, Peter. 1981. "The Field of Language in Film." *October 17: The New Talkies* (summer): 53–60.

Day of Judgment, 19, 68, 102. *See also* messianism.

Death of Yazdgerd (*Marg-i Yazdgerd*, Bayza'i 1981), 18

deixis, 16–17, 20–21, 39, 45–46, 60, 66, 68, 82, 84, 86–88, 142–43, 159, 162–66, 175 n. 41

Delacroix, Eugene, 100

Diba, Farah, 89

Dinner for One (Kiarostami, 1995), 109–10

discours (associated with agent or I producing the story) 175 n. 41. *See also* enunciation.

displaced allegory, xii, 3, 12 , 47, 160; "commandments for looking" as, 21, 103–4, 139; conditions of the film industry as, 12, 14, 81, 103–4, 108–9, 139; modesty system formative of, 103, 139; village films as, 98–99

duality of vision (Metz), 154, 179 n. 61

dubbing, 49, 52, 61, 158

editing, 23, 25–26, 34–35, 37–40, 44, 47, 49, 52, 55–57, 60–67, 77, 110, 138, 142, 156, 163–66, 170 n. 6. *See also* film grammar.

énoncé (film statement as distinct from enunciation), 175 n. 41

enunciation, xi, 77, 128, 168, 172 n. 29, 175 n. 41; as bridge between the narrative and the film industry, 13, 47, 55, 84–86, 112, 143–44, 151; female body as site of, 11, 13, 15, 87–88, 108, 110, 113, 117, 133, 138–39, 150–51, 165; as filmic reflexivity, 45–46, 112; as grammar and syntax, 14, 44–45, 59–60, 125, 138–39, 145, 150–51, 154, 156; national cinema and, 12–14, 46–47,

67, 88, 139, 143–45, 151, 167; as process and location of film production, 13–14, 43–45, 49, 55, 59, 66, 81, 108, 112, 117, 125, 143–45, 150–51, 165; as repressed, 67, 76, 110, 125, 164

ethnographic fetishism, critique of, 100, 122, 133, 138, 144, 146, 149, 160

European modernism (in cinema), 68, 90–91, 95, 97, 139, 147, 174 n. 23, 178 n. 32

exhibitionist cinema, 136

Farabi Cinema Foundation, 147, 178 n. 30

Farah Diba, 89

Farrokhzad, Forough, 93, 174 n. 15. *See also individual works.*

Fatima (daughter of Prophet Muhammad), 5

Fatima (daughter of Iman Husayn), 70–71

female body: as absent, 91, 99–100, 108–10, 113; as bearer of heterosexual desire and potency, 2, 9, 171 n. 14; fetishism of, 42, 144, 153; as lack, 179 n. 40; negative aesthetics and, 149–51; as productive of cinema's address, 16, 108, 110, 121, 129, 153, 162, 165; as site of contamination, 1–2, 153; at threshold of filmic enunciation, 11, 16, 88, 115. *See also* veiled female body.

feminist film theory, 11–12, 14, 140, 143–44, 148–51, 154, 156–57, 168, 170 n. 6, 175 n. 40, 180 n. 70. *See also* feminist gaze theory; feminist "negative aesthetics."

feminist gaze theory, xii, 2, 4, 9,14, 16, 17, 149–50, 154–57, 170 n. 6, 175 n.

121, 130–31, 133, 165, 168. *See also* stutter; suture.

national cinemas, xi, xii, 2, 5, 12–14, 46–47, 95–96, 140–41, 143–49, 151, 168, 177 n. 1

negative aesthetics, 4, 11, 16, 150, 157, 167. *See also* feminist film theory.

now-time (messianic time), 7, 21, 68, 86

Orderly or Disorderly (Be Tartib Ya Bedun-e Tartib, Kiarostami, 1985), 89

orientalist harem fantasies, 100

politicization of aesthetics, 29, 153–54

post-Revolutionary Iranian cinema: absent-presences in, 91, 110, 113, 167; address of, 41, 9–20, 43–44, 47, 56, 66–67, 77, 80, 82, 84, 86–87, 107–8, 112–14, 121, 129, 131, 134, 138–39, 145, 151, 167; Arabic grammar and, 62–66, 173 n. 34; audiovisual detoxification in, 96; carnality of, 9, 15, 68–69, 77, 88; censorship and, 4, 7, 14, 17, 20–21, 27, 81, 96–98, 108, 129; critique of ethnography in, 100, 122, 131, 133, 138, 144, 146, 160; codes of perception in, 4, 15–16, 41–42, 47, 60, 66, 71, 107, 121–24, 142–43, 152, 155–57, 162, 164–68; color in, xi, 15, 99, 141–43, 148, 155, 158–67; desexualization of, 9–10, 20–21, 81, 96, 103, 107, 122, 129, 138, 171 n. 14; diegetic spaces as problematical in, 10, 11, 16, 162, 171; disruption of dominant codes by, 39–40, 50–52, 56–61, 66, 68, 74, 78–81, 86–87, 98, 104, 108, 110, 113, 115–17, 160–67; female body and, 2, 4, 11, 23, 68, 87–88, 107, 113–14, 121, 133,

138–39, 151, 162, 164–65; feminist film theory and, xii, 2, 4, 11–12, 14, 16, 140–57; heterosexual desire and, 9–10, 96, 103, 122, 156, 171 n. 14; heterosexual love and, 20–21, 81, 96, 103; heterosexual relations and, 107, 138; international film festivals and, xi, 15, 48, 67, 90, 96–97, 140–41, 145–48, 173 n. 1, 178 nn. 30–31; language of, xii, 4, 12, 29–35, 37, 41–42, 62–68, 97, 99, 108, 113–14, 138, 155, 162, 166; male viewer and, 9–10, 13, 19, 26, 156, 171 n. 14; modesty laws and veiling in, 2–3, 8–11, 16–22, 42–43, 48, 80, 96–97, 99, 101, 103–4, 121, 138–39, 154, 166; modesty laws and the look in, 5, 122, 129; modesty laws and realism in, 162; national identity and, 43, 47, 58, 67; new subject of, 2, 3, 8, 16, 25, 152; Persian grammar in, 62, 63, 65; purification of, 2–4, 6–9, 15, 41–43, 47, 81, 95–96, 152–53, 157; realism and, 11, 12–14, 67–69, 71, 76, 86, 88, 107, 139, 141–42, 145; refusal of voyeurism in, 2–4, 9–10, 13–16, 41, 68, 122, 129, 131, 136, 153–54, 156–57, 165, 167–68; the senses and, 1–10, 15, 28–30, 34–35, 40–42, 60–61, 96, 152–57, 162, 166, 168, 169 n. 3; spatio-temporality of, 3, 9, 15–17, 19–21, 47, 60, 66–68, 86, 88, 142–43, 162, 164–65; ta'ziyeh and, 7, 17–21, 60–63, 66–71, 77, 84–86, 88, 109, 134, 159; utopian vision of, 8–11, 29, 68–70, 87, 152, 155, 157, 167–68; veiled woman and, 9–11, 88, 107, 113–14, 121, 125, 131, 138–39: as woman's cinema, 5, 9, 12, 14, 117, 157, 167

veiled female body: as associated with filmic technologies, 11, 88, 97, 100, 108–10, 113, 115–17, 121, 129–30, 139, 153; cinematic realism impossible in relation to, 10–11, 16, 61, 68, 98–99, 162; questions of framing and, 98, 119–21; as reference to male presence, 10–11, 156; as shield against heterosexual desire, 9–10, 154, 156; as site of enunciation, 4–5, 11, 13–16, 22–25, 42, 67, 77, 88, 108, 115–17, 125, 133, 139, 162, 165

"vernacular modernism," 148, 170 n. 6, 171 n. 2

"village films," 48, 59, 98–99

voyeurism, 10, 14, 103, 136, 142, 171 n. 6, 179 n. 61, 180 n. 70; as cinema's meta-desire, 2, 13; association with ethnography, 148–49; melodrama encoded by, 2, 11; resistance to, 2–4, 9–11, 13, 15–16, 41–42, 81, 104, 107, 122, 129–32, 152–54, 156–57, 165, 168; ta'ziyeh's diectics in relation to codes of, 20–21, 68

woman's cinema, 5, 9, 12, 14, 117, 157, 167

"Westoxification," 2

Where Is the Friends Home? (Khane-ye Doost Kojast?, Kiarostami, 1987), 90, 112, 114–17, 122–24

Wind Will Carry Us, The (Bad Mara Ba Khahad Bord, Kiarostami, 1999), 96–97, 105, 107, 119, 126, 135–38, 141, 167; "subterranean scene" in, 91–95, 128–29; "Taj Dawlat's coffee shop" scene in, 130–34

Negar Mottahedeh

is an assistant professor of literature

and women's studies at Duke University.

Library of Congress Cataloging-in-Publication Data
Mottahedeh, Negar.
Displaced allegories : post-revolutionary Iranian cinema /
Negar Mottahedeh.
p.cm.
Includes bibliographical references and index.
ISBN 978-0-8223-4260-1 (cloth: alk. paper)
ISBN 978-0-8223-4275-5 (pbk.: alk. paper)
1. Motion picture—Iran—History.
2. Women in motion picture. I. Title.
PN1993.5.I846M68 2008
791.430955—dc22 2008028458